When Can I See You Again?

When Can I See You Again?

NEW ART WRITINGS

W. S. DI PIERO

W. S. di Piero

2010 : PRESSED WAFER : BOSTON, MASS.

Copyright © 2010 by W. S. Di Piero

typeslowly designed

Cover: Photo by Ben E. Watkins all rights reserved
"Vestry, Mission Concepcion, San Antonio, 1992"

Printed in Canada by Friesens on Rolland Enviro, a 100% PCW paper

First printing in 2010

ISBN 978-0-9824100-6-6

Pressed Wafer / 9 Columbus Square / Boston, Mass. 02116

CONTENTS

Preface

The practice of criticism is an exercise of judgment about life. Looking at pictures is an inquiry into erotic attention, into what delights, tickles, enchants, or makes us weep, shout, or groan with loathing. Pictures are climates of feeling: to criticize pictures is to live for a while in and decide how much you like and how well you tolerate the climate. Its air can waken or narcotize or stun or unnerve or astonish. While I know it's not a truth of fact, it's a truth of feeling that I sometimes sense I've been found out by something I've seen, that the picture I'm examining, sassing, or wooing is doing something similar back at me. Sometimes it stares at me and I realize I've not allowed myself to feel a certain way, that I've unknowingly censored something in my inner life. Art tests our internalized self-censors. You test me, it says, and I test you: you try me, I try you. Turning the encounter into writing takes form for me in the close-to-the-ground, loping scrutiny of the essay, or the jumpy, get-in-get-out randiness of the review. Reviewing jacks me up with surprise: fourteen hundred words ago I didn't realize I so liked (or was so bored by) the objects my assignment deposited me in front of.

In 1999, the *San Diego Reader*, an alternative press weekly, asked me to write a column on art. I'd written essays on artists and catalog bits for gallery shows, but I'd not tried art journalism and thought it was time. I'm still doing it. I cover shows mostly in southern California because the paper is local, though it lets me forage more widely when the occasion warrants. Of the one hundred and thirty columns I've written, I've picked fifty-four that represent the variety (Rembrandt, Maya art, 1950s American design, Pre-Columbian marine animal amulets, whatnot) of stuff

I've covered. There's a lot about photography, from its beginnings to yesterday afternoon. (Photography is *our* art: it belongs to us moderns.) I regarded my *Reader* assignments, whenever possible, as mini-essays barely adhesive to the exhibitions that occasioned them, so here, wherever possible, I've finessed things with the intent of dissolving the Reno wedding bonds between column-content and show. In some cases it's impossible: my remarks are too fastened to arguments made by certain exhibitions. To organize things, I've pouched pieces into three-year bundles; I've ordered individual columns in each bundle in the hope of giving a smudgy shape to my preoccupations and to the way artists of very different times and places converse. I've listed in the Appendix the particulars of exhibition titles, venues, and dates.

While doing the journalism, I still wrote longer essays for magazines. I've included the ones whose voices sing along, if a little off key, with themes and issues that drive the shorter pieces. The chronology is screwy: the opening essay, on Giorgio Morandi, is the most recent I've written; I wrote the closing one, on Jackson Pollock, in 2006. But those two matter most to me. Morandi and Pollock have been spirit guides, not only in formal, technical ways, but in the ways of the heart and its self-enchanting, meditative attentions.

San Francisco
November, 2009

When Can I See You Again?

Good art changes on us as we change. The form-finding imagination that brings certain works into startling existence has an afterlife in the dialogue between giver and receiver. We continue to look at certain works in part because we want to understand the tropism that won't let us turn away, that makes us lean into what holds the eye, because we want to better understand ourselves. We interrogate a painting while it interrogates reality, we puzzle out a picture because it's puzzling out the very activity of seeing the world, we watch it as it watches us and shapes our consciousness. We might first be compelled by formal questions, and twenty years later that curiosity remains alive but has folded into itself a life of feeling. Certain art, perfectly adequate art, thins out as we age because it doesn't answer to our deepening sense of destiny, the awareness (or suffering) of matter, conflict, illusion, mortality. Great pictures conspire with our projects of self-invention; they get kneaded into our character and history.

While living in Bologna in 1986, I went to an exhibition of work by Giorgio Morandi, who spent his entire life there, mostly at the same address in the working-class neighborhood of Via Fondazza. In 1934, the art historian Roberto Longhi declared Morandi, then forty-four years old, "one of Italy's finest living painters," and in 1989 Balthus called him the greatest Italian painter of the century. Most painters I've met revere him. Anyway, the pictures in the show took such hold on my mental life that I used them as my first occasion to write about an artist. I'd never studied art history but was pigheaded enough to believe that inarticulate passion and curiosity would suffice. Expertise would have to look after itself. Morandi's still lifes of vases, compotes, *caffellatte* bowls, pitchers,

fry pans, tin funnels, Ovaltine canisters, deployed in endlessly varied tableaux (four small objects lie on a table isolated like characters in a Beckett play, or several bulky forms cluster like buildings in a medieval hilltop town) are the most lushly exposed yet self-contained enchantments of the modern period. He made flower pictures and landscapes, too, about 1300 paintings plus hundreds of drawings, prints, and otherworldly watercolors. Isolated objects tend to appear in the early work, then the jammed-up things dominate. The paint can be alluvial, buttery, torpid, or dashed, thinly whisked, nearly transparent. For years he ground his own pigment and returned all his life to variations on a familiar range of tones, the sanded-down oranges, blushed umbers, and smoky maroons of Bologna's walls.

The 1986 exhibition included artists Morandi was obviously in dialogue with (De Chirico, Giacometti, Cézanne) and tanked the misapprehension of him as a provincial recluse cut off from European modernism. His life invited the misperception. He lived with his mother and unmarried sisters, earned his bread teaching etching at Bologna's Accademia di Belle Arti, and except for two hops to Switzerland never left Italy. He knew most of modern art from reproductions in books and magazines. By nature solitary and taciturn, he yet kept in touch with numerous writers and artists. He absorbed lessons from Futurism, Cubism, and Metaphysical Painting as practiced by De Chirico and Carlo Carrà. Besides, why leave Italy? He had Masaccio and Giotto in Florence (Morandi's oil paintings sometimes look like frescoed canvas) and in Rome had Caravaggio's eroded, wounded physicality. ("In Caravaggio," he said, "painting defines the reasons for painting.") His few interviews confess debts to Chardin, Corot, and Seurat; he was interested in Rothko and Pollock, unsurprising from an artist who insisted that "nothing can be more abstract, more un-

real, than what we actually see. Matter exists, of course, but has no intrinsic meaning of its own, just the meanings we attach to it. Only we can know that a cup is a cup, that a tree is a tree."

In 1986, I was in thrall to the expansive beauty of those small canvases where the same humdrum things recur in unrealistic settings—his table tops are only gesturally table tops: they're really pressurized pictorial zones where Morandi experimented with assorted kinds and degrees of flatness. But I used the pictures, finally, to illustrate a preoccupation: What makes any artist settle into an achieved style, to accept limits. I'm shamed by the obtuseness that tweaked Morandi for his *limitations*, his *struggles* to vary or dilate his idiom. I was too green to see how he uses the material world to disclose the inner life, to get us to see into the secret lives of things and the instabilities of matter. The work scrutinizes in a visionary way the immaterial in the material. The pictures are extreme acts of attentiveness and can induce the kind of mania Ortega described when he wrote that a maniac (or lover) is somebody with an abnormal attention span.

Morandi is a warm painter who doesn't invite clinginess. Like a lot of memorable poetry and music, his art is intimate without being cozy. The pictures' uncanny stillness is composed of tremblings and undulations of color and line not only across the surface but down through the impasto. It took more exposure before I felt the work really blend itself into my consciousness. It took the Museo Morandi, opened in 1993 in the 14th century Palazzo Comunale in Bologna's Piazza Maggiore. I've been several times, it's one of my favorite viewing spaces, over two hundred widely spaced works strung out through small, uncarpeted, usually empty rooms. It's the best-kept secret quarters of any great modern artist. I've never felt so settled into some sort of manic fugue state as in those rooms. The pictures create a weather of

quietude under duress; the demure rectangles, spheres, cylinders, and triangles seethe with inquiry. The processual world streams through their stillness. None of this is vitiated by a tonier venue, like the plush catacomb of the Lehman Wing in the Met where a selection of Morandi's work was recently exhibited. Hooded by fine art enhancements—scrupulous dialed-down lighting, carpeting's whispery tranquility, tinted walls, echoless voices—the work looked magisterial. But in the stripped-down Museo Morandi, they look sublime.

The modern sublime isn't about magnitude or clarion ambition: it rubs perception so close to ordinary facts of physical reality that we feel pressed against a membrane that obscurely separates us from whatever lies on the other side, if there is another side. It intensifies and restores physical reality while suggesting something larger than consciousness. The frontal, sensuous forms on a Morandi canvas induce an exhilarating anxiety about what's unnameable and invisible but felt along the nerves. In the work of the late 1950s and 1960s especially (he died in 1964), the veil trembles more transparently and unsteadily, the veil that's at the same time just a hand making its marks, testing the confines of the sayable. Morandi was the least performance-conscious of the great moderns. The only audience other than himself was the space between his eye and the canvas. And no modern more-or-less figurative artist so resists or shrugs off the use of words, the kind of verbal field of resistance I'd tried to craft many years ago. Surrealism, Cubism, and Futurism make magpies of us, but his works don't offer themselves up to words any more than Wallace Stevens's poems offer themselves to illustration. "The sentiments and images awakened in the visible world, which is a formal world," Morandi said, "are expressible only with great difficulty, or perhaps inexpressible with words." Art transports us even while, especially

while, it's accounting for the actual. Stevens wrote: "The way through the world / Is more difficult to find than the way beyond it." Morandi's chamber music of color harmonies, the degrees and directions of brushiness, the vibratory frequencies in and around objects—they don't *invite* admiration, though they can charm us into casual awe. Modestly sumptuous to the eye, his art is tensely interiorized, it possesses a reserve that puts us at a remove where we can observe the working relationship between the painter's transformative eye and his silent sitters.

Morandi is a poet devoted to similitude complicated by unlikeness. One pair of paintings in the Met exhibition shows a nearly identical grouping of several long-necked bottles, yet each inflects space, rectitude, and atmospheric temperature differently. One looks braced, the other relaxed. The strange, unpredictable, self-renewing power to transmit a way of seeing to the hand allows exceptional artists (check this against Bonnard and Picasso or Bacon and Freud) to stay fresh even while migrating to recurrent subjects. Morandi had his preferred motifs virtually from the beginning. Even when he was teasing out Metaphysical Painting in the late 'teens, he wasn't as interested in the darkly comic situational conundrums of De Chirico as in spectral angularities—mirrors, boards, boxes—and hard-edged curvilinear objects that look carved from wood. By the late 1920s he was well on his own way, adapting formal inquiry to the daily feeling for material reality. His touch becomes more fleshily rotund, more florid and liquid. He pursues continuity, especially apparent in his skeletal sleight-of-hand drawings. An exquisite group of these ran concurrently with the Met show at the Italian Cultural Institute. Their stark pursuit of completeness made me gasp—they graph inquisitiveness. Each is an existential autograph. The paintings narrate a day-to-day meditation on seeing and feeling. The still

lifes become hermetic chambers so complete that we forget about everything that's been left out. His narrow gauge of subjects pressured him into ways of staying fresh and surprising himself (and us). He allowed dust in the studio to accumulate on his magician's kit of objects—one visitor said the dust unified all those different shapes. Photographs of the objects show the chased, weathered surfaces that the action of his brush imitates. He undermined their sameness not just by re-staging arrangements. He painted his boxes and canisters, he filled glass containers with pigment, he had tin utensils made to order, all so that he could keep creating occasions for surprise and disclosing endless difference in apparent likenesses: "The important thing," he said, "is to touch the core, the essence of things."

The table top in a Morandi is a field of change, and nature, which Morandi (like his hero Cézanne) insisted was his true subject, wobbles with change, is smeared by it. ("I think that to express what's in nature, that is, the visible world, is the thing that most interests me.") In a 1953 still life in the Phillips Collection, there's no platform, only an imagined surface where objects appear. In the front rank, yellow and brown Ovaltine cans stand next to a white-faced box that wears a sidewise stripe identical to the brown that outlines the Ovaltine tin. Behind them squats a tight twosome: a vase of which we see only the torqued grooved neck, and a nearly invisible Prussian-blue canister. But the marvel of the picture is the wolf's-head shadow next to the brown box streaked like spoor behind the gossipy little crowd of objects. The following year he made a sly picture where the flat tops of similar vases and boxes *are* the horizon line of the table's upper edge.

In Morandi's harmonics of uncertainty, everything lives in provisional greetings: the emergent forms greet us and his hand greets them in a space where these correspondences coalesce into

the marvelous and the uncanny, those conditions claimed by sur-
realism that Morandi kidnapped and applied in a completely oppo-
site mood—quietude and unrest instead of brassiness and iconic
exaggeration. Sometimes the paintings literally greet or beckon
each other. The Met paired two pictures that feature boxes and
a tin pitcher shaped like a knight's visor. One reverses the direc-
tion of the pitcher's pointed beak so that the pictures stare each
other down. The wit of the installation is possible because the
wit inheres in the method. "The important thing is to commu-
nicate the images and sentiments that the visible world awakens
in us." Francesco Paolo Ingrao, one of his major collectors, says
this: "Morandi's poetry is a poetry of quotidian feelings, but the
dailiness of them—day after day—conveys a sense of the eternal.
In Morandi's pictures the empty space between two objects takes
on a figurative value. This is *pittura-pittura*." That is, "painting-
painting," the way we speak of a movie-movie, or poetry-poetry
like Stevens's or William Carlos Williams's, a practice that brings us
the richness and completeness of what's irreducible in an art, what
Stevens called "the mind in the act of finding / What will suffice."

The most mysterious work is the watercolors of the 1950s and
1960s. They depict an almost-ness of matter, a phantasmagorical
life of things. All that is solid in his familiar canisters and bottles
melts into marine-layer air—they become atmospheres, exhala-
tions. He's preoccupied not with liquidity and consistency but
with what's aspirated. He makes us see the ghost of a thing *in*
a thing, as if he's painting dark matter's hues, a thing's negative
existence. The watercolors marry the support as the pictures do
not. The suffusion, the binding of color, form, and ground is so
total and consonant that he creates a floating world as particular
and identifiable as Rothko's huge canvases, but without Rothko's
titanism. Morandi is the least histrionic or presumptuous of great

artists. His paintings don't exercise the kind of attack so critical in Picasso or Miró or Pollock, and in the watercolors you feel he's simply condensing vapors on the blank support, not applying anything to it.

Morandi's art has everything to do with teasing out problems specific to the art, but one of its essential, sustaining pleasures is its comprehensive candor of presence (the studio paraphernalia expand and contract in a complex choreography of architectural or structural possibilities) blended with a humility that's not reticence at all but something mighty and self-contained. Whether landscape, flowers, or still life, nothing stood still for him: his feeling for nature, as he would say, is momentarily arrested in a condition of change, and that condition, that instability, is what Morandi paints. Look long enough and the reappearing paraffin lamps, shells, Tin Man hats and the rest begin to feel like company. They were his company certainly, and they feel like they're keeping us (and themselves) company. And the great ones, where the harmonies are achieved not by consistency but by different volatilities, speeds, degrees of formality, and mood-swings all held within one frame, have the reliability and the fastness in our mental lives of a Corot or Chardin. Their presence says: Recognize us, know us in order to know yourself.

SAINTS

ع

2000–2002

The Full Treatment

A San Francisco acupuncturist refers to any procedure requiring many needles as "The Full Frida." He assumes his patients are familiar with a Frida Kahlo self-portrait where wiry tendrils radiate from her head, or another where flathead nails stick out all over her head and body. A woman I know went to a costume party dressed as Frida. Imagine going dressed as Helen Frankenthaler or Grace Hartigan or even Georgia O'Keefe. *That* would keep them guessing. For Kahlo self-portraiture was icon painting. No artist of the modern period except Van Gogh—not even egomaniacs like Dalì, Picasso, and Gorky—made self-portraits so immediately identifiable to so many people. They aren't just representations of selfness, they're altar images, *retablos,* of a self in pain. An automobile accident when she was eighteen, and the many surgeries that ensued, made her life infernal and prevented her from bearing children. In the paintings, it and other kinds of emotional pain come tightly and tidily wrapped in a mordant, virtually unchanging visage.

I'll get this out of the way right now: Kahlo's work either gets to you in a big way or it doesn't, and to me it doesn't quite. Her career was a critical passage in the history of portraiture because she used herself as a kind of milliner's dummy—and intended us to recognize this—that she costumed in psychophysical states of distress. She represented her body as a construction and demolition site. Her seditious, acidic wit and pick-a-fight-with-me solemnity are aimed at us and at herself. The imagery is unsettling, but the painting is tight and stiff (even when she's depicting tropical abundance in a still life of watermelons, bananas, and mangos), and the over-controlled iconography has a faint stink of

sanctimony, though I'm also sure this wasn't her intention. Her way of showcasing symbolic and actual agonies makes suffering seem perversely glamorous. For all the daring costuming and that deadeye look, most of her pictures are buttoned down. Even when there are surprising details like the needle-beaked bird of paradise flower in *Self-Portrait with Monkeys* and the papier-mâché baby doll in *Self-Portrait with Bed*, it's canned surprise. Subjectivity, as she represented it, drew its life from decoration, from the dressing up of agonies.

But her presence in the history of portraiture goes beyond her paintings. Kahlo was born to be a camera subject, and there's an ample archive of photographs by various hands. Consider a snapshot taken of her at age four. There she sits with an armful of flowers, self-possessed in a perky dress, owning the camera. But this is an as yet undamaged Kahlo, not the woman who after her 1925 accident lived with the kind of chronic pain that shapes a person's nature. (In 1950–51 alone, she spent nine months in the hospital following a miscarriage that resulted from the accident's damage.) Kahlo remained available to the camera all her life. She exploited its presence to express her character, to make political statements, and to comment on her art. She even used it to editorialize about her relationship with Diego Rivera, their shared enthusiasms, his work in her life, and his infidelities. (At one point he was sleeping with Frida's sister.) And she used it—as photography had been used since its invention—as medical evidence, a record of the surgeries on her broken spine. She was an inexpressive Joan of Arc of pain, a warrior artist-princess whose grim sense of gaiety caused her to spangle the plaster body casts she wore with mirrors and other shiny surfaces—they looked like Damascened breastplates. When photographed, she couldn't entirely control, as she could in her paintings, how she was perceived, so her presence has more

plasticity, her subjectivity a molten subtlety. She liked to pose as different personae, all grounded in her experience. She's the trousered roughneck revolutionary smoking a cigarette, she's the friend of Trotsky, she's the peasant Marxist who wears under her *huipil* blouse a body cast painted with a hammer and sickle, she's the goofball donning a photo-lamp as a hat, she's the artist-patient in a wheelchair posing next to the doctor she credited with saving her life. The political, erotic, and personal tumble together in an image of her (again in a wheelchair) with Diego Rivera before his big mural, *The Nightmare of War and the Dream of Peace*, in the Palacio de Belles Artes in Mexico City in 1952. She's the heroine of the picture, as she was, at times, the heroine in Rivera's life.

The archive of Frida photographs makes for a staggered narrative of self-exposure and self-construction. In a few images, especially those taken by her father around the time of her mother's death in 1932, the girlish Frida is plainly dressed, wears little jewelry, and looks haunted. No personality rind has formed. In later pictures she's more often in traditional dress, wearing jawbreaker necklaces and chunky rings on every finger. She had a serious collection of animals, so the dogs and monkeys we see in her paintings turn up in the photographs (though not her parrots, deer, and baby goat). No matter how contrived or staged the images, they simmer with Kahlo's peppery character and the bristly mischief of her paintings. Even if you knew nothing about her physical problems, after looking at many pictures in many guises—artist, prophetess, agitator, flirt—you'd find it strange how still she seems, how *stopped*. Incipient movement, or a momentary pause in the process of becoming, is visually coded into most portrait photography, but in hers there's no motion imminent. She looks statuesque because she was statue-fied by pain. She's usually sitting but, whether sitting or standing, her military bearing is a

stone post memorializing her accident. Unlike two other great camera subjects, Picasso and Giacometti, who were usually photographed in the studio, at a bullfight, or on a Paris street, in a state of actual or imminent motion, Kahlo is fixed, camera-pinned to the spot.

It's moving, instructive, and disconcerting to watch time remodel her face, head, and body. One of the most troubling pictures I've ever seen was taken in 1952, by Héctor Garcia, of a bed-ridden Frida in the rarest of instants, when she isn't composing herself for the camera. She's de-composed, lost, her slack-mouthed face disoriented, garments rumpled, her entire being wasted (I'd guess) by narcotics, her brain flooding her body with so much pain that she looks in shock from its intensity. She's a lifetime removed from the exquisite four-year-old with a sure sense of a filmable self and an armful of fresh flowers.

My People

I became aware of Norman Rockwell only in my late teens. My family, relatives, and neighbors didn't subscribe to magazines, so the 321 covers he designed for the *Saturday Evening Post* from 1916 to 1963 never sailed through our lives. The vision of American character in a picture like *Freedom from Want*—a large, get-along family sit gleamingly around a white-on-white table setting, one figure faced toward us as if in invitation to their communal ceremony—was a world apart from my immigrant Dago culture, a grasping, clannish, boisterous, semi-secret society that didn't think of itself as American at all. We were Italians, the Irish were Irish, Jews were Jews, and Negroes were Negroes. Whenever such people appeared in Rockwell's pictures, they were adorable caricatures, a pasty German, freckled Irish, or swarthy Mediterranean. And he made their context taxidermy chambers of trapped familiarity. He represented experience in a way that presumed hospitable intimacies but wasn't intimate at all. His articulation of an America of shared dreams and experiences was rhetorical in the worst sense: it made big-banner claims but ignored complexity and trouble. The Rockwell exhibition that traveled to different venues in 2001 (eighty paintings and hundreds of cover illustrations) sported catalog essays by high-brow art historians and critics that were official commissariat reconstructions—they argued Rockwell's homely majesty as painter-illustrator and dream merchant of middle brow American culture. The exhibition certainly had nothing to do with connoisseurship, but it didn't yield fat dividends as historical research, either. It was an archeological mash party, dusting off, highlighting, and hugging images that are an essential part of the archive of American self-imaginings,

and like a lot of American self-imagining, it made a peachy but
sick-making presentation.

Rockwell wasn't a very good painter. The pictures are inert not
because they're realistic and anecdotal but because the dynamics
are lifeless and mechanical. When he devises complicated spatial
relationships and cropping, as in *Saying Grace*, where restaurant
diners pause to stare at a grandmother and child praying before
they eat, the construction is modeled on Old Master precedents,
which Rockwell didn't have the pictorial inventiveness to re-imag-
ine. That's not a fault, it's a shortcoming that critical confabula-
tions about Rockwell's awareness of the genre-painting tradition
can't override. I don't question his good faith or his insistence on
hope, courage, decency, and piety, all essential civilized values,
but for these values to be fresh and vital in a work of art they also
have to be, somehow, acts of criticism. Rockwell wanted a pure
tone of sincerity and good will. He was and will be always loved
by non-museum-going people because he offers uncomplicated,
non-cynical representations of what they believe themselves to
be, and he succeeded as no other American artist in sustaining a
consensus on his peppy vision. Such delusions poison actual po-
litical processes, though, and occlude our moral vision of social
realities. Rockwell can't be faulted for his corny sincerity, but we
can be faulted for the purposes it's been used to serve.

When I first saw Rockwell's America spread before me at that
exhibition, it could have been Bali, not because it was so weirdly
becalmed and overripe with contentment, but because the people
and their culture looked so different from those I grew up with.
As I made my way through the galleries, bombarded by curatorial
tonnage about the People, I kept waiting for *my* people to show up.
Rockwell's vision includes very few Southern European and Jew-
ish faces, not to speak of African-Americans, whose explosive and

bloody civil rights struggles Rockwell reduces to creepily propri-
etary statements of "understanding." He never meant blacks to be
appropriated and re-indentured to an image-system in American
art, but he contributed to the cause. Compare Rockwell's world of
American facts to the raspy, excessive, growling, glamour-puss,
vicious America represented by social history painters like John
Sloan, Raphael Soyer, and Leon Golub, or even an illustrator like
Ben Shahn, whose vision of America's greatness was grounded in
mixed tones, in doubt, uncertainty, violence.

In his 1964 *The Problem We All Live With* (a *Look* cover), a black
girl walks to school possed around by U.S. Marshals; the tomato
that hit and streaked the wall behind her looks massaged into
the scene by a prop manager. Artists who challenge us don't fuss
much about audience response, but Rockwell's composition seals
off any response other than rueful pity and compassion. Then
there's a 1943 picture of a happy coal miner, happy because his
work is crucial to the war effort. The human fact—the misery and
profiteering conditions of mining—is subsumed by the ennobling
role it plays. Propaganda of any kind is almost always self-enno-
bling. Rockwell's narrow pictorial and moral range left nothing to
chance. He over-managed effects and stiffly controlled audience
response. His pictures are by and large cold Yankee products in
which human intimacy is a contrived icy gaiety.

Rockwell was a scrupulous, hard working craftsman. He left
high school at the age of sixteen to enroll at the National Academy
of Design and later went to the Art Students League and studied
with the illustrator Thomas Fogarty. In his teens he was already
earning money illustrating for *Boys' Life*. At twenty-two, he paint-
ed his first *Post* cover, which he called "the greatest show window
in America." He had no illusions about himself and what he was
about. He once said he painted America not as it really was but as

he would like it to be, so his pictures are more blatant than bold, more declarative than inquisitive. The illustrations and paintings alike squeal with gleeful lighting: the cheery whites and bumptious reds can bully you into submission. He was better at turning on the juice of sentiment than he was at measuring it out. Most pictures are so completely defined by anecdote—Tom Sawyer whitewashing the fence, two young sweethearts at a prom night soda fountain, a group of men gathered around a radio during wartime—that they're airless. Ambiguity is the enemy. Rockwell was no fool. He knew the limitations of illustration. He remarked that a *Post* cover had to be a rounded-off story that left nothing to be explained, it shouldn't be an activist goad to the social-political imagination. His America *had* to be all shrink-wrapped contentedness and hope. It was in its way Official Art because it propagated the pious desire to believe that we are as he makes us seem. Rockwell, a decent man and hard-working artist, was in fact sickened by wartime killing. He did very few World War II posters and refused to make images of the Vietnam War. The social issue that most concerned him was civil rights, though his representation of it is coy and precious. There's one picture, though, where he loses (or surrenders) his good-natured equilibrium. His grisaille-ish, sepia-toned picture of three civil rights workers about to be killed in Philadelphia, Mississippi, is loosely, nervously painted; instead of applying technique to a social issue, he allows moral disturbance to shake up the consolations of standardized technique. The subject matter rattles the tidy household of his pictorial imagination and slips its standard controls and strategies. It's the one picture you don't get in three seconds.

Pardon my dyspepsia. I'm ragging on Rockwell for not being what he never wanted to be. But it's irritating that so much blockbuster expense and space—the show ended its tour at the

Guggenheim, whose manipulative curatorial strategies so often cynically twist art-world rumor into established greatness—is given over to such an artist when we need more good, substantial shows of Marsden Hartley, Milton Avery, Arthur Dove, and Fairfield Porter, all of them purer American artists than Rockwell could ever hope to be. Rockwell's pictures, at any rate, are the kind that schoolchildren should be required to see more than once, first as an earnest monument to homogeneous American dreams, then as a misrepresentation or avoidance of unpleasant social realities, which also make us what we are.

Museum Going

Halfway through *The Museum as Muse,* there's a room where the walls are covered with four hundred and eighty small, differently sized, silver-framed black paintings. But the joke's on us. They aren't paintings. They are Allan McCollum's *Plaster Surrogates,* solid molds meant to play with our museum-bred expectations. Where we expect a painting to be, there's a black blank. Kynaston McShine's catalog essay tells us that McCollum's work addresses the issue famously stated by Walter Benjamin, that in an age of mechanical reproduction a work of art's unique aura becomes meaningless. Mr. McShine's remark that the *Surrogates* "come close to suggesting that a museum of multiple imageless frames would be somehow viable" and that "our memories of paintings, our ideas about what painting is, almost allow us to fill in the blanks" gives away the game. This kind of art, like much of the stuff on exhibition, is important not for what it is but for the speculation it occasions. The show originated at MoMA but I caught it at the San Diego Museum of Contemporary Art in La Jolla, where McCollum's faux paintings are gamely and disastrously installed in a cubicle facing the ocean. Artifice has always contested nature. It's something we humans were born to do; the evidence is on the cave walls at Altamira and Lascaux. The water's muscular shape-shifting swells and combers are complexly beautiful, a cadenced formlessness that teases us out of thought. *Plaster Surrogates* isn't up to the contest. The scene reminded me of Hilton Kramer's anecdote about his early years as a New York art critic: after a long gallery-hopping day spent viewing Pop smugness, Minimilist gigantism, and Conceptualist mind games, he went straight to markets to linger over peppers, bananas, beets, anything whose

forms and colors were only what they were. No politics, no intellectual coquettery, no cultivated impoverishment.

"Museum" derives from the Greek *museion*, a place inhabited by the muses, whose mother is Mnemosyne, memory, and in the modern period it has evolved into a hoard of objects that the culture values for their archival and aesthetic importance. It's not the culture that chooses, of course, but a population of experts skilled in connoisseurship, administration, preservation, and restoration. A collection is the result of filtering discriminations that are in some ways barely concealed patterns of censorship. Exhibitions are displays of intellectual and cultural bias. Determinations, obviously, are made for us, if not always on our behalf. It's a waste of energy to make an issue of what's obvious, even if artists and curators build hearty careers on it. The foxy, dapper grandfather of the art in *The Museum as Muse* is Duchamp, and his work is the actual and ideological centerpiece of the show. His charming *Boîte-en-valise* series is made up of briefcases containing reproductions of his own work (a moustached Mona Lisa, a "Nude Descending a Staircase," etc.). Each valise is a publicity kit or samples case, but it's also his own nutshell museum, his personal portable cabinet of curiosities. Duchamp makes issues of authenticity, artifice, selfconsciousness, and chance into a light, comedic art. His breezy gambler's wit, however, has generated a lot of sluggish, smug, look-at-me art.

The Museum as Muse is mostly about how contemporary artists have used museums as subject matter or objects of criticism. To somebody like me who thinks easel painting is still a juicy, pliant medium for form and feeling, the only thing missing from the exhibition is everything. Museums are muses mainly because artists copy and build on what they find there, so it's frustrating that no contemporary painters are included. One self-portrait

by Gregory Gillespie or *Windhover* canvas by Nathan Oliveira or marine-scape by Paul Resika or figure painting by Lex Braes, to choose artists of different generations and practices, would say something worth knowing about how museum "products" enter the bloodstream of different traditions. But to have included such work would have cracked open complicated issues this simplistic show doesn't want to deal with: influence, style, formal feeling, compulsion, craft. It would have also canted us into the tradition of copying the work of grand predecessors. Instead of traditional copies, there are Sherrie Levine's trendy black and white images that replicate work by famous artists. She considers herself a still life artist whose images are "ghosts of ghosts," thrice removed (painting, slide, plate, Levine reproduction) from the originating object. Her art is representation-as-reproduction, and it's haunted by Benjamin and Duchamp, but unlike Duchamp's *Boîte-en-valise*, Levine's work is affectless and conceptually arid. She responds not so much to an image as to the fact of its existence.

This sort of tendentious exhibition makes me think I should be living in a monastery eating beans and thistle. Its thesis thins out fast. But it does also offer special things like Joseph Cornell boxes. These creepy-cozy memory chambers, with their mysterious but sharply defined contents, house what Cornell called "the sense of something thought lost and found again." (His journals and letters collected in *The Theater of the Mind* are essential reading.) He was big on ballerinas. Legend has it that in the winter of 1855 the great Marie Taglioni was stopped by a Russian highwayman who commanded her to dance on a panther skin spread over moonlit snow. To preserve and evoke the atmosphere of that starry night, she kept a piece of artificial ice in a jewel casket. Cornell's *Taglioni's Jewel Casket*, with its plush velvet interior, glass ice cubes, and microprint legend is a little museum of precious,

hermetic memory. Cornell's boxes make me feel happy, but they also make me sweat, because out of their intense physical presence and exactitude of imagery comes an asphyxiating sensation of evanescence.

It's appropriate that most of what's in *The Museum as Muse* are photographs. Photographers were making images of museum interiors in 1853—they fell immediately in love with antiquities, and the affair lingers. Christian Milovanoff has photographed feet in famous paintings in the Louvre like Mantegna's *St. Sebastian* and David's *The Oath of the Horatii*. They look like the "detail" images in art books because that's exactly what they are, but that's also exactly what they're not, because Milovanoff singularizes physicality in a way that turns his photographs into fine art. And the long exposure in Thomas Struth's colossal cibachrome pictures of a crowded room in Venice's Accademia smears the bodies of viewers moving and lounging before Veronese's *Christ as the Banquet in the House of Levi*. The painting bustles with movement, though there's no movement at all, while the viewers in motion seem grotesquely still. Elliott Erwitt's picture of some unidentified Venetian masterwork, because of its strangely pitched angle and lighting, decomposes the original into mournful, elegaic sludge. And Zoe Leonard's spooky, disturbing pictures of antique mirrors in the Met create a kind of black light: nothing's reflected, nothing's given back.

Our Lady of the Mineshaft

The Christianity Spain brought to the Americas settled as topsoil on bedrock animist beliefs. To celebrate their annual corn festival, the villagers at Santa Ana Pueblo north of Albuquerque attend Mass in native costume then exit into the plaza and, to the beat of drums and rattles, perform a traditional line-dance, carrying ears of corn and scattering cornmeal. The priest who says Mass also participates. The Yaqui Easter ceremonies in Tucson include an enactment of Christ's triumph over evil; at the Christian line of defense a deer dancer stomps and shakes his rattles. Farther south, the relationship between Spanish and native cultures becomes tighter and more complex. When Our Lady of Guadalupe appeared to a Mexican peasant in 1531, it was on the site of a one-time shrine to Tonantzan, the Aztec mother goddess. Bolivian miners prayed in Spanish to the Virgin Mary, who protected them to a certain depth, where their protector became the Andean earth goddess, Pachamama, to whom they prayed in Quechua and to whom llamas were once sacrificed. I recently saw an 18th century miner's lamp decorated with an image of "Our Lady of the Mineshaft." At both sides of her halo stand llamas.

That lamp, images of Our Lady of Guadalupe, and hundreds of other folk art objects were included in *El Alma del Pueblo: Spanish Folk Art and its Transformation in the Americas,* a stringently astute exhibition that traced the origins and transmission of pottery, imagery, textiles, carvings, and those endearing votive offerings called *milagros*. The hidden narrative of an apparently miscellaneous show like this tells us about crossings, spillovers, incursions. Militarily the Spanish conquest was monolithic, but the influence

of Spanish folk art on New World products was subtle and com-
plicated. Spain itself was and is composed of idiosyncratic prov-
inces, each with its own traditional crafts. When these regional
idioms infiltrated the New World, they were refined, adjusted,
and articulated according to local customs and needs. It's played
out, for instance, in images of San Isidro Labrador. A 12th century
woodcut from Madrid sets the story: the pious farmer San Isidro
spent so much time in church that his crops suffered, so God sent
an angel to do his plowing. In a busy nineteenth century Boliv-
ian painting, San Isidro is represented as a prosperous landowner
done up in breeches, stockings, and frock coat, surrounded by
New World denizens: *mestizos*, Indians, African-Americans, plus
toucans, monkeys, peacocks. In a 19th century Mexican picture
he's a devout horse rancher. In a Paraguayan woodcarving he's a
squat barefoot peasant behind a yoke of oxen.

The bluntest and most immediate expressions of folk passion
are sometimes the most delicate. Spanish shepherds passed the
time by carving animal horn into densely ornamented drinking
cups, powder horns, and spoons, which they gave to friends and
wives. The designs aren't as meticulously and tenderly defined as
New England scrimshaw, but they carry the same shiver of fastidi-
ous affection. The bucolic bower scene on the 18th century pow-
der horn of a guitarist serenading lovers looks like a Fragonard
motif. Bread stamps (small, incised wooden squares like children's
building blocks, used to identify a family's bread in the communal
oven) are the folk equivalent of a landowner's heraldic seal. But
folk art isn't always used by the folk. An exquisite bone-and-silk
fan illustrates pastoral and urban cultures, its slats decorated not
only with flowers, butterflies, bees, and women carrying bread
baskets and water jugs, but also with images of a newspaper ven-

dor, a bell-ringer, a town crier. It's the sort of thing a Goya duchess might be holding; she might also be wearing a blood-vermilion *manteo* and dangling from her arm a purple silk purse from Salamanca. She'd be courted by a gentleman wearing bright red and green garters embroidered with winning, subtle rhymes like *El dia que te hablè, enamorado quedè*: When I saw you that day, you took my heart away!

The Spanish brought new good things and new bad things. Their diseases wiped out indigenous populations, but their horses and domesticated cows became in the New World life-changing technologies. Although Indians for centuries made pottery by coiling clay, the Spanish (who got it from the Arabs) introduced wheel-turned majolica, its bright, tin-enameled glazes fixed by double firing in a super-hot kiln. Towns and regions developed signature methods—apron designs from Teruel, greenware from Triana—and after absorbing Spanish techniques, Peru, Guatemala, and Mexico fast developed their own styles. Some of folk art's freshness inheres in its anonymity and practicality. There's a palpable joy of pious expressiveness in those shepherds' carvings and other erotic creations like *milagros*, ornaments offered in thanks for divine help or deliverance. Erotic because they position the devotee in a life-determining field of relatedness. The small, finely detailed, silver *milagro* of a hand made in 19th century Toledo must have been commissioned by someone cured of a hand ailment or injury. I carry on my key chain a contemporary *milagro*, beaten silver in the shape of a leg, that a friend gave me after knee surgery. And so even while the exhibition reminded me of modernism's affinity for folk art—so many of the forms recall the vocabularies of Brancusi, Elie Nadelman, De Chirico and Léger—it's a rocky experience to wander distractedly, as I

did, from the special exhibition galleries into a roomful of Impressionist canvases. On a good day, I appreciate these as much as anyone, but this time they made me turn straight back to the folk wares, to imaginative activity with no ego structure, an art made by everybody and nobody.

Origins

I believe there exists something like a world imagination, not a Jungian image-hoard but a vocabulary of shadow forms shared by the entire race. You can study the historical distinctions that define one culture from another, the belief systems expressed in pictorial patterns and the local circumstances that shape a culture's representations, and sooner or later they all melt down into an inventory of rhyming imagery. In the wilderness of southern Utah I saw an elk petroglyph virtually identical to an Iranian figurine dated 1000 B.C.E. that I saw two weeks later in a museum. Next to that petroglyph were domino, circle-inside-square shapes; I saw these, too, in the same museum, carved into a Mayan stele (ca. 400). Tiny fertility figurines from New Mexico's Mimbres culture (ca. 1000) and Arizona's pre-conquest Anasazi culture (ca. 900-1300) have the spatulate shape and physical features of figures made for the same purpose by Cycladic craftsmen in the Aegean around 1500 B.C.E. The great city of Casas Grandes, a major center in Chihuahua during the late 13th and early 14th centuries, produced boxy, bulbous figures (one smoking a cigar) that look like dead-on prototypes for the pneumatic caricatures in Fernando Botero's work. It's now a commonplace that modern art was created not in the 19th century but in classical antiquity and ancient indigenous cultures—Picasso and African masks, Brancusi and Cycladic carvings, Pollock and Navajo sand painting.

Most indigenous cultures have a mythic place of origin and the memory of a golden age where peace reigns and the land is rich with gold fashioned into objects that emanate unending light. In the 12th century the Mexica people who inhabited what is now the American Southwest were led by the man-god Huitzilopochtli

to central Mexico, where they founded the city of Tenochtitlan, center of what was to become Aztec civilization. They brought with them a memory of a place they called Aztlan, "place of herons." The physical site, wherever or whatever it was, became in their imagination a mythic ancestral homeland and sacred site of their spiritual roots. The Mexica ruler Moctezuma later sent men to rediscover the place; they arrived, the legend goes, only after being transformed into birds and animals. Most civilizations have believed in a vaguely locatable imaginary place that allows all humans to share a memory of origins and orient themselves in the universe. Athenians had the *omphalos*, the world-navel, in the Temple at Delphi. To this day the shape of the Hopi dugout ceremonial chamber, the kiva, recalls the original "orifice" called the *sipapuni* from which their progenitors emerged. As an idea or place in the mind, Aztlan was center-as-continuity, reaching from the American Southwest to Mexico, linking Olmec, Maya, and Aztec cultures with the Pueblo cultures of New Mexico and Arizona. The myth lives on in Chicano culture as a narrative of spiritual and ethnic identity.

Look at enough artifacts that for centuries have expressed that envisioned place and you'll feel you've seen things left behind by a lost paradise on earth. Aztlan represents an idea of passage and transmission. In pre-contact Mexico and the Southwest there were well-established trade routes between major cities like Tenochtitlan and Hopi, Zuni, and other Southwest cultures. Formal ideas flowed back and forth, borne by objects of use (basketry, textiles, ceramics) and materials (clay, turquoise, bead, shell), a family of aesthetic and practical forms that bound together diverse communities. Artifacts transmitted homologous stories. I've seen three ceramic containers from different zones and periods that illustrate the heroic twins, a motif associated with origin stories

from Mexico to the Southwest. A dazzling ochre drinking vessel from the Maya classic period (593–830), gorgeously painted with aristocratic twins, rhymes with a bowl from 12th century New Mexico bearing a mysterious image of two figures and a fish that covers their heads like a lunar cowl, and yet another New Mexico site has yielded a bowl decorated with blocky twins quite different in form and expressiveness from the others.

Aztlan also stood for shared religious and fetishistic elements. All over the region the parrot and scarlet macaw were power creatures—gorgeous feather mosaics have been found in various places—as was the turkey, which the Hopi associated with the sun because its head was once scorched by its heat. Sun, rain, lightning, and maize were the four cardinal points of indigenous life. Belief systems were built on those foundations. Without sun and rain, no maize. Without maize, no life. Anyone who has been to New Mexico in summer knows the terrifying *strike* of its lightning storms and flash floods. Aztlan populations lived, and in many places continue to live, with an awareness of animals and the elements lost to us who live in industrialized societies. And industrial civilization certainly didn't invent the sculptural imagination. A big carved Aztec image of the feathered serpent Quetzalcoatl, a religious totem, is pure sculpture—its ropy surface sucks space *into* the stone with deeply grooved convolutions. Aztec culture also produced a turquoise mosaic knife-handle shaped liked a crouching man. Decorative, yes, and ceremonially beautiful, but only a complex, self-aware imagination would create a human shape to be held in a human hand, crouched so much like an animal that it could be a shaman's avatar. Two of the most exquisite objects I've ever seen are a small butterfly and frog effigy made of turquoise and carved shell from the Hohokam culture in Arizona's Navajoland, ethereal spirit-essences that look as if

they'll take flight any moment.

These cultural streams and moments aren't stopped in time. Tradition isn't a scholarly conceit. Aztlan identity drives a lot of contemporary Chicano art and gives it an edgy cynicism, bitterness, and anger. Unlike post-Conquest "double valence" art, which ingenuously honored both Christian influence and indigenous pre-contact motifs, a lot of contemporary Aztlan-driven work snarls on self-consciousness, with two conspicuous exceptions. Santa C. Barraza makes figure paintings in flat, high-keyed, mineral colors like ochre and lapis that present startlingly frontal (but not confrontational) imagery rich in Aztlan associations. In one of her pictures an *in utero* vermillion woman lies buried under Zapata's feet, and even he is depicted as part of an emergence myth, an armed peasant rising from prickly agave leaves. And Roberto Juarez's quasi-abstract visionary landscapes remind us that painting isn't only still alive but that it can respond to and renew ancient themes. Juarez terraces and patches large canvases with imagery of a rich but eroded Eden, a fragmented Paradise haunted by snake gods.

Mastering

When Mao bid us to live in interesting times, he meant bloody, revolutionary times. Mexico lived through interesting times from 1910, when Porfirio Diaz's autocratic thirty-year regime was overthrown, to the Revolution's end in 1920 and the broils that followed—assassinations, labor strikes, the murder of President Alvaro Obregón. Chaotic tossings of the social order are usually trailed by disruptions in the arts. In the 1920s, a young Manuel Alvarez Bravo, who would become Mexico's greatest photographic artist, began to work under the influence of *estridentismo*, "stridentism," which followed the mercurial, streamlined aesthetics of Italian Futurism, and like Futurism *estridentismo* drilled into the future rather than mining the past, celebrated the forms of the machine, and thrived on abstract values and clarity.

The twenty-one-year-old photographer learned much about modernist technique from his mentor Tina Modotti, the Italian-born American photographer who went to Mexico in 1923 with her husband Edward Weston. Alvarez Bravo met Modotti in 1927 and emulated her brilliance in manipulating spatial relationships so as to turn a mundane scene like opened French doors into an essay on abstraction. Modotti and Weston were among many artists who migrated to the new Mexico. Revolutionary excitements attracted the Russian filmmaker Sergei Eisenstein, who had lived through interesting times of his own and came to Mexico in 1930 to document the history of the Mexican people from pre-Christian to post-Revolutionary times. Alvarez Bravo worked as a cameraman on this unfinished project, which resulted in what would have been a majestic movie but was left in ruins, *¡Que viva México!*

Wherever Eisenstein and other artists looked, they saw colonial and contemporary social orders floating rockily on the eternal tide of pre-Conquest Mexico. It was *this* Mexico that President Alvaro Obregón's ministry of education had in mind when it initiated the great mural project of the 1920s depicting Mexican history, myth, culture, and daily life. Alvarez Bravo was again on the scene, hired by the magazine *Mexican Folkways* to photograph Diego Rivera's murals, but his most eloquent response to the project was anti-heroic, a close-up of the artist Rufino Tamayo's slender, softly veined hands. Tamayo countered the histrionics of muralists like Rivera and David Siquieros with a more magical and formally exquisite representation of Mexican realities.

Mexican artists then and now have dealt with the crude grafting of pre- and post-Conquest elements. Alvarez Bravo made images throughout his career of the way indigenous religiosity bangs up against Christianity and the way ancient *campesino* culture is roughly kneaded into the lumpy textures of modern Mexico. In a sense, he was born to such a mission, growing up around the *zócalo*, Mexico City's central square where the Pre-Columbian past, colonial remnants, and modern technologies all crunched together. After passing through the predictable stages of Pictorialism and formalism, by the late 1930s Alvarez Bravo had developed his mature style and his judicious eye, and made one of his primary subjects the eye itself, or optics, the ways and means of vision. In one of his famous pictures, *Parábola óptica (Optical Parable,)*, an up-from-under shot of an optician's shop, heavy-lidded oval eyes stare from windows and signs. Alvarez Bravo loved devilish ironies, so this image works double time: it eerily (and comically) meets our gaze with its own disembodied googliness, but because the image has been printed in reverse, the signage can only be read in a mirror. What you see is not always what you think you see.

In 1938, at Diego Rivera's house, Alvarez Bravo met André Breton, but by that time he had already added surrealist tactics and subjects to his vocabulary. His *Sympathetic Nervous System* from the mid-1930s features an illustrated cross-section of a male torso collaged into an ad for corsets ("With Elastic Abdominal Reducing Belt"), and in the 1940s he made images of X-Rays, using this surrealist motif to pry into the relationship between photography, corporeality, and death, one of photography's favorite subjects— the little finality of every exposure turns reality into a negative. In Mexican culture the membrane (or film) separating life from death is extremely thin and porous, the threshold to oblivion always a tissue away from where we stand. In Alvarez Bravo's *Visitation to the Dead*, a family of women and children sit outside the locked gates of a graveyard, an adobe archway rising high and, in its shabby way, majestically above them. Beyond the wall are leafless trees. The figures are so small that they look like outcroppings of the earth momentarily *here* only until the gate opens and they cross the threshold to whatever waits on the other side.

There are crosses everywhere in Alvarez Bravo's pictures, at gravesites, beaches, roadsides. "Crosses" isn't quite accurate. They're the *rood*, that wood of nature upon which Christ the man-God was crucified, *crossed*. In the 1939 *Sea of Tears*, background combers roll toward a cross planted upright in sand; at its foot leans a thick shank of driftwood hunched in apparent grief. In 1971, having returned full time to still photography after working from the mid-1940s to the late 1950s as a cinematographer in Mexico's booming film industry, Alvarez Bravo was still treating this subject. In *Tomb Ornament*, a lodge-pole cross is wired to a carved broad-beamed cross decked with colorful paper flowers and ribbons. This doubling up is some kind of festive observance darkly complicated by the withering plant shoots scribbled behind. It's a cool, disturbing celebration of the death of all things.

The cross is just one motif layered into the palimpsest of Mexican religious history. During the post-Conquest conversion, missionaries urged the Ocuitelcos people indigenous to the town of Chalma to renounce their worship of the pre-Conquest deity Otzocteotl, God of the Caves. One day, in the cave where offerings were made to the god, its stone idol was found shattered, replaced by the crucified figure of the Señor de Chalma, Lord of Chalma. The cave soon became a shrine, and the Rio Chalma drew, still draws, pilgrims seeking the curative powers of its waters. Alvarez Bravo's *Cross of Chalma* shows us a roadside shrine of braided crosses draped in palm leaves, flowers, ribbons, paper ornaments, and other votive decorations, next to which rises a tree trunk. Its bulky crooked presence that so resembles the human trunk, and the broken dirt mound from which the crosses rise, are signs that the gods of Mexican antiquity continue to pressure and destabilize the structures of Catholicism jerrybuilt upon them. Christian iconography takes especially bloody, flesh-mortifying form in Mexican Catholicism. The church crucifix in Alvarez Bravo's *Figure of Christ* does nothing to beautify Christ's anguish. The image wants us to feel how the human body, a shapely bag of bones and water, really suffers.

One of Alvarez Bravo's greatest images—I haven't even touched on his melancholy female portraits and dreamy, mythic nudes—is of a 1950s brick-making factory outside Mexico City. In the foreground, in crisp industrial patterns, lie crosshatched slabs of fired bricks; behind them a kiln billows ashen smoke that races toward the edge of the frame. That kiln looks like a Mayan temple burning, and in the deep background two idle kilns stand as if waiting for the conflagration to spread their way. Alvarez Bravo was blessed with a long life. The old fox was still bounding lightly in his old age: in 1988 he made a sly, mirror-encased self-portrait, as watchful as ever.

Stray Dog

A friend in Kyoto once sent me a book by the Japanese photographer Yasuzo Nojima, who worked from 1910 to the early 1950s and whose early images of smoky landscapes, chunky nudes, and thickly textured portraits were exemplary Pictorial emulations of painterliness. He loosened up later and produced more casual compositions, giving up coquettish lighting for scrambled, starker effects. That was my first encounter with Japanese photography and made me want to know more about the post-war period, after Pictorialism had run its faux luxe course and the war changed Japanese life and culture. Daido Moriyama fills in some of those blanks. Moriyama was eight when we bombed Hiroshima, so he came of age as an artist when Imperialist Japan was being dismantled and turned into, if not a subject nation, something less than a sovereign state. Japan's ancient culture, foundational to its martial ambitions, survived the war only to be challenged by modern, especially American, influences.

In the early 1950s, photographers like Eikoh Hosoe, Shomei Tomatsu, and Ikko Narahara rejected Pictorialism's creamy niceties and the consistent, homogenous culture it peddled. Unashamedly imitating 1950s Americans like Robert Frank and William Klein, they made roughed-up images of *their* Japan, the Japan of American military bases, post-nuclear wastes, and deformed rebuilt cities. They photographed survivors with radiation burns, wretched provincial mine workers, and dreggy back streets. They used gashed, oblique points of view, goofy cropping, wiped-over focus, and scoured surfaces. Their ambitions coalesced in VIVO, a photojournalist collective in Tokyo formed in the late 1950s that supplied an ideology for the new radical style. VIVO artists

wanted to wake up their country to their culture's new demoralized and demoralizing realities. In 1961, Moriyama, having earned his living as a graphic designer, moved from Osaka to Tokyo to join VIVO, only to find it about to disband, but he managed to apprentice himself to Hosoe, who taught him the rudiments of the confrontational style Moriyama would exploit and push to scary edges for the rest of his career. His late 1960s work, apart from its obvious debts to Frank and Klein (who did a photo essay on Tokyo in 1961), has a jagged nervousness. The images look Brillo-ed, with shredded textures, acidic light, and twitchy kinetics. For years Moriyama shot from a 35mm camera tucked under his coat, or from a moving car, or while running down a street. It wasn't his discriminating eye choosing and framing the subject through the viewfinder, it was his passing presence in the world that caught the image. "I'm taking pictures," he said, "more with my body than with my eyes." The compositions are pitilessly unstable: stare at them long enough, they dissolve into abstraction.

Moriyama's obsession with masks and costumes took him to strip joints, karaoke parlors, gangster hangouts, any interior, really, that was theatrical. He followed guerilla theater troupes and street performers. He caught that self-aware, bemused agony and humor we take on when we know our image is being taken hostage by the lens. He also hectors us that a photograph is a mask, a contrived reality publicly displayed. Sometimes he replicates canned illusions like movie stills and posters. One image, from a *Bonnie and Clyde* still, shows Faye Dunaway torn up not only by bullets but also by the warping, disintegrating action of the photograph. Another shows Brigitte Bardot posed in bouncy, leather-girl gear. Moriyama was doing what post-war American photographers did, drilling pop culture through us to get a discomforting, sharper, and more complicated response, though he

insisted his concerns were more formalist than political: "I was not against America, or the war, or against politics. I was against photography."

Product design filled pop culture, and Moriyama made many pictures of Japan's new American-influenced prosperity, wobbly stacks of Coke bottles and Campbell Soup and Green Giant cans. Borrowing Warhol's wearied vision of the wispy perishability of pop culture, Moriyama gives many of his pictures a silk-screened look, but he isn't interested in Warhol's (and, generally, Pop Art's) poker-faced ironies. For his *Accident* series, he made heavily grained scabrous pictures of television and newspaper imagery, and he cropped details from police posters of horrendous traffic accidents. His images are criticisms of life not because they disapprove of things but because they show the world as an illusion-ridden place toothy with harm and danger: a garbage dump strewn with dirty light; a prostitute running down a trashy alley; a woman peeing in the street. They're critical because they reveal troubled and troubling tones of feeling. The nappy hound of *Stray Dog* is a sad-sacked but suspicious and volatile cur trapped in the box of the photograph, looking at us, making a judgment on us, on what Moriyama calls "this grotesque, scandalous, and utterly accidental world of humanity." He also said that the dog was him. The later work literally expands the early things. In the 1980s he experimented with a large format Polaroid mounted, as we might expect, on the back of a truck. The images are pneumatic, gigantic, but the tonalities are more calmly resolved than the ripped effects of earlier pictures. Moriyama's eye for consumerist culture is still stunning. An enormous fishnet-stocking-ed leg hangs from the side of a brick building. A gray fedora—it looks like a dune landscape—fills its large frame the way that fleecy dog filled its much smaller box, but the sumptuous hat is a vaguely menacing

fetish object. Early and late, Moriyama's pictures look like skins pulled tightly over reality. He makes us see both the skin—its tics, pores, pelt—and the object it covers. He's made many images of couples, one so bleached through that it's hard to make out the two sneaking lovers sitting in a car. The picture is where they're hiding, in the photograph, or where Moriyama is hiding them. One blasted photo—so much post-war Japanese work has intensely explosive light—is taken from a television image of two professional midget wrestlers. Moriyama smears the light as to make over-muscled sideshow icons look like frail Siamese twins being steamed apart.

Bluebirds of Happiness

Joy shouldn't be boring, but artists risk third-rate work when they try to make happy art. If it's not a nearly-out-of-control fire sparked from the friction between the aspiring imagination and the chafing of actual experience, if it's not juiced by *joy*, art (of any kind) gets maudlin, sappy, or superfluous. Inside the most expansive praise we should hear the throaty hoarseness of experience. Joy isn't something given and announced, it's worked toward and for. Many of Hans Hofmann's works on paper make me want to dance before them. Each is a shout of joy. He's one of those mid-century abstractionists that canonical art history hasn't quite accommodated. After emigrating from Munich in 1930, Hoffman became the most famous art teacher in New York. In his later years all his energies went into painting, and from 1958 to his death in 1966, he produced excited, inventive work. He practiced what he preached: to use the plasticity of abstraction to convert nature—a *feeling* for nature, he said—into pictorial form. He was that rare sort of artist whose work has no melancholy in it. It's the visual equivalent of W. B. Yeats's line, "the soul claps its hands and sings." A photograph of Hofmann in his sixties shows him wickedly gleeful before a picture-in-process, like a magician about to perform his best trick. Whatever his inner life may have been like, when he painted he made songs of happiness that pealed from the hard stuff the world offered him.

To compare Hofmann to Grandma Moses is, I know, grotesquely inappropriate. Who would compare Nathan Milstein to a country fiddler? Hofmann was a gifted painter whose exuberance was stoked by centuries of tradition. Anna Mary Robertson Moses was a prudent, self-taught artist whose homely, homespun

images represented idealized rural American life in upstate New York. People who weren't museum-goers exulted in such plain, self-contented representations—they loved them as one loves home samplers and the cracker-barrel nostrums they peddle. Though no sort of garden-variety opportunist, Grandma rang the bell. By the time of her death in 1961 at the age of one hundred and one, over a hundred million greeting cards had circulated bearing her images. She appeared on the covers of *Time* and *Life*, was interviewed by Edward R. Murrow, and welcomed to the White House by Harry S. ("Jackson Pollock makes ham and eggs art") Truman. In 1946, the Du Barry Lipstick company illustrated an ad for a new product, "Primitive Red," with a Moses country scene: "A red for the woman who knows as instinctively as a primitive painter stroking color on canvas."

Grandma Moses was an American case and not really a lipstick kind of girl. Born in 1860, she married at twenty-seven, bore ten children, five of whom survived infancy, and worked as a tenant farmer. When her husband died, with time on her hands ("If I didn't start painting, I would have raised chickens"), she taught herself to paint. She was seventy-two and had no greater ambition than to make pleasant pictures of life around her to give to friends. Her friends weren't masters of illusion and invention. That's a skill art dealers develop. When a New York dealer noticed a few of her paintings in a pharmacy, "Grandma Moses" was created. She was a dauber, thumbing pigment onto the canvas in tiny masses agglomerated to form large scenic settings, and her favorite subjects were domestic routine and communal work—harvesting, barn building, sugaring-off, baking bread. She depicted a mostly harmonious, hardworking Yankee world, and the satisfactions of her art lie in our desire for (or imagination of) such a world. But admirable moral quality doesn't guarantee an admirable prac-

tice; usually it impedes it. Decency, honesty, and humility glaze nearly every painting Grandma Moses produced. This isn't to say her work doesn't have its charms, it's just to say that such charms marked her limitations.

She wasn't a folk artist. Her manner and tone were too idiosyncratic, and her paintings expressed a vague wishfulness; it didn't articulate, as folk art does, a culture's systemic needs and passions. She was, if anything, a Primitive, or Naïf: she didn't *choose* to paint flatly and (with ingenuous human warmth) mechanically. It's the only way she knew. (Paul Klee could "do" Naïf to achieve playful but intellectually angular, skeptical effects.) Seen close up, her pictures possess some textural nuance, humorous detail, and playful color. They're very *constructed*. Wishbone, horseshoe, and oxbow forms (usually water courses or fences) tether one pictorial element to another and hold her pictures together. Even a brash painting like *The Burning of Troy*, which has a visceral, out-of-control energy and should have real punch as a unified entity—it depicts the fire on a wooden bridge that spread to and destroyed Troy, New York, in 1862—breaks down immediately into its patchwork swatches. Her sweet picture of a quilting bee imitates and celebrates her own compositional basting and stitching.

Tonally, Grandma Moses's pictures insist so much on good conscience that even a fire is queasily festive. A painter like Hofmann doesn't *display* conscience in his paintings; his pictorial language is itself a largesse and an enthusiasm. Certain moderns—Picasso, Giacometti, Soutine, Beckmann—allowed or bred into their art a cruelty inseparable from fearlessness. In Grandma Moses's pictures, decency rules. Painting for her was a way of valuing the world. The act of valuing is visible in her method: she blocks out a scene with horizontals and verticals then creates diagonals for definition and faux perspective; she calibrates surface space

between table, wife, stove, then *puts* a fence outside, then *fastens* a horse to that fence. Because she's a painter of such limitations, academic writers—who are always looking for "new ways of conceptualizing the subject"—explore predictable, non-painterly issues. What is Moses' relationship to modernism and its cult of the primitive? What's her place in feminist art history? What did her staggering popularity (she licensed her images to appear on curtains, cookie jars, dinnerware, etc.) say about the industry of cultural production in the post-war period? It's the knowledge industry's equivalent of producing a better, healthier hot dog.

As she aged—a daffy phrase in her case—the pictures get busier. Figures proliferate, genre scenes become more complex, but the nature of the painting doesn't change. This too is a Naïf trait, a single tonal frequency sent strongly and unchangingly over a long period of time. Her solutions to pictorial problems can be charmingly abrupt. In *Halloween,* to represent the happiness of the scene entire, she simply cuts away part of the house so we can see the identical button-eyed, rosebud-lipped kids inside, their heads decorated with hair or hats—remove the hair or hats and you'd get a cutaway view of their skull. For all the sameness of mood and gesture, lack of speed (in a time when, among Abstract Expressionists, speed was all) and limited compositional finesse, Grandma Moses's pictures offer their own peculiar delights. One is their aura of loving kindness, another is their vision of a Peaceable Kingdom in which humans cooperate to shape their lives in a world subject to destructive natural forces. And there are formal pleasures. Though there's not much wrist in her work, occasionally an effect startles. My favorite is the black boa of smoke winding from the locomotive smokestack in *Eagle Bridge Hotel.* She slides our gaze down that dark airy nothing until it condenses and solidifies into the rough, churning matter of smokestack and camshaft.

French-American

This isn't about Robert de Niro, Sr., one of the generation of distinguished American painters born in the 1920s that included Nell Blaine, Leland Bell, and Luisa Matthiasdottir. De Niro worked in a sensuous, colorist School of Paris mode. His motifs—nudes, flowers, landscapes, interiors—were traditional. He was, in the pictures, a man of the south, big-gestured and loose, playing a high-keyed palette of reds, yellows, and purples that express a love of physical reality brought directly off his nerves on to the canvas, a love indistinguishable from his love of the history of painting. But for all his impressive gifts, even as a mature artist he never succeeded in exorcising Matisse's ghost from his work. His loaded, sinuous lines and gestural summoning of the figure remained hostage to Matisse's practice. To de Niro, this might have been high praise. In the end, it put a pinching frame around his achievement.

But this isn't about him, it's about Frederick Carl Frieseke, born in Michigan in 1874 and one of the esteemed painters of his time both in France, where he spent most of his adult life, and in America, where his pictures—certain kinds of them at least—were much in demand. As a boy, Frieseke showed impressive drawing skills; as a young man, he wanted to earn a living drawing cartoons for periodicals, but that soon gave way to his decision to become a painter. Like many young American artists, he went to Paris to study at the Académie Julian, where he trained in classic academic technique (which emphasized draftsmanship and fidelity to the motif), and at the Académie Carmen, overseen more or less by James McNeill Whistler, then at the peak of his fame as a painter and dandy, who occasionally showed up at the

school in full dress—hat, frockcoat, cane—and would sometimes soil his gloves by correcting students' paintings with his finger. (A factotum stood by to provide a fresh glove.) Until his encounter with Whistler, Frieseke produced ethereal watercolors, but the older painter persuaded him to work in oils. In 1901 Frieseke had a picture accepted for the Salon of the Société Nationale des Beaux-Arts—he was launched. By 1904 he was winning medals at international exhibitions. He lived in Paris but starting in 1906 he spent summers in Giverny in Brittany—Monet was a neighbor—until 1920, when he bought a country home in Normandy where he lived until his death in 1939.

His early paintings bear Whistler's influence. The subdued palette, *sfumatura* effects, and subtle tonal modulations of the 1901 *Brittany Landscape* are very much in Whistler's manner. Later in his life Frieseke told a reporter that an artist shouldn't be bound to one style. The move to Giverny in 1906 converted him to impressionist technique. The sheeted, steady surfaces of his earlier pictures become more excitable. Like other Americans, Frieseke came to Impressionism when in Europe it was just a memory. (He was born the year Impressionism made its debut.) He announced he was a true Impressionist in 1914! He admired Renoir enormously and the influence is blatant in the fluttery brushwork of a titillating nude, *Venus in the Sunlight,* and a lush boudoir picture, *Before her Appearance (La Toilette),* in which a woman sits at her vanity applying lipstick, a loosely draped peignoir slipping off her shoulder.

Frieseke was a virtuosic stylist who passed with uncanny facility from Whistler's way of giving a painting an opaque, mood-bearing skin, to a crustier impressionistic surface built up from choppy, jabbing brushwork. His impressionist pictures have a different theatricality, not performative or "framed" but

emergent, breaking forth beyond the proscenium of the picture plane. In *Garden Umbrella*, stabs of pigment drizzle and pelt across the surface, both building up and passing through the scene. The woman in this picture is caught in, and created from, anxious color platelets. After 1906, color becomes a definitive agent, not a medium, of feeling, and it registers degrees of excitability. The movement of the pigment on canvas, in true impressionist fashion, is itself the object of vision. Frieseke's favorite motif, which in time shrunk his market in a still prudish American art scene, was the Renoir-esque nude. He also made many portraits of women dressed to disclose, in a highbrow peek-a-boo way, a breast, aureole, or nipple.

By 1915 Frieseke was playing with the flat, ritualized-decorative style of the Nabis. (Nabi is the Hebrew word for prophet.) Bonnard and Vuillard were exemplars, and their influence determined a 1913 interior, *The Robe*, where the pattern of the woman's kimono (draped to reveal her breasts) picks up the wallpaper striping and armchair upholstery. Nabi painting doesn't have the thrills of Impressionism, that dream of catching the sensation of the instant in every mark, or at least our imagination of that instant. The Nabis were more deliberate and emblematic. Impressionism doesn't take us out of time, it delivers us to time's particulars, to the ticking of instants registered in forms. Frieseke's Nabi-ish, panoramic picture, *Afternoon at the Beach,* pushes forward and flattens bathers, horseback riders, children, and hovering striped umbrellas. It's stop-time, a stilled processional. As he aged, Frieseke devoted a lot of energy to gently expansive domestic scenes. His palette darkens a little, as a singer's voice darkens with age, so that a quiet picture like the 1926 *The Practice Hour* of a girl playing the piano, bears ever so lightly a shadowy mantle of mortality. His very late paintings of women in modern dress are subdued, worshipful

presentations of an entire female presence, not just a celebration of flesh. On very rare occasions, this reliable painter—with reliability comes a buzz of tedium—jumps his own methodically laid tracks: the Nordic, expressionist feeling for transcendence in the 1931 *Night Scene* creates a pitch of mystery none of his other pictures achieve.

I collared de Niro at the beginning not to match him up against Frieseke, but to illustrate how a derivative painter can be a very good painter, not inconsequential or deficient, merely lesser, one who offers intense sensations even while we know we're actually looking through the veils of better pictures by greater painters.

Hit and Run

Brits pioneered early photographic processes. In 1802, Thomas Wedgwood and Sir Humphrey Davie were already trying to make pictures on a light-sensitive silver nitrate surface but had no way of fixing the image, a problem solved by another Englishman, Henry Fox Talbot, who in 1841 patented the calotype (the Greek *kalos* = beautiful; *typos* = outline or sketch), a process for developing and fixing a latent image on chemically treated paper, thus producing a negative from which an indefinite number of positives could be made. After Talbot published the first book of photographs, *The Pencil of Nature*—actually a manual illustrated with images—the team of David Octavius Hill and Robert Adamson emerged as the first self-declared art photographers. Hill, trained as a painter and technically assisted by Adamson, brought to photography the traditions of portraiture, historical costuming, and landscape. While this team was making subtle, genteel portraits, Roger Fenton was in Russia documenting the Crimean War with disturbing images reproduced back home as wood engravings in the *Illustrated London News*. One of the first American war photographers was, in fact, a Scot, Alexander Gardner, photographer to the Army of the Potomac. Even before Gardner, Timothy O'Sullivan, and Mathew Brady made their famous pictures of Civil War carnage, a Brit named Henry Peach Robinson produced *Fading Away*, a composite made from five negatives depicting the death in 1858 of a young girl, an image whose questionable taste made Robinson's career. Later on, one of England's best known turn of the century photographers was Julia Margaret Cameron, a well-to-do, socially connected inhabitant of the Isle of Wight who took up photography at the age of forty-eight and produced soft-

focus "painterly" portraits that are Pictorial to a fault. Mea culpa, maybe, but I can hardly stand to look at her—or for that matter any photographer's—precious, pathos-wooly representations of human presence.

Documentary realism, attention to human suffering, and Pictorial coziness were all compounded in the career of Bill Brandt. The joker in that mix was Surrealism. Born in 1904, Brandt began taking pictures in the 1920s, a critical decade for him since he spent much of that time in Man Ray's Paris studio absorbing Surrealism's ways and means. Ray (Emmanuel "Manny" Radinski to his friends back home in Philadelphia) started out as a painter who, when he failed to sell his work, began to create Rayographs, photograms made by exposing objects on light sensitive paper. Back in England by 1931, Brandt kicked off his career in earnest, and the surrealist influence would linger for decades: even in his straight documentary work he wanted to subvert normality and impishly interrogate reality. Every now and again a doll, manikin, or piece of statuary, all surrealist props, puts in an appearance. Brandt's description of the photographer as a "traveler who enters a strange country" covers all kinds of documentarian adventures. Man Ray was in his own bent way a documentarian, recording distorted states of being. The term has an interesting history. In the 19th century a documentary photographer was one who made copies of documents. By the 1930s it referred to photographers who caught reality on the run, subjectively, with an instigating and sometimes propagandist passion. Brandt took André Breton's assertion that "Surrealism is contained in reality itself" and applied it to the visual facts in Europe between the wars. In a photo of a Hungarian opium grower smoking a pipe among his plants, the bulbous pods seem to be conversing with him, and the bubbled warts on his nose seem part of the conversation. A Billingsgate

porter in a bloodied smock balances a huge fish on his oilskin hat.

The images Brandt made of English life between the wars were astringent enough to be taken as socialist propaganda. He exposed the manifestations of class and the coarse divide between rich and poor. He photographed in theaters, great houses, prisons, common lodging houses, and Turkish baths; he photographed parlour maids in frilly aprons running a bath or preparing tea service for their masters, youths lounging at backgammon in posh interiors, street kids fighting, professional wrestlers performing, lovers canoodling in pubs. No photographer has so edgily sealed in images the boozy good fellowship and volatility of social drinking. The sudsy, gap-toothed joviality in Brandt's pub pictures comically shows how the body can bullishly refuse to be deterred from living passionately. In one nighttime image we see from behind a man leaning into a disengaged and somber woman with her back to a wall; he's grabbing his crotch while the heavy shadow of his hat wedges toward her head like an ax.

During the 1930s and 1940s Brandt produced most of his best work as photo-stories for the mass circulation magazines *Picture Post* and *Lilliput* and up through the mid-1950s worked freelance for the UK and American editions of *Harper's Bazaar* and other slicks. The uncompromising reserve of photographers like Walker Evans and Edward Weston borders on cruel disinterestedness. Brandt brought to his discipline a preternaturally vigilant eye but also a bedrock moral decency. Think of Chekhov's cool, steady moral concern, or the filmmaker Robert Bresson's. Brandt enshrines the self-possession not only of people—in heartbreaking images of girls on a stool peering out a window, or a sexy young thing showing off her gams, or miners' gaunt skulls staring out from the mineral matter they seem made of—but of objects, too, like milk bottles or newspapers on a stoop. One image that's pure

Chekhov is of a trash picker ransacking a dustbin observed by a swell in a tux.

Because he was essentially a pragmatic photojournalist prepared to "take" whatever was given (by assignment or self-interest), Brandt's range carried him from the social, urban realities of the 1930s and 1940s to the nudes and celebrity portraits of writers and artists he later became famous for. He was a scrupulous student of the 20th century's smokestack world, of chimneys, factories, coal refineries, trains, cigarettes, cigars. Consider two insinuating pictures: 1) a miner sits by a coal fire, face and forearm charred with coal dust, smoking a cigarette, as if vulcanizing his own flesh and bone; 2) scavengers pick coal from a steaming slag heap, climbing a slope in a homemade hell. Brandt presents the British as dignified, self-contained social creatures in all sorts of environments, but he also shows them as an underworld population during the Blitz, hiding in Tube stations, wine cellars, and church crypts. One old woman sleeps in a sarcophagus; a girl sprawled among a hundred others on a Tube platform sports gleaming thick-heeled pumps and sateen blouse. Photography means writing with light, and during the wartime blackouts Brandt made nocturnal exposures by the light of the moon, which silvered the masonry seams on brick buildings and put a razor's edge on cobblestone streets. He photographed St. Paul's cathedral during the Blitz: against a leaden background, the great dome looks too much like a target, a "before" paired with the "after" of chunky bombed-out rubble in the bright foreground. Since September 11 we like to say that everything has changed, until this picture gently reminds us that since 1939 some things haven't changed much at all.

At the other extreme of his practice, Brandt's nudes are the most formally experimental of his images. He sees in flesh a puffy elasticity and electric illumination. He pulls the body into picture-

ness, sometimes posing it in a self-conscious, "gazing" manner, at other times plumping or stretching a thigh or forearm as if to memorialize the surrealist moment. He liked using an ancient wooden Kodak with a wide-angle lens that, like 19th century cameras, had a pinhole size aperture and no shutter. When photographing nudes, he exercised minimal control; he let the instrument determine the image. It enlarged space, elongated volumes, and distorted proportions. The *camera* intensifies the sensuality of these loopy images. The less control, the more sensuous the image, the blast of lit-up flesh supported and profiled by soft-paved dark.

City Lights

Every great city has its own central nervous system that good street photographers make visible. Walker Evans's images of New York, even those he snapped from beneath his overcoat on the IRT, are cool and suspended. Robert Frank's cities—New York, New Orleans, Paris, St. Louis, Lima—wobble with unexpected, vaguely sorrowful flashes and globs of light. Louis Faurer, Philadelphia-born of Polish immigrants (named Fourer) in 1916, had his own vision of cities and their not so secret secrets. His work has always drawn enthusiasts, mostly a smallish group of photographers, scholars and curators. Walker Evans was an admirer, Robert Frank a close colleague and long-standing friend, but people with only a casual interest in photography don't know much about him.

I confess a special interest: Faurer grew up and started making photographs in South Philadelphia only a few blocks from where I was raised. He was obsessed with the way commercial prosperity plays off against individual trauma, eccentricity, and destitution. The 1937 *Silent Salesman*, taken in center city, features a mute peddler of razors, pencils, laces, and other novelties. Atop his peddler's case sits a dog, wearing a hat and holding an American flag between its teeth. To the side, slightly out of focus, we see two well-dressed businessmen sauntering down the street—it's an image of American enterprise going different ways. Faurer loved the focused mania of Market Street and packed his images with visual information. "Whatever you saw passing by," he said, "could be photographed." In one Market Street picture, a black amputee begs for change. He's the only element in sharp focus, and we see him through the legs of a store-window manikin. The glass re-

flects the store interior and is a lens through which we see a Horn and Hardart automat across the street. Sheeting and veiling pictorial elements in this way—Faurer sandwiched negatives, double-exposed, and exploited reflecting surfaces—became a signature touch. It was his way of achieving the "perfect truthfulness" he so respected in Evans's work. In 1947 he went to New York and began earning a living as a fashion photographer, working for Harper's Bazaar's famous art director Alexey Brodovitch. Faurer's salad years for his personal work were roughly 1946 to 1951; his images were pure American products, jumpy, a little "off," with splashy allover energy. The improvisational Faurer style, however, was manipulated into existence with great effort. He'd work around the clock in the darkroom to achieve a desired effect.

New York changed Faurer's style, or rather he changed his style to adapt to his new home. The Philadelphia pictures are fully, diffusely lit. The images tend toward melancholy but it's daylight moodiness. In New York he started doing nocturnes that are wild, purebred American classics. New York presented him with the incandescent lights of Times Square, the photographer's equivalent of a painter's drapery. He could dress a scene with them, use them as framing or as counterweights, and play up their excitability. He pushed the medium as it hadn't been pushed before, using very slow film in under-lit situations. You sense light being squeezed like fluid from its black surround. In a smashing picture of young people in a convertible, the street light reflections slash city signage across the hood, while the car's interior light (an effect achieved in the darkroom) feeds into the teenagers' exhilaration. In *52nd St. Pier Looking Toward United Nations Building*, two kids in the foreground lean over a match to light cigarettes. The match tip's disk of shattered illumination is repeated along the rigging of double-exposed streetlights trailing into the background. It's as if

the kids hold the city's life-giving fire in their hands.

Faurer loved marginalized city folk, the beggars and cripples, the nameless and unseen. He grew especially fond of a mildly retarded man named Eddie, who hung out around 53rd Street and 3rd Avenue, a frail, semi-adult waif whose gaze is interiorized and agonizingly shy. And a disturbing image titled *Champion* features a human primate, a heavyweight palooka with a mantelpiece brow, crushed countenance, and Paleolithic jaws, snappily dressed in suit and tie: he's staring hard into a middle distance, but out of a profound disorientation, as if he got all dressed up to be a lost soul. Robert Frank usually stands one step back from the chaotic emotional charge of a scene. Faurer positions himself formally and emotionally closer to turbulence and dread. Many of his images have a clear foreground but heavily grained background, a crusty, abrasive powder of light and matter. His subjects often seem to have emerged briefly from an undifferentiated speedy whirl.

Fashion work was good to him, but Faurer was so profligate and generous that he never seemed to have much money and, when he did, would spend it to hire a limo to take him three blocks, or impulsively buy a red convertible, though his good friend Robert Frank, who reports this anecdote, says he didn't think Faurer even knew how to drive. He did less and less personal work through the 1950s and 1960s, and in 1968, because of troubles with the IRS and in his marriage, he moved to London then Paris, returning to New York in 1974. He went back to photograph 42nd Street, but by then it was grunge central, the lighting changed from firecracker-string detonations to a drained-out florescence, the street-people not tickled by fun but predatory or wary. He produced remarkable things anyway, like a 1971 snapshot of a procession of Times Square trawlers with himself in the midst of the crowd, and a sub-

way car interior in which a beautiful pouting women stares at us from the graffiti-ed bulkhead; behind her, the narrowing tube of the crowded next car makes her seem like someone about to pass over into an underworld.

In 1978 the Museum of Modern Art mounted a photography show that included Faurer with Frank, Evans, Helen Levitt and others, which finally conferred critical prestige and historical significance on his career. Though from 1974 till 1984 he was often acknowledged with grants and fellowships, he mostly taught and was working less and less. A traffic accident injury in 1984 forced him to abandon photography, though he lived on until 2001. The fashion photographs he produced for his day job early in his career are elegant, witty, and airless. This was the convention of the time: nothing haphazard or unstable was allowed to ventilate the product display. He behaves so differently when he finds a subject instead of executing an assignment. American photographers have heavy-romanced the automobile. In Faurer's 1950 picture of cars parked in a garage, the enameled surfaces are so deeply black that the paper looks inked, and the lighting makes the chrome trim and fenders look like phosphorescent jets. It's an essay on formal dynamics, I suppose, but also a nocturnal love letter to its subject.

Head Shots

Photography and celebrity like to close dance, and it's nothing new. In the 1850s, Gaspard Félix Tournachon, known as Nadar, was making portraits of the most famous personalities of Second Empire France, including George Sand, Victor Hugo, and Charles Baudelaire who, though happy to be photographed, believed photography could never be a fine art because it was "a slavish imitation" of reality. Photography's archiving of what's visually *there* made it a new taxonomic tool. It was also visual taxidermy. Jump cut to the late 1970s, when Cindy Sherman became famous with *Untitled Film Stills*, where she dolled herself up in costumes and wigs to look like B-movie and film noir hot stuff. Playing the sultry broad, vixen, or girl next door, she tantalized viewers with the theatricality of celebrity and the mechanics of glamour. She depended on our savvy, cynical willingness to appreciate layered representations of the self and to play along with her authenticity-versus-illusion game. Often her "character" seemed caught by surprise, though Sherman knew that we knew that she knew there was no candor at all. In a 1979 image, we come upon her sitting at a garden table, a platinum blond floozy in a negligee painting her toenails, looking up from behind dark glasses, a photographer hiding behind a fictional character hiding behind sunglasses. She's a celebrity, *any* celebrity, most of all the kind we sometimes fancy ourselves to be. Later, in the 1990s, Sherman made portraits of herself armored in artificial body parts, then began to photograph disjointed, mock-up, prosthetic female bodies straight out of the playbook of the surrealist Hans Bellmer, who in the 1930s used dolls and mannequins to represent deranged, grotesquely fetish-istic female anatomies.

I saw the Sherman toenail-painting picture in an anthology exhibition, *Double Vision*, along with a Bellmer in which plastic, varicolored molds of a female head, hand, pelvis, and abdomen are loosely and incoherently joined. The exhibition folded in other artists. The trumpeted colors in Tina Barney's big images of tense, upper-middle-class domestic scenes are played off against Nicholas Nixon's subdued black and white group portraits of women. Barney's pictures seem a blast of candor, but they were made with a bulky, large format camera that requires careful set-ups and long exposure times. The scenes we feel a bit embarrassed to happen upon have been meticulously staged. Nixon, too, has used a large format camera to make twenty-six portraits, one each year from 1975 to 2000, of his wife and her three sisters. While the group arrangement never changes, we see the changing relations among the sisters, and between them and the camera. The series is an ongoing act of witness to the way time writes itself into the skin and to the fearless handsomeness of middle age.

Sherman's identity manipulations play back and forth in photographic history. In the early 1970s, Lee Friedlander got his hands on plates made by E. J. Bellocq that depicted the prostitutes of New Orleans' Storyville district early in the last century. The prints Friedlander made showed Bellocq to have been an insinuating portrait artist with complicated erotic relationships to his subjects. A picture from 1912 shows a woman standing at the foot of a bed dressed only in black stockings and high-heeled mules. Her body possesses a voluptuous ease; there's no irony in the display, either on her or on Bellocq's part. The irony gapes at us from the condition of the print: the woman's face, as in several of the Storyville pictures, has been scratched out, no one knows why.

There are other, more provocative, correspondences. The German photographer Thomas Ruff has pursued a project that

extends one begun long ago by his predecessor, August Sander.
Between the wars, Sander set himself the task of making a so-
ciological compendium of Germans from different walks of life.
He photographed, in mostly formal poses, farmers, trades-people,
businessmen, and laborers. Sometimes he shot them in their
context or with the materials of their work. He intended to make
thousands of these and collect them in a series titled *Man in the
Twentieth Century*, but only the first volume, *Face of Our Time*, ap-
peared in 1929. In 1934 the Nazis banned it, seized the negatives
and destroyed the plates; Sander's diversity of physiognomic types
didn't conform to the Reich's vision of Aryan homogeneity. His
project was to state and reveal character, personality, social sta-
tion, and the body's relationship to work. Ruff's stark headshots
of young Germans, in glossy color against a white background,
reveal as little as possible about the subjects beyond their age. The
stripped down authenticity turns each into a mask that gives away
nothing. The bland mug-shot format—the pictures look like they
were made in a freezer—is unsettling because it offers unreach-
able affectlessness. Ruff doesn't want his portraits to be readable
and seems not at all interested in the character of his subjects. His
mission is theoretical: he wants to demonstrate how portraiture,
far from being the reliable sociological register Sander envisioned,
is authentic *and* artificial, that it projects authentic illusions.

While Sherman is said to be a shy, quiet-spoken person, her
pictures have played loudly in the art scene. Similar noise was
raised in the 1980s over Doug and Mike Starn, identical twins who
made photographs of Old Masters' paintings that they roughed
up, crudely cropped, and pinned to the walls of exhibition spaces,
"re-mastering" the imagery. Their amiably hangdog pictures
didn't have the coquetry and insider, downtown cool of Sher-
man's work. To judge by a recent portrait they made of Doug, the

Starn Twins have become a little less angular but no less ironic. Doug's portrait is antique-ed, its textures scoured and its tones soaked with sepia running to charcoal black so that it looks like a 19th century studio product. It has a crafty, self-aware elegance, but Doug's pose is absurdist, antic glamour-boy stuff; head resting on hand, he stares moodily into the distance, with the intention, I suppose, of de-constructing the corniest cliché of portraiture. How different is Paul Strand's wary, respectful, probing image of a young Egyptian woman made in 1959. As always, Strand makes the camera eye seem like a curious, benevolent visitor, one of the Magi. The most violently lovely thing in *Double Vision* isn't a portrait, it's Roman de Salvo's 1999 *Hydrant Fire,* which makes a fireplug look like a flame-thrower. And Candida Höfer's hard-sur-faced contemporary image of a reading room, at first off-putting because of its sterile décor, begins to look like a haunted place, as if the egret-shaped reading lamps, austere ladder, and floor-to-ceiling bookshelves might come alive late at night and perform a mad dance, just as the celibate, self-controlled Shakers would blow off sexual energy by dancing, without physical contact, until they dropped.

Meat

It's easy to occupy an entire week in Rome looking only at Caravaggio's pictures. It's also a task. To see *The Entombment of Christ* in the Vatican collection you have to walk through endless map-lined rooms, with maybe a stopover to see the Sistine Chapel restorations that have turned Michelangelo into a Mexican muralist—a *great* Mexican muralist. The 1603 *Entombment* is Caravaggio's most mechanically complex picture. Nicodemus cradles the legs of a smudged, livid Jesus while Joseph of Arimethea supports the upper body; behind them stand the three Marys, each expressing a different response: grief, mournful curiosity, shock. The meatiness of Christ's corpse is palpable. Caravaggio wasn't painting a dead person, he was painting deadness. The scene is staged on a stone slab, so this epoch-making event looks like crudely improvised theater.

No maps delay you to the church of San Luigi dei Francesi near Piazza Navona, which contains *The Calling of St. Matthew* and *The Martyrdom of St. Matthew*. In the *Calling,* Caravaggio painted the mouth more expressively, more *instrumentally,* than any previous artist. Christ stands to the right of a group of figures counting money on a table and points his finger at Levi, the dandified tax collector with a coin in his hatband, who gapes with surprised dismay at the claim made by this arrogant intruder. The funnel of bristly "cellar light" that wedges down into the scene supercharges the unreasonable absolutism of the call. It channels the man-God's summons to sacred service. Levi became the Apostle Matthew in an instant of light, just as Saul on the road to Damascus, knocked from his horse and blinded by lightning, became the tireless proselytizer St. Paul, a scene Caravaggio painted for

a chapel in Santa Maria del Popolo. In Caravaggio's vision, God's intervention in history is a jagged light rending a pasty darkness. Saul was struck blind so that Paul could see. In another chapel is the *Crucifixion of St. Peter*. Caravaggio painted flesh, especially when in distress, charged and shaped by the inner life. Peter's body, inverted on the cross and pushed forward on the picture plane, is an offering of corporeal suffering to history, to us. Caravaggio makes us see the clay of our flesh, a material "worked" by pain, devotion, and endurance.

There are few official records documenting Caravaggio's life. A couple of brief contentious biographies appeared shortly after his death in 1610, and in recent years we've had Peter Robb's *M: The Man Who Became Caravaggio* and Helen Langdon's *Caravaggio: A Life*. Michelangelo Merisi da Caravaggio was born probably in 1573, but what we reconstruct about his day-to-day adult existence comes largely from police reports, trial proceedings, and inventories. He was a man on fire, an unstable compound of hyperconscious artist and swaggering street mutt, constantly picking sword fights, antagonizing friends and patrons, roughhousing at brothels and tennis courts (the equivalent of the bowling alleys of my youth) frequented by roughnecks, young bravos, and assorted louche characters with their blood up. One measure of his heedless, headlong way of devouring life was to spend big money on a suit of clothing then wear it, only it, until the fine cloth hung from him in rags. At the peak of his career he killed a man in a brawl and was exiled from Rome; later, in Naples, he was attacked and disfigured by unknown hired assailants. He aspired to, was elected to, then expelled from and imprisoned by, the Knights of Malta. He died of fever, impoverished and alone, while making his way back to Rome. His burial place is unknown.

Caravaggio's story is largely a patchwork of information triangulated from contemporary events, art transactions, and ecclesiastical and municipal documents. The lives of some other artists are similarly information-poor, but we normally don't infer from the data and work a personal familiarity with the artist. With Caravaggio, the work boasts the character of the man who made them. We see the paintings and feel we know not just *what* but *who* he was, because he painted skin, light, and fabric as expressions of spiritual recognition, suffering, seduction, menace. He transformed scriptural and apocryphal episodes by passing them through his own chaotic nervous system and hot belief. He left his feeling for all of life and death on his canvases and created a new intimacy of violence. *Judith and Holofernes,* in the Palazzo Barberini, derives from the story of the Jewish heroine who delivered her people from destruction by an Assyrian general by seducing her way into his tent and cutting off his head. The painting shocks because of the technical accuracy of the beheading. Judith is grabbing Holofernes' hair, slicing away, blood sheeting like long tongues from the wound, her mission half-finished while Holofernes, rousing from a drunken stupor and still alive, is horrified to realize he's already dead. The look on her face, oddly detached, reveals a clear conscience performing an irreversible act. In the same room is *Narcissus*: the exquisite boy, enraptured by his image in the water, dips his hand in the pool as if about to plow its surface and smash the image he so adores. It's a portrait of the artist, any artist who feels compelled to disrupt an established manner, even at the risk of other losses, because to remain enthralled is a kind of self-embalming. Also in the Barbarini's room are pictures by the *caravaggisti,* who imitated Caravaggio's style. Some were decent painters, but their work is overripe with feeling, and the compressed lighting Caravaggio created to fuse spiri-

tual and material worlds becomes overexcited scenic melodrama, which reminds me of Oscar Wilde's remark that all bad poetry springs from genuine feeling.

Caravaggio was a poet of erotic neediness and appetite. In *St. John the Baptist* (it's in the Capitoline) he wanted to divest the subject of its conventional dignified, stark, draped-with-flesh physiognomy. *His* young boy wants something from us. He certainly wants our sexual interest. Posed in the nude, half-turned as a sexual come-on, this opportunist looks straight out at us, as if he's taken off his clothes exactly for the purpose of being in *this* picture, posed in *this* coquettish, awkward way. The saint's body becomes a strange mediator between us and the ram, which he hugs in a flirty way as if, apart from his future as the Baptist, his real function is to broker sexual power and desire. His moist, open-mouthed smile tells us he knows more than we do about sexual wilderness and has secrets he knows we want to know. He's a boy who thinks he will never die, giddy with happiness and danger, ready to risk anything for the sake of a moment's pleasure. With neediness and appetite went sensuous excess. Bacchus' skin in Caravaggio's *Self Portrait as Young Bacchus* in the Borghese looks wrapped in a pearly mould tinted greenish gray. The grapes Bacchus holds—he has lips like Chazz Palmintieri's—are tinted the same hue, bearing a kind of sepulchral promise: He dares us to taste them, taste their power to make us surrender to the god of disorder. In *David Holding the Head of Goliath*, David seems quite cool to the extraordinary act he's just committed. Slaying and decapitating Goliath is just something he happens to have done. Goliath's ferocious head, a self-portrait of the artist, its features dripping away in blood and sagging skin, tells us he's a monster. David's face tells us he may be a born killer. *St. Jerome in His Study*, on the other hand, is a portrait of saintliness eroded by suffering.

His flesh looks worn with use, yet while the body fails and muscle shrinks to the bone, the saint's concentration is still fervid. The vanitas skull Caravaggio puts in the picture reminds us that one's work in the world, writing and scholarship in particular, is sponsored by death.

Rembrandt's Etchings

The first dated etching was made in 1513 by a Swiss draftsman named Urs Graf, a negligible artist, villainous mercenary, and by all reports thoroughly vile human being. The process developed out of engraving—incising lines on metal plate, for years the most popular form of printmaking—then surged in the 17th century in the Low Countries during the Golden Century when Holland, a marshy strip of land 150 miles long and 90 miles wide, became the most prosperous country in Europe. Trades and trading flourished, the middle class grew and prospered, and superb artists documented the social expressions of the new wealth. Etching was a way of drawing on a wax-coated copper plate (Albrecht Dürer had made a few using iron) that would yield an image when the plate was dipped into an acid bath that bit into the metal. The length of the bath determined the depth of the bite, and the plate could be reworked after each print. Different tools produced different effects. The pointed burin furrowed clean, sharp lines. The dry point stylus, a steel needle used on the plate after the wax had been removed, left burred tracks useful in creating deep shadows. The formal life of etching depended largely on the way chiaroscuro released tidal energies by setting light against dark.

In the 1620s, when Rembrandt began to turn it into a modern instrument for making great art on paper, etching was held in high esteem, on a level with painting. Because of the vestiges of the medieval guild system, a painter or an etcher was treated as a specialized craftsman possessing specific talents. Rembrandt wanted to dissolve this tight definition and invent himself as an artist in the modern sense, as an idiosyncratic temperament of signature expressiveness working in different media and treat-

ing a variety of subjects. He had great hands, voracity for image making, a scrupulous eye, and an ambition to promote himself and conquer the market in whatever medium he worked in. His astounding productivity was driven in large part by commercial demand, nearly exclusively so, if we are to believe Svetlana Alpers argument in her controversial 1988 book *Rembrandt's Enterprise: The Studio and the Market*, which argued that "Rembrandt" was a creation of market forces.

Because etching allowed multiple states to be printed from the same plate, we can watch Rembrandt making formal decisions and experimenting with technique. One of his innovations was to apply a thin film of ink on the plate after pulling the first print so that when the second sheet was run though the press it absorbed the surface coating and created unusually subtle tonal variety. He could also, luckily, maximize his income by varying a print from one state to another, leaving out a tree here or putting in a window there, peddling four prints, say, to buyers who believed they were each getting a unique work. Rembrandt took in student assistants. One of them, the greatly gifted Ferdinand Bol, learned the master's technique so well that his etchings are sometimes indistinguishable from Rembrandt's. In at least one (*Man in High Hat*) we can actually see where Bol's signature was scraped away (by some loose-fingered dealer probably) so that it could be passed off as a Rembrandt. The 1730s and 1740s were Rembrandt's salad years. His paintings were much in demand, and he had sufficient means to compile an art collection of his own—paintings, drawings, prints, Persian miniatures, Asian ceramics—before ill events bankrupted him in 1656. In 1648 he etched a darksome self-portrait, his last in the medium, in which he's sitting at a work desk making an etching, making marks that are himself, his attention aslant but stonily concentrated. The corner of the short

window curtain behind him curls flirtatiously in the wind with a delicacy of detail only he (or an expertly trained student) could pull off.

Etching can achieve a velvet nocturnal gravity, but in Rembrandt's hands *gravitas* is always executed with a quality most artists (and writers) aspire to: lightness. Etching also permits a tight economy of gesture and pose. In a genre scene of a poor family begging alms at a burgher's door, their burdensome destitution—the mother carries an infant on her back and a young boy in tow—is balanced by the householder's kind countenance and tender gesture. The unhappy scene doesn't bring our spirits down (though it makes us recognize the anguishing disequilibrium of capitalist affluence) because Rembrandt's hand lets the scene bear its grim meaning lightly. He constructed such figure groups in etchings as he did in his paintings, building up the composition for maximum but measured pathos.

Much has been said about how Rembrandt "probes the depths of the human soul." I don't know what that means exactly. The soul has no depth, not as I think of it anyway: the soul is energy irreducible to observable or material accidents that drives and fills life's dynamics instant to instant, in the strungalong narrative of our existence. *This* is what Rembrandt made manifest. His etchings isolate one frame in the narrative saturated with and brightened by an awareness of mortality. He could write into a face or body a sum of expected or imagined appetites, desires, aspirations and responses, stilled into a way of being, a way of greeting the world of contingency. His portraits are sumptuous articulations of contingency. An etching of his aged mother made in 1631 is a textural drama of the feathery leathered-ness of aging skin. Rembrandt makes us see the flesh as an aging soul, skin and muscle tone drooping from the proximity of death. She's locked into a

contemplative pose, hand clenched on her breast, and one feels her entire body doing the work of reflection, just as Rembrandt's corporeal form in that early self-portrait is one tough node of attentiveness.

The Golden Age produced great landscape etchings. Artists exposed how nature expands through space as a network or webbing of matter. In Jacob van Ruisdael's *The Little Bridge*, the natural world and the constructed world of footbridges and thatched houses are precariously scored and crosshatched upon an initial emptiness of non-being. Like so much Netherlandish art, it has a muted glee for the simple presence of trees, rocks, rivers, humans, dogs, goats (*many* goats in Dutch printmaking) and pouchy-faced leopards modeled on animals brought back or reported by trading expeditions. One of the great landscapes is Rembrandt's etching, *Three Trees*, a portrait of weather as an unstable housing for human beings. As our eye moves left to right, we pass from deeply scored straight lines of hard rain, to a drizzly whipping up of wind and clouds, to columns of sunshine. Across the landscape, miniscule figures go about their lives. A horse pulls a loaded cart, an artist sketches with his back to the scene, a fisherman watches his line, and in the darkest shadow, two lovers in the bushes appear tangled into the landscape that holds them.

Along with lightness, artists—some anyway—want speed, and one of the speediest things in Dutch art is Rembrandt's etching of Christ driving the moneychangers from the temple. The small, congested composition jumps with a crisp, supercharged physical immediacy that tracks different actions. The gale force of Christ's anger drives the moneychangers leftward, his fury modulated and gently retarded by temple activities performed in the upper right of the image. Even a sedentary pose can have quickness, like Rembrandt's *Diana*. He re-imagines the conven-

tionally youthful goddess of chastity as an older woman who has borne children, apparent from her prolapsed uterus and sagging breasts. She's a Dutch household-style goddess, homely, unflappable, mildly amused by what she seems to know is our studious and voyeuristically disappointed gaze.

Pretty Girls

I once was at a New York dinner party when an argument erupted between a painter and critic. Actually, it wasn't an argument so much as vehement pronouncements beyond which it was pointless to argue. Both had been forming their opinions over many years and neither was about to give an inch. The painter thought Renoir one of the greatest modern artists, the critic thought Renoir not only *not* an important artist but not even a good painter. Those mark the extremities of Renoir's reputation in the last hundred years. Of the major Impressionists, he's the one whose critical reputation remains unstable, though among casual museum-goers he continues to be, along with Monet, the most beloved. The calibrations of his achievement keep changing. The stargazing awe of the multitudes doesn't abate. It wasn't always like this. American opinion in particular, and Renoir's influence on American painters, vacillated over two generations, when he went from being just another Impressionist to being the most celebrated, emulated, and collected painter of his time. Before 1904, Monet had seven solo exhibitions in the States and a growing critical literature. Until 1904, Renoir had no one-man shows or critical recognition. By 1907 Roger Fry, who as curator of painting at the Metropolitan had just acquired one of Renoir's now famous works, *Madame Georges Charpentier and Her Children*, wrote that there were critics and connoisseurs "who think that Renoir is destined ultimately to take a higher place than any of his contemporaries in the annals of art."

What accounted for the change? Renoir's important early champion, Camille Mauclair, who wrote the first book length study of Impressionism in English, anointed Renoir "the most

lyrical, the most musical, the most subtle of the masters of this art." Renoir was evidence of Mauclair's thesis that Impressionism wasn't a revolt against traditional French painting but an extension and continuation of it. Mauclair had been an advocate of Symbolism and held to its belief that all arts should aspire to the condition of music and that lyrical subjectivity was everything (even if it led to hermeticism or inscrutability), qualities he simply carried over to his evaluation of the Impressionists.

No one would accuse Renoir of inscrutability. His pictures, even the interiors, have an breathy, open-air musicality that appealed mightily to American collectors like Leo Stein (Gertrude's brother), Albert Barnes (who created the stupendous Barnes Foundation outside Philadelphia), and John Quinn (New York tycoon and sometime benefactor of James Joyce and Ezra Pound). American painters scavenged Renoir's pictorial ideas and valued what so many museum-goers still love: colorism; affectionate presentations of bourgeois intimacies; a curvy fleshy female type; anecdotalism equivalent to nationalism. An unfriendly viewer would flop these and say that Renoir prizes decorative dazzle over colorist dynamism; that his presentation of social realities is idealized, stultifying, mere flourish; that his fondness for a particular female type is a mannered, belabored lyricism; and that he exploited for local color the kind of smug Frenchiness left out of pictures by Degas, Bonnard, Manet, and Matisse.

By contrast with these painters, there's no anxiety in Renoir's work. He had a dashing confident touch and believed in the unambiguous goodness and inherent desirability of certain forms. If you enjoy his ostrich-plume style, it's exuberant; if you don't, it's chintzy-breezy. When he painted the female figure, Renoir's familiar pink/white/red palette flirts with us. His women look whisked into form, swept into a satisfyingly stabilized structure.

The manner was imitated by numerous American admirers. William Glackens, who as consultant to Barnes acquired several important Renoirs, made pictures like *At the Beach* and *The Soda Fountain* that are American renditions of sweet, Renoir-esque, American-style past-times, and the handling looks practically copied. It's when Glackens makes a more nervous picture, however much derived from Renoir's example, that his work engages us more deeply. His big *Family Group* shows off a young girl and three slinky, comfortably bourgeois Jazz Age dolls. The brushwork recalls what Robert Henri described as Renoir's "strokes that move in unison," but the figures cant and list oddly (a little sadly, too) toward one another, and the over-decorated scene quivers. Renoir's interiors induce a narcotizing pleasure. Glackens' picture, like the sound of his name, induces a crackling unease.

When Renoir painted the French at leisurely pursuits, he made pictorial structure part of the pleasure of the scene. Here, too, he influenced American artists. Such influence locks down the 1920 *The Shoppers* by Kenneth Hayes Miller, where the brushwork looks like a photographic reproduction of a Renoir surface. There's also a funny detail: the fur stole draped across one of the shoppers' shoulders looks about to leap down and light out for the territory. Another Renoir enthusiast, Isabel Bishop, hung out around a group of realist painters in downtown New York. The two women in her *At the Noon Hour*, leaning arm-in-arm against a wall in Union Square, may be curvy-fleshy body types, but they don't look much like Renoir's happily busty ladies. They stand, slouching a bit, side by side, and against the verticals of the figures Bishop brooms subdued gray, blue, and yellow horizontals—a squeegee swipe—so that the picture looks like a cylinder revolving upright on an invisible axis. Fully integrated elements like hats and signage look mysteriously collaged in. It may be Bishop's

womanly eye that makes the scene so unlike anything by Renoir. These women aren't subdued and softened by the handling, they're made sassier, looser, smarter. It's not their beauty that matters, unstable in any case because of the racy handling, so much as these American girls' casual sexy manner with each other's bodies.

Except for some eccentric early pictures, Renoir is pretty much pure *bonheur*. Nothing wrong with that. *Young Shepherd in Repose*, from 1911, was a hit then and now: it was exhibited at five different museums and galleries between 1939 and 1944 and is still a surefire crowd-pleaser. So sue me, but I can hardly stand to look at it. The shepherd's druggy look, his rouged cheeks and lips, his finger extended as a perch for birdies, the body hugged by bucolic greenery—it all adds up to squishy prettiness. Much modern art in Renoir's time aimed for fractured definition, for broken or disrupted continuities that released a new kind of sensuousness. The shepherd picture illustrates Renoir's lack of interest in the sort of realization-by-facture pursued so unstoppably by Cézanne, Manet, Matisse, and Picasso. The formal cruelty they exercised to achieve voluptuous pictures simply wasn't part of Renoir's artistic nervous system. It *was* part of Marsden Hartley's. Like his contemporaries, Hartley looked hard at Renoir, but take just about any of his New Mexico landscapes that raucously play inky violets against watermelon reds and, for this watcher, any Renoir that happens to hang nearby dims and dulls.

Plaster Angels

In a 1923 manifesto, the Mexican muralists Diego Rivera, David Siqueiros, and José Clemente Orozco announced their position: "We *repudiate* so-called easel painting and all the art of ultra-intellectual circles because it is aristocratic, and we glorify the expression of *Monumental Art* because it is a public possession." They wanted an art of immediate ideological value to the masses that would replace wasteful subjectivity with a shareable, public beauty. In the 1920s, Álvaro Obregón's new revolutionary government commissioned large mural projects. Rivera, the senior of the group, made for the Secretariat of Public Education in Mexico City a fresco titled *Rural Schoolteacher*: an armed revolutionary on horseback watches over *campesinos* plowing a field while their children cluster around a schoolteacher dressed as poorly as they. It has Rivera's trademark idealizing of revolutionary egalitarianism, as well as his mythic treatment of the land, and has a dignified serenity quite unlike the ferocious work Orozco was beginning to produce.

All three were leftists to some degree—Rivera joined the Communist Party, Siqueiros was Stalinist—and spent time in North America executing mural projects, Rivera's most famous being the one we no longer have, created in 1933 for the Rockefeller Center then under construction, later destroyed because of its celebratory depiction of Stalin, Lenin, and Trotsky. The names have become such historical tokens that it's hard for us to re-imagine the public and personal furies these names let loose. Siqueiros, for his part, established a school briefly in 1936 in New York where he and students—Jackson Pollock among them—made paintings by dripping pigment onto canvases spread on a floor. Orozco's 1927–1934 sojourn in the States resulted in some of his best work, easel

painting as well as mural projects. He had been to San Francisco briefly between 1917 and 1919, when he ran a movie poster business—he called the speedy lithograph process his "new toy"—and worked for a time in a factory painting plaster angels. Although he made easel pictures driven by a focused fieriness about revolution and class conflict, Orozco all his life remained a vehement partisan of populist mural painting, which he called "the highest, the most logical, the purest and strongest form of painting." He loved and praised it because "it cannot be made a matter of private gain; it cannot be hidden away for the benefit of a certain few."

Orozco began studying art in his youth—he was born in 1883—and in his early twenties, after a gunpowder accident more or less blew off his left (non-painting) hand, he began his career in earnest by entering the Academy of San Carlos in Mexico City. There was no gallery culture to speak of in Mexico, no system of private subsidies or public grants, so there wasn't much opportunity for a painter to earn money. But mural painting was state supported, and a painter could earn a little notoriety and a little bread by snagging a commission. As a young man, Orozco published political cartoons that are like acid burns of radical fervor, and he soon developed a slashing, aggressive painting style. Rivera by contrast was a more decorative, emblematic artist, a kind of Hispano-French painter who translated into a Mexican idiom the sophisticated experiments of Gauguin and Cubism. Orozco's style raced from sardonic to mournful without missing a beat, and his palette, for the easel pictures at any rate, was the colorist equivalent of musical threnody, all viscous sepias and keening reds. When he came to North America he wasted no time picking up on the sharp social awareness of Ashcan painters like John Sloan and Reginald Marsh, whose influence is stamped on Orozco's street scenes and his pictures of vaudeville and Coney Island side

shows, but he was also on the scene when feisty young Americans like Stuart Davis, Charles Demuth, and Charles Sheeler were conducting their own formal adventures.

New York's tipsy verticality, so unlike the sprawl of Mexico City, expressed itself in Orozco's pictures as jagged diagonals and wedged masses, and he responded with vitalist enthusiasm to New York's brutal quotidian magnitude. He turned the Queensboro Bridge into a kind of huge girder-ship rockily balanced on a plank of water, and the bulky overcoats in his 1932 *Winter* look like cartouches or puffy armor. Whenever he chose, he could also show off his classical training, as in the dark, rotund *Self Portrait* of 1928, where he looks like a professorial anarchist. One of the barbarisms coined by current academic critical theory, to "exoticize"—it's right up there with "problematize" and "ironize"—applies to Orozco's New York experience. He knew that *nordamericanos* had stereotypical notions of Mexican-ness and that, if he was going to achieve any commercial success, he'd have to insert himself into those notions without surrendering authenticity. In a sense, he became Mexican all over again in the United States, refining his nativist figural vocabulary of the cult of revolution, earth, and blood. His Mexico is sometimes sleepy and harmless, sometimes hyper-vigilant and dangerous.

The most important and magisterial work Orozco did in North America were wild frescos he painted in the Baker Library at Dartmouth and the refectory at Pomono College. He kept alive for modernism the ancient (and Romantic) notion of art-as-prophecy, treated these days by many younger critics as quaint, piquant, *ironized*. But too much self-aware finesse neutralizes and neuters passion; there are times when frontal cartoonish boldness is the just response to subject matter. The central panel of Pomono College's *Prometheus,* executed in the 1930s, swells with an over-muscled

Blakean agonist, a hero in apotheosis flanked by desperate masses of humanity slanting toward him for deliverance. At the center of the *Hispano-America* panel of *The Epic of American Civilization* at Dartmouth stands a peasant-costumed Zapata, stolid, Indian-featured, with hugely knuckled hands, surrounded by tinpot generals, greedy bankers, corrupt bureaucrats and politicians. It's a familiar agitprop scheme but in its bristly anger persuasive nonetheless. On the adjacent panel, *Anglo-America*, the ranks of conformist citizens and blond *Village-of-the-Damned*-ish children are schematic, too, but the imagery is as menacing in its way as its companion panel is lurid.

Orozco's Christian imagery in Old World settings is clenched or explosive, blocked up or flooded. He was one of several modern artists who depicted Christian imagery in a brutal 20th century context. The Englishman Stanley Spencer, the Italian-born New Yorker Joseph Stella, and our homegrown Marsden Hartley—bold painters all—attacked this subject. What kind of Messiah suits our brave new world? The Christ in the *Modern Migration of the Spirit* fresco in Hanover is a flayed, outraged prophet who has just taken an ax to his cross; behind him lies a mountain (or burial mound) of artillery pieces, tanks, gas masks, bayonets, fallen statue of Buddha and broken classical column. It's a vision of potential restoration through violence (a revolutionary axiom) and the spiritual destitution such violence creates. The haunting maguey plant, with its triangular leaf-blades, spikes into several of Orozco's pictures. Its prickly flamboyance is a metaphor for the kind of sharpened, menacingly lovely art Orozco made. His position in modernist art is inevitably pinched by his regionalism and the stylized rhetoric of mural painting, but his art historical niche doesn't diminish the work's toothy vividness. His best pictures always seem ready to bite back.

Sea Creatures

I grew up in a river town, Philadelphia, whose two main water-ways, the Delaware and Schuylkill, were long ago contaminated by the refineries and industrial sites they served, though in recent years the city has worked hard to clean them up. It still gives me a rush to watch them flow, dull and sluggish though they be. When sculls groove across the Schuylkill's surface, they look lazily toler-ated by the power of the waters. Over the years I came to regard them as great entities poisoned by lesser beings who killed them in order to make a killing, but I never pretend to myself that they were deities. Not so among most indigenous cultures. The reli-gions of early peoples living in coastal areas or along rivers were usually powered, so to speak, by power. The Kogi who occupy a ridge above the coast of northern Colombia regard the sea as the mother from whose womb the cosmos issued. Before that there existed an inchoate undifferentiated sea of energy they believe to be the mind of the Great Mother. Before Her, nothing existed. The sea *thought* things into existence. Kogi shamans dip beads into water to divine what the Great Mother is thinking.

I'm not the sort that gets dewy about the natural world, but the one time I saw a pod of dolphins, off Venice Beach while roll-erbladers shimmied past, I felt a tingle of awe and happiness that such creatures exist, leaving afterimage arcs in the air as they lope in and out of the water. A dolphin's ocarina shape is a primal form in our psyche, but while these creatures induce wonder (or a self-serving sappiness in those who believe dolphins *belong* to our psyches) they aren't woven into mythic consciousness as they are among indigenous peoples. A terra cotta vessel of a dolphin from Colombia that I saw in *Pre-Columbian Art: Marine Animal Forms* has

a primeval perfection of design. Its top and bottom halves look riveted together like a seagoing ironclad, its tiny bottlenose charmingly out of proportion to the body. It has a sweetness of nature we certainly don't find in a tuna effigy from the Chorrera culture of Coastal Ecuador dating back twenty five hundred years, whose sleek caliper jaws and tail fin give it the look of a hungry resistance fighter.

Some figures painted on the ceramics of coastal and river peoples are so gestural that they're nearly abstract, like a code or notation. Others present specific images, such as a bowl with a softly modeled crawfish lying at its bottom waiting for prey, or emulate the thing itself, like fish-shaped graters used to shred manioc in southwest Colombia. Not being a seagoing guy and so a little obtuse about such things, I never realized how musical the fish form is until I saw a few Pre-Columbian conches and remembered that the contemporary trombonist Steve Turre sometimes plays a conch shell (and really swings). Early peoples made ocarinas in the form of round fish, and whistles in the form of flat fish or crustaceans. The whistles are quite small, no larger than netsukes, those exquisite jade or pearl squares the Japanese use to cinch kimonos.

I'm sometimes grateful for information-heavy (not the same as boringly tendentious) exhibitions. *Pre-Columbian Art* delivers a lot of information. The earth is 70 percent water. Every second, 100,000 tons of water evaporate from the Mediterranean. The underwater mountain chain called the Mid-Ocean Ridge stretches around the globe some 47,000 miles. The Marian Trench off Guam runs 36,000 feet deep, large enough to contain earth's tallest mountain. It also recalls the ocean's power over the imagination. I remember from childhood the otherworldly menace of jellyfish; for city kids they were monsters from the deep. But they were

half-pints compared to what archeologists just recently found in a Wisconsin quarry: thousands of fossils of jellyfish stranded in a small lagoon some five hundred and ten million years ago, many up to one *meter* in diameter. The ocean's phenomena have a grandiose specificity. As many as one hundred thousand rock lobsters, scavenging bottom-walkers that sometimes live one hundred years, migrate annually on nine-mile-a-day treks for as long as five days, split into platoons of sixty spiny-armored grunts marching single file.

Once, at an exhibit of Olmec art in Washington, an emergency room physician I know, who has seen some pretty awful things, cringed before a statuary group showing a shaman transforming himself into a jaguar, and I have a friend who even in middle age can't bear to watch Lon Chaney, Jr., change into a werewolf. In animist cultures, the shaman is a vessel of terror and awe, a "power person" whose soul can leave the body and shape-shift. He's custodian of his culture's religious health and is its intermediary with the spirit world. One motif in art produced in Central Panama around 900 A.C.E. is a snaky fish with a "tail" flowing from a spade-shaped head, which decorates the interior of pedestal bowls. Looking down at the image, we seem to be looking at the deep-sea creature up from under. Anthropologists speculate that these are shamans transformed into fish, a notion based on a splendid terracotta plate from Central Panama showing a composite figure with a sawfish snout, human arms ending in claws, and a body studded with barbs. This is a typical shaman-in-transformation composite, though like a lot of what has survived from early coastal cultures, the anthropological evidence is so scant and fragmented that experts can only hypothesize about their meaning.

The shaman was also expected to assure the proliferation of

marine creatures that comprised his tribe's diet. A marvelous stir-rup vessel (so-called because of the shape of its handle) from the Moche culture of coastal northern Peru shows a robustly painted fanged shaman wearing a seal-effigy headdress and braced on a rock, a large ray caught at the end of his fishing line. The detailing knocked me out: a shell-shaped lure bellies on the line a short distance from the hook; dark waves are marked by high-relief sine curves; near the hooked ray swim a shark and another ray to indicate the available abundance of sea life. Moche iconography includes a ferocious creature called the Strombus galeatus monster—dog- or cat-like head, clawed feet, fangs, reptilian tongue—housed in a conch shell whose species gives the monster its name. One vessel shows the monster lurking underwater, fish swimming nearby. Experts think it's a shaman, because of the human arm and sharp knife in its hand. In this manifestation, the Strombus galeatus monster is in process of shape-shifting and may be related to a shamanic avatar called the "decapitator," always shown with a knife, though as in so many instances, this is as far as anyone can go in determining its meaning. If that even matters. In the presence of this thing, intellectual curiosity caves in to mindless shivers.

Healthy Minds

During the Civil War, writing from a Washington field hospital where he was nursing Union soldiers, Walt Whitman estimated the heap of amputated arms and legs he saw under a tree to be "about a load for a one horse cart." His moral bravery didn't shy from such details, but they seldom made it into his poetry, where even sorrow carries a charge of futurity and betterment. Some forty years later, in *The Varieties of Religious Experience*, William James described what he called the "religion of healthy-mindedness" as a state of mind "organically weighted on the side of cheer and fatally forbidden to linger over the darker aspects of the universe." His example was Whitman, whose contemporary, the painter Eastman Johnson, could have been another. Johnson was at Antietam and Bull Run, and he marched with the Union Army after Gettysburg, but the work that came out of that experience was pretty tepid. His drawings of a field hospital should carry a terrible moral jolt but don't. And *The Wounded Drummer Boy*, an earnest chunk of patriotic fervor, made Johnson famous and became an altarpiece in the imaginary museum of classic Americana, the one that includes pictures by other great illustrators like Norman Rockwell and Andy Warhol. But I'm getting ahead of myself.

Born in 1824, Johnson began his youthful training in a Boston lithography shop and built a modest career as a crayon portraitist. He did a plummily self-satisfied Longfellow, a dazed Hawthorne, and an oddly blissed-out Emerson. But Johnson wanted to paint, so he went to study in Düsseldorf and later in the Hague, where he absorbed his deepest influences: Rembrandt and other masters of Dutch portraiture, and genre painters like Jan Steen and Gerard Dou. After six years abroad he returned home, committed to the

ambition of painting contemporary and uniquely American sub-
jects. At mid-century, figure painters in America and Europe had
new kinds of competition. Engravers could endlessly reproduce
and disseminate grimy, twisted images of war dead. And photog-
raphy was already performing its surgery on physical reality. First
the ghostly light-incisions of daguerreotype, then the two-toned
world of wet plate photography, created intense, unmediated ver-
sions of physical reality. Painters like Johnson were aware of all
this and in response began to exploit painting's ability to disclose
the process of its own making. It's thrilling to watch Johnson's
wrist, in his best pictures, build and slash and break down pas-
sages. In a portrait of his wife in a white dress, he composes and
dissolves a fabric of light in long, streaky, pleated strokes.

In 1853, two years before his return from the Hague (and two
years before the publication of Whitman's *Leaves of Grass*), John-
son was already aspiring to represent "the present condition" of
the United States, and treat distinctively American subjects—slav-
ery, the Civil War, Indian culture, rural life. In 1857, he went to
Wisconsin to work among the Ojibwe. His pictures were the first
to present indigenous peoples as any other portrait subjects might
be treated. He didn't "Roman-ise" or heroize them. Some carry an
erotic buzz that can originate not so much in an artist's feelings
as in the sensuous realization of ambiguous or unsaid feeling in
the physical action of applying paint. Painterly touch equals erotic
touch. Two exquisite drawings Johnson made of a young woman
named Sha men ne gun are achingly desirous and candid. Had he
made more images of her, Sha men ne gun would be remembered
as one of the great modern models, right up there with Courbet's
Jo and Madame Bonnard.

By 1857 Johnson was settled into a studio in New York, where
he conducted his career with canny discretion. Most of his pic-

tures are not sunny exactly, but they favor demure good cheer and emotional moderation over the darker disruptive forces in the universe that artists like Blakelock and Ryder felt so disarmingly at ease depicting. He wanted to make a socially inclusive art. His first famous picture, *Negro Life at the South*, depicts black folks going about normal activities—a young man courts a pretty girl, another picks a banjo, a mother holds hands with her shindig-ing son—at the moment they're visited by a gentrified white woman who enters through the picture's side door. It secured Johnson's reputation as an artist truly of his time who could depict a peculiarly American scene and paint it big: the picture contains thirteen human beings, a dog, a cat, a chicken, and a rooster. But *Negro Life at the South* is more compelling as illustration than as painting. One person's illustration is another's great art. A critically generous painter friend of mine thinks Thomas Eakins was mostly an illustrator; I think he was the purest American painter of his time. If he'd been in Civil War field hospitals, we would have a more disturbing archive of war imagery. Eakins was keen on what William James, describing a tragic artist, referred to as the bright particulars of existence which, when they go, we go, and there's nothing waiting for us but darkness and wandering in an impoverished, overpopulated warren of shades.

Illustration occurs when iconography is allowed to plead a special case over painterly dynamics; the image solicits unambiguous response; anecdote predominates. An illustrator honors subject matter at any cost: the desire for likeness overwhelms the desire to investigate formal possibilities. Johnson knew his genre depictions of African-American life—*Negro Life at the South, A Ride for Liberty-The Fugitive Slaves*, (child, father, and mulatto mother escaping on horseback), *Fiddling his Way*, (a black playing for his supper to a white family in a Jan Steen-ish interior), *Union Soldiers*

Accepting a Drink (from a black woman)—would wake people up, and as historical documents they're compelling. They're also too judicious and discreet. Except for occasional startling effects like the fiery sundown light streaming down the horse's flanks in *A Ride for Liberty*, these works aren't very interesting as painting. Johnson's cozy domestic interiors, for which he was equally famous, also tend toward illustration, especially those involving children. He was essentially a sweet painter. (Henry James called him "homely.") I don't mean that as faint praise. Our culture needs such artists. Later on, Norman Rockwell carried this tradition forward in a likewise winning, sometimes insinuating, sometimes hammering way. And waiting down the line was the most commercially adaptive and astute illustrator of them all, Andy Warhol.

Official art is always hostage to prescriptions, even if they're prescriptions artists write for themselves. When he wasn't trying to fashion an official American art, Johnson made some wonderful, probing, ambiguous pictures. The Johnson I prefer is the one who paints loosely, experiments with lighting, and lets a picture come into its form; a painter not hostage to anecdote or local color, who handles pigment so freely that a monochrome swatch serves as a face. Nantucket, where he spent considerable time as he got older, loosened him up. His Degas-esque *Woman Reading* jumps out at us because of the crusty, prickled light around a hat that mimics the shape of white sails in the background, and the sepia groundcover that creeps up the back of her dress. Johnson went to Nantucket for that particular iridescent shave-the-ground Cape light, beautifully rendered in *The Cranberry Harvest, Island of Nantucket*. Cranberry pickers, maple sugarers, cornhuskers—such scenes of people working in concert with a shared communal purpose brought out the best in Johnson. Some of these pictures

have fast, robust, improvised effects. All of them are evidence of compassion and human decency. And a handful of his pictures have details so thrilling you want to keep going back to them. The hand of a black man holding a Bible in *Old Man Seated* looks like a grappling tool constructed of rods and bearings and sheathing, fire-lit and worn with use. In *Head of a Black Man*, a wild and great picture, the side of the face is so roughly painted that the coppery skin looks raw. I track, for the sheer pleasure of it, the yellow pigment gashes that compose the sea of cornhusks in *Husking Bee*. *Five Boys on a Wall* gently offers a compositional finesse and painterly excitement comparable to Giorgio Morandi's early work. Considered together, the vividness of such painterly details and the big, anecdotal, almost opportunistic pictures show how Johnson fashioned his career out of a series of carefully arrived at decisions, of choices made, for better or worse.

Spiritual America

Alfred Stieglitz is one of our great photographers, but his achievement, I think, rests on relatively few photographs. Pictures like *The Steerage* and *The Terminal* have become foundational in our mental lives. At his best, Stieglitz possessed a seer's gift to look into the life of things and make an image of its essences. His career was a textbook illustration of the movement from 19th century Pictorialism and its smoky-parlor effects (his soft-focus portraits of young girls are shrouded with a winsome gooey innocence common to the time) to straight photography and the formal austerities of high modernism. But Stieglitz wasn't satisfied with being just a photographer, and his extra-photographic activities were at least as important as his work. Gertrude Stein's famous crack about Ezra Pound, that he was a village explainer whose utterances were useful if you lived in a village, and if not, not, could be aimed at Stieglitz, too. After studying engineering and photography in Berlin from 1882 to 1890, he returned to the States on a mission to elevate photography to a fine art and jolt artists into making a uniquely American art on a level with the energetic experimental sophistication of Braque, Matisse, and Picasso. So in 1902 he established a society of art photographers, the Photo-Secession, and opened on Fifth Avenue the Photo-Secession Gallery, commonly known as "291," where he championed the work of young artists like Marsden Hartley, Arthur Dove, John Marin, and Georgia O'Keefe.

"291" was Stieglitz's aesthetic laboratory, theater, lecture hall, and court. He was promoter, proselytizer, theorist, all-purpose haranguer, and giver of the law, the kind of force of nature where the force is felt more than the nature. Few artists dared contest

Stieglitz's pronouncements until it was safe to speak out, which meant after he was dead or his career-brokering power had waned. The youthful Georgia O'Keefe, who said she "would rather have Stieglitz like something –anything I had done—than anyone else I know of," years later admitted that his ideas "contained a good deal of contradictory nonsense." And the testy Walker Evans said: "He should never open his mouth. Nobody should, but especially Stieglitz."

Steiglitz's best work was the New York street scenes of the 1890s and the cloud studies he made at Lake George in the 1920s. I'm partial to the New York pictures because they're distillations of northeastern winters, and their formal prowess has an animal energy. Steiglitz believed a photograph was made twice, first on site then in the dark room. The negative of *Winter—New York*, a picture of a horse-drawn carriage in a snowstorm (Stieglitz stood in position three hours to catch the right moment), diffused and flattened out its visual information; his severe cropping of the print, roughly a third of the original negative, snapped the pictorial data into an impacted chiaroscuro. The finely articulated crenellated slush looks like a little arctic garden. And his best known picture, *The Steerage,* quite apart from its superb structure—the stanchion supporting the gangplank has the same y-shape as suspenders worn by a man down in steerage; the gleaming straw boater worn by a man on the upper deck harmonizes with the smokestack—is a blunt, unsentimental vision of displacement.

Stieglitz called his cloud studies "equivalents." He believed the photographic image could carry the precise emotional or spiritual charge the photographer experienced when making the exposure. Reading an image was a way of reading a soul. Subject matter was inconsequential, revelation everything. I don't see a shape of spirituality in these very small pictures, I see apparently

infinite momentary re-castings of changeful physical reality. Each image is a different world of weather about to come undone. They recall what Stieglitz called "picturesque little scenes" that he had made earlier in Europe. He (like a thousand artists before and after him) made canal views in Venice. His eye moves vertically and stacks two Venices: the one that rides the water atop the one *in* the water. His submarine city consists of streaky, attenuated battlements as El Greco might have imaged them. But he could just as handily, and with equal passion, make a mawkish picture like *Venetian Gamin* of a street kid with a scarred face dressed in rope-cinched rags. What saves the picture is the child's bold refusal to be owned by the photographer's sentiment: he's not exposing himself to the lens, he's living his life at it.

The portraits Stieglitz did of O'Keefe between 1918 and 1930 are the least interesting of his pictures. O'Keefe camps it up, as self-absorbed artiste, haughty glamour-puss, coquette, and Mystery Woman, always nestled in her self-awareness as a photographed object, even when she's only modeling her hands. She knew how to cast a celebrity's stare, daring the lens to pick up any trace of authenticity. Stieglitz of course collaborated in and encouraged the glamourization. When he uses her image for its formal values, as in a 1922 portrait where she's standing next to wood siding, he makes an issue of the contrasts between wood and flesh, identity and utility. The reductiveness is trivial. But we owe O'Keefe: when Stieglitz died in 1946, she became keeper and overseer of his artistic estate and quickly created sets of Stieglitz's work that represented the range of his career then distributed them to American museums at a time when few of them collected or exhibited photos. Her custodial passion didn't stop there. The detailed protocols she established for handling and preserving Stieglitz's negatives and prints are still applied. She made it pos-

sible for the art of photography to create an album of its own on-going self-invention.

Stieglitz was a visual ideologue. His 1902 *The Hand of Man* image of a locomotive pulling into a rail yard, and a 1920 view of the New York skyline, *City of Ambition,* seethe with American triumphalism. Both bear his trademarks: smoke, steam, iron, glass, the solid and the vaporous—the horses in the winter scenes I mentioned above are blanketed in steam—as if all that is solid does indeed melt into air. Because photography was such an endorsement and record of material reality, Stieglitz (like Man Ray, Minor White and others) was intent on investigating its immaterial dimensions. This is what led to the "equivalents." His unsubtle politics and poetics collide in the polemical *Spiritual America* (1923). This image of a white gelding is so tightly cropped that we see in extreme, almost prurient close-up, its hindquarters cinched in a harness, its penis sheath just barely visible. The camera peeps into the fold between hindquarter and loin as if searching for a potency that isn't there. Stieglitz in fact was mad about horses his entire life, thoroughbreds especially. (His father, a successful cloth merchant, Sunday painter, and patron of the arts, was the first Jew admitted to the New York Jockey Club.) He once wrote from Paris about four work horses, stallions, he saw on a Parisian boulevard: "The horses stood there, throbbing, pulsating, their penises swaying half erect . . . All the horses in [New York] are geldings." He was enthralled by a working or racing horse's ferocious musculature and, cliché though it is, a stallion's sexual power. The America of *Spiritual America,* especially by contrast to the Parisian scene, is a place of raw force emasculated, strapped into submission, by materialistic pursuits. Many of Stieglitz's pictures lean, like *Spiritual America,* toward overstatement. It's no surprise that he dropped from *Camera Work,* one of the most important art

magazines of its time, an article on the symbolist painter Odilon Redon, a greater artist than Stieglitz, who was completely at ease with spiritual indefiniteness and had a subtler understanding of the unseen-alive-in-the-seen. Stieglitz possessed a blunter, more totalizing American-style intelligence. He was also sometimes an intellectualized example of the simplistic American provincialism he so detested.

The Anatomic Bomb

The iconic image the sculptor Jacob Epstein made nearly a century ago, *Rock-Drill,* now looks quaint. The seven-foot-tall male figure, arched over and helmeted to look like a praying mantis, looms aggressively above his jackhammer. *Rock-Drill* isn't only a vision of man-as-machine, it draws on a formal vocabulary of forms being looted by many of Epstein's cohort—rods, cylinders, shafts, and pistons. American-born but British-by-choice, Epstein made *Rock-Drill* in 1913, though it was later destroyed and had to be re-cast from a plaster model in the 1970s. Ezra Pound titled a section of his epic poem, *The Cantos,* "Rock-Drill Cantos." Both were hijacking the materials, shapes, and velocities of an increasingly machine-tooled civilization. Epstein knew that images we make report back a vision of ourselves. He put it bluntly when he said he wanted to create "a machine-like robot, visored, menacing. No humanity, only the terrible Frankenstein's monster we have made ourselves into."

In the post-war era, the machine, as cultural model and promise of a fuller life, was replaced—or at least exponentially expanded—by the promise of the atom and the energy it produced. Raw material ceded to the vaporous, the dirt and grease of industry to the sharp clean coats of the laboratory. After decades of Depression and bloodshed, America was in any case primed for life-enhancing prompts. The new age gave us the atomic bomb and ambiguous metaphors in things atomic. The actual effect of nuclear detonation, a "mushroom" cloud, was a monstrously organic form. In "Asphodel that Greeny Flower," William Carlos Williams, always eager to absorb new facts into poetry, said that "the bomb, too, is a flower." The bomb, too, was a fast sell.

The hottest new swimwear, the bikini, was named by a French designer after the Pacific atoll test site. *Life* ran a photograph of a Hollywood starlet, the "Anatomic Bomb," her newly popular curvaceous shape stretched out beside a swimming pool, and the one-time Ashcan painter, Reginald Marsh, showcased the same fleshy female type in a 1952 drawing titled *Atomic Blonde*. Old styles don't vanish overnight. Versions and modifications of the mechanical vocabulary persisted into the 1940s in American art and design. Cars were still built to look like tanks or helmets, with maybe a hint of rocketry in streamlined chrome trim. But by the early 1950s another design idea superseded it. Mineralized angularity and sharpness softened into more elastic, pliable forms. Inorganic models gave way to organic ones. De Kooning, whose career took off with his tablet-teethed, bosomy "Woman" pictures of the early 1950s, was an aggressive painter, but his work wasn't modeled on the mechanical sublime. It could appear jagged but was essentially carnal and florid—he made the female figure into a manic bucolics. The same goes for Alexander Calder, Jackson Pollock, Adolph Gottlieb, de Kooning's great friend Arshile Gorky, and David Smith, whose sculpture took the materials of industrial design and transformed them into a restored nature, a re-visioning of Wordsworth's sublime.

The term that stuck to this new vocabulary, "biomorphic," announced a return to life, from angle, rectangle, straight line, and rigor, to oval, sphere, crescent, and a cultivated instability and looseness. Protozoa, kidneys, lily pads, corpuscles, beans, root systems, pistil and stamen and bloom—these were the forms picked up and adapted by painters like Gorky and, a bit later, Rothko, whose nebulous fields look like cellular smears seen under a microscope. The new visual lexicon of fine art and everyday objects—ashtrays, wall clocks, swimming pools, furniture,

and the tail fins of the 1959 Cadillac *Eldorado Biarritz* (O Winged Victory!)—had its philosophical grounding in Vitalism, which, though rooted in Aristotle's description of the *psyche*, the soul, as a vital force or life principle, has never been taken too seriously as philosophy. Henri Bergson, its 20th century advocate, believed that all matter, even inorganic, possessed a mysterious quality, an *élan vital*, that empowered existence. Bergson's ideas are now taken more as literary conceits than philosophical notions, but his thinking found its way into 20th century art discourse via the historian Sir Herbert Read. The artist, Read believed, handles inorganic matter such as pigment, chalk, stone, wood, or steel, in order to release life-sensations from it or to represent the vital force that inheres in it.

It's difficult to re-imagine recent cultural history without recycling clichés, but we have to construct models of some sort for what happened in the American imagination between 1940 and 1960. Culture is process, a work-in-progress, so style and substance bleed into each other, and the membrane that we like to imagine separates high (fine) and low (pop) art since the 1940s has become so porous as to be useless. (Even recycled clichés can prevent culture from becoming sclerotic.) In painting, we see the porousness between representation and biomorphic abstraction. Gorky's form language from 1935 to his death in 1947 is abstracted from nature and re-composed into suggestively figural patterns and sometimes even anecdotal content. My favorite abstraction of his is *How My Mother's Embroidered Apron Unfolds into my Life*. Gorky explained the occasion: "My mother told me stories while I pressed my face into her long apron with my eyes closed. Her stories and the embroidery keep unraveling pictures in my memory." The painting is an image of loss restored to consciousness, loss articulated in diaphanous canals of color connecting

solid masses like a circulatory system. (The more the apron un-
folds into Gorky's life, the stiffer and richer the pain of her loss.)
Other artists caught forms coming and going. Almost the mo-
ment Georgia O'Keefe's and Arthur Dove's pictures come onto
our nerves as dense figurations of the natural world, they break
down into forms in flux. All these artists are streaked in some
way by Surrealism. Paintings by Matta, the Chilean immigrant to
America who influenced surrealist practice here, are often hard
to tell apart from pictures by Gorky. The tropical viscosity of the
dream life, which Surrealism wanted to represent, oozes through
all their work.

The design art of the period produced non-stop chiming
motifs. The organic bulb-and-bloom form repeats itself in the
wasp-waisted lighting fixtures popular in the 1950s, in the Che-
mex coffeemaker, and in the *Barbie* doll. The kidney or boomer-
ang figure is the shape of Elvis's Graceland pool, Miami Beach's
Fontainbleau Hotel, and the pattern scattered across the surface
of Formica tabletops vintage 1954. With the post-war construc-
tion of the interstate came the cloverleaf; with or without it came
Charles James's "Four Leaf Clover" gown, its skirts flaring down
in four directions and its velvet "Petal Stole" rising high and sculp-
tural like Ming the Magnificent's collar. Salt and pepper shakers
designed by Eva Zeisal (who also designed "Cloverware" table
settings) are ringers for Al Capp's roly-poly Shmoo character in
Li'l Abner. Consider the Slinky toy, Irving Harper's "'Ball' Wall
Clock," and the hula-hoop. The creamy sculptural lines of décor
and architecture—candy dishes, chairs, cocktail bars, the swoop-
ing aerodynamics of the TWA terminal at JFK designed by the
great Eero Saarinen (whose table design is still found on patios all
over the country)—reached some kind of apotheosis in the 1953
Chevrolet *Corvette.* Which brings me back to those Caddy fins.

Around 1945, Harley Earl, chief of General Motors styling division, was given a glimpse of the twin-tailed *Lightning* pursuit jet, and thus was born the idea for the discreetly bumped fishtail fenders that first appeared on the 1948 Caddy. By the time of that 1959 *Eldorado Biarritz*, the tail fin assembly rose three and a half feet above ground level. For some snobs it was the low point in postwar automotive design, for others of us it was the tops.

Saints

Certain images possess such mysterious tenacity in our mental life. I look at a great many paintings, sculptures, and photographs, never sure which ones will outlast others on the screen of consciousness. In recent months, among those that have lived strongly in me are two Rembrandt etchings. The pliant crosshatching and nested filaments in his *Three Trees* become a rendering of the completeness of physical reality: different weathers (rain, clear sky, clouds), vegetation, the human figure (fishermen, farmers), art-making (an artist sketching) and man-made structures are all included in the summing-up. The other, a portrait of Rembrandt's aged mother, isn't expansive and all-gathering like the tree image; it's congested, close-fisted, self-involving. The old woman's eyes hide at the center of layers of curvilinear incisions, of collar, hair, forehead, brow. The downcast eyes slide our attention to the hand clenched at her breast. She looks as if she's holding on to her own reality. Images like these guarantee an emotional charge on request. But not everybody absorbs such imagery as a life habit. For many, a visit to a museum or gallery is a special event or tourist activity. Another order of imagery, though, is just as tenacious. Most of us keep under our noses, or just above them, objects and images that slant into our inner life in an incidentally momentous way. Snapshots of family, friends, or lovers, don't simply recall distinct personalities, or remind us of the space they occupy in our emotional lives; they make us feel a nearly palpable presence, as if to touch the image is to touch the person. If it represents someone who has passed, it momentarily restores that life to ours and maybe reminds us of our own passage to come.

On the walls of artists' studios, above writers' desks, in shops and office workers' cubicles, wherever anyone spends roughly the same number of hours working as when asleep, there's usually a picture postcard. If the written message faces out, the lines of print or script compose an image of the person who wrote them. The characters shape in memory the character of the person writing. A tourist picture, demure or wild, tweaks us to migrate briefly from the familiarities of habit to, say, a sunny beach scene done up in parrot greens and jolly blues with maniacal banner graphics: MARTINIQUE EXOTIQUE! These things are also *memento mori*, little death reminders. They recall something absent or gone and faintly spark an awareness of mortality more easily talked about (as I'm doing here) than held in mind as sustained moment-to-moment knowledge. They are instances when the accident and randomness that rattle our lives are suspended. For writers, picture postcards can be meditative objects; for visual artists, examples of desirable form. For anyone at all, they're fixed points in the felt life. We all know people who greedily collect postcards of places they have never seen—"AHOY TAHITI!"—as if to see the image is to fully imagine the place and therefore, somehow, experience it.

Van Gogh called the humble objects he painted his "saints." Broken down boots, old horse, monkish bed and chair, grieving man, jug of flowers, tree. Saints are mental presences we invoke to intercede between us and another life. They watch over us, sponsor our actions, pray back at us. We listen for their presence. "I want to paint men and women," Van Gogh said, "with something of the eternal that the halo used to symbolize." The objects he took as motifs reminded him of what's elemental and irreducible in human existence, what the desirable poverties are. If we keep close a reproduction of his room at Arles, or a sunflower picture, or a self-portrait where he wears his doggy look, we remind our-

selves how the human hand and invention can transform stark essentials into wildly celebratory presences.

Artifacts, too, are saints of a kind, especially if they're fragmentary or of faraway origin. Under my nose here at my work table I have a sand dollar—its subtle, sea-fashioned relief and combed edges look hand-tooled—given to me by someone who picked it up thirty years ago just before leaving her native Taipei to come live in America. When I rub my thumb over its surface I'm looking to feel the excitement and melancholy of migratory-ness. Many of us beach-comb, I think, in a pretty mindless way, hoping that when we later look at our gatherings we'll feel the charge of beautiful, happened-upon, pocketable things, like the seagull skull I also have on my table, a *memento mori* of a classic kind. And there's the potshard of Coptic origin, a gift from an artist friend who wanted to commemorate my visit to his hometown of Verona. Fulvio Testa, a superb watercolorist, picked it up many years ago while vagabonding alone and penniless in Sudan. His work (like that of his hero, Giacometti) creates complexly orchestrated effects with minimal means. In giving me that palm-sized chunk of ceramic, he was also observing and carrying on a tradition of gift giving. Fulvio was a good friend of Pierre Matisse, the painter's son and famous art dealer who represented Balthus, Derain, Giacometti, Roualt, and many others. That evening in Verona, Fulvio handed me a 1950s matchbox and asked me teasingly what was special about it. Nothing, so far as I could tell, until I opened it. Inside was a miniscule sketch by Giacometti (about whom we'd just been talking), a gift from Pierre, who had been given it by the artist. In certain indigenous cultures, a gift can't remain with one possessor too long. To retain its power, it has to circulate.

I make no special claims for these things. The vague force they have in my life is no less resonant than a rabbit's foot, Smurf

figurine, clam shell ashtray, squeeze toy, or other tchotchkes that to some are talismanic, to others tacky. None is really complete in itself. We imagine around them persons and activities and climates. Bus tokens, driftwood, toy trucks and soldiers, rocks or mossy branches, plaster statuettes of Elvis or the Infant of Prague, poker chips, sea glass, bar coasters. They're saints that angle us into a slightly different state of awareness and enhance our way of being in the world. I think of the imagination not as a faculty but as restless energy. It always wants to complete the pot, re-embody the gull, fill in backstory for beach and sea and road. It drives us toward the object of our desire: coherence. My mind doesn't have to "treat" those Rembrandt etchings, because they're already complete. But the imagination also possesses a useful agency: it applies its store of images to daily life, and so the picture gallery in my head is available whenever I need to re-see images that waken me to a moment. Like the stuff on my worktable, the Rembrandts are, in their own way, pocket-able.

WHAT'S LEFT

و

2003–2005

Montmartre in Chicago

The designers of the big dance number in John Huston's *Moulin Rouge* did their homework. One brief bit, cut into the cancan hoopla, showcases a *quadrille* with a woman doing jackknife kicks and come-hither petticoat flourishes. She's La Goulue, a famous dance hall performer of her time, and her partner, a tall elastic gentleman with a prosthetically hooked beak, is another familiar dancer, Valentin le Désossé. La Goulue's moves, Valentin's somber self-composure, and the splashy yelping atmospherics were lifted straight out of paintings and posters by Toulouse-Lautrec, chronicler and habitué of entertainment establishments in the Montmartre of the 1880s and 1890s. The scene ran as a video loop in an exhibition I saw at Chicago's Art Institute about Montmartre and the artists who worked there, many of whom took advantage of the relatively new and speedy color lithographic reproduction technology. A few decades earlier Baudelaire had hailed the new process because it caught modern life as it was being lived. Lautrec, who designed posters for very popular joints like the Moulin Rouge and the Moulin de la Galette, was that rare artist that we still take seriously whose pictures literally covered the walls of Paris.

Semi-rural, sited with its characteristic windmills on a butte overlooking Paris, Montmartre lured Parisians with its dance halls and café-concerts crowded with workers, shopkeepers, pimps, prostitutes, and highbrows cruising the lush life. Its culture, to judge by Lautrec's representations, was steeped in absinthe, a nighthawk's poison of choice. In Lautrec's pictures absinthe's thin milky green lies like an acqueous shadow on faces or condenses into rainy mist wafting through street scenes and interiors. His palette was broader, of course, though not by much—he espe-

cially loved soft mauves and fruity reds. His color, like his flashy handling, was carnival-esque, but the drizzly greens infuse high times with melancholic delirium. What kept his work just this side of maudlin nostalgia for the gutter was his gift for wicked, gleeful play-as-performance. The self was a moving feast that could in a wink become a parody or caricature of its own identity. His enterprise was boosted by photography, which created a new kind of showtime self-consciousness. Your soul could go on public record sheathed as whatever it chose to expose or fake to the camera's eye. Lautrec fit Baudelaire's description of the dandy, a crowd-loving but aloof self-fashioner—he had himself photographed as a Chinese princess, as a cabaret singer dolled up in feathered hat and boa, and as himself, whatever that was. In his painting, *At the Moulin Rouge,* the performer May Milton's green face rises like a masked wraith from the lower right corner. Lautrec puts himself in the deep background, recognizable because he's the shortest person in the room. (As a boy, because of a bone-softening malady probably passed on by his consanguineous parents, he broke both legs, which ceased to grow.) In many pictures Lautrec treats the figure as a performer, or *performance*, a contrived event watched rather than observed. He used his materials—chalk, crayon, pigment diluted with turpentine to create washy scrims—as a cosmetic to "make up" people and places, even when he depicts private moments of public performers. Baudelaire wrote about make-up as a metaphor for the creation of a self-aware modern self. Like him, Lautrec used all this heightened consciousness to make an art of classically formed, subversive, irreverent grotesquerie.

The Chicago show was like summer clothing, loose fitting and lightweight. Though Lautrec was the nominal star, its broader reach was Montmartre and its artists. It included, for instance, a small minor Van Gogh street scene where pairs of strollers sus-

pended in a faint, airy impasto meander alongside a tipsy picket fence. Small blue-white-red banners droop in the wind, their feeble vitality played off against bare trees in the background. Van Gogh himself fancied absinthe and made a whirlpool still life of a glassful, and he posed before such a glass in a Lautrec portrait that beautifully renders the fanatical, pitched-forward concentration he burned into his life and work. Montmartre culture promoted the streaming of art into life, and some of its best productions were saloon art. After my first run through the show, I took myself to one of my favorite joints, Miller's Pub in the Loop, one block from the museum, a longtime chophouse which, but for the Kelley greens and nasal Chicago accents, exudes the sort of frisky and calamitous dreaminess the exhibition illustrates. It's decorated with celebrity photographs (Uncle Miltie, Sinatra, Phyllis Diller) and, behind the bar, bad craggy paintings of charming hobos. Montmartre's Le Chat Noir had sharper, nastier decorations. The great print-maker Théophile-Alexandre Steinlen (whose poster for Le Chat Noir thrills with its wiry drawing and rolled-on reds and blacks) made two paintings, *Gaudeamus (Be Joyful)* and *Apotheosis of Cats,* which must have given the locale a debauched, jubilant state of nerves. In *Gaudeamus,* an emaciated yellow-eyed alley cat flaunts a red banner from a rooftop, cheering on good times, though the cheering looks suspiciously like menace. And *Apotheosis* is the greatest saloon decoration ever: a phalanx of yowling sexed-up cats gather on a hill topped with a yellow moon that haloes a black cat's silhouette. It's night's essence animalized, just the sort of energy nocturnal trawlers need. When I finally left Miller's late that night, the Irish greens of its barstool covers and signage crept closer to the green that drains down Lautrec's pictures and momentarily balances human figures that otherwise look as tipsy as Van Gogh's pickets.

Lautrec quite consciously tied his career to the stars and was an early model for subsequent artists tethered to entertainment industries. He made mass-consumption poster art for the hottest entertainers of the day: the song-writer singer Aristide Bruant (whose pale supercilious visage and dashing red scarf decorate college dorm walls across America); and café entertainers like May Milton, the pouty angelic Jane Avril, and Yvette Guilbert—she of the birdy Audrey Hepburn neck, and so famous for the slinky black opera gloves she performed in, that Lautrec's picture of the gloves alone (they look like ripped up tree-roots) sufficed to identify the subject. The oddest act was the American Loïe Fuller, who danced with silk sheets—lavender, chartreuse, gold—attached to poles that she swooped about her person in shape-shifting whorls like huge hallucinated propeller screws. Baudelaire's model for the painter of modern life was the (now negligible) illustrator Constantin Guys, whose fashion plates flooded Parisian society, because he thought Guys's up-to-the-minute use of lithography could preserve the lived moment, the eternal in the transitory, and would establish the heroism of modern life and prove that moderns were heroic even in their silk cravats and patent leather boots. Like Guys, Toulouse-Lautrec was a man in a hurry (and convinced he wouldn't live much past forty, which he didn't). His paintings and illustrations are anti-deliberation. One doesn't sense the inquisitive, exploratory hitches visible in Cézanne's or Manet's touch. We see his impatience in the brisk handling, the pigment thinned for drippy streaky effects, and the crayoned look of the drawing—he makes the motif look shredded, raked through with the compulsion to get on to the next thing. His pictures tend to look lean and dry, not plump or moist or squeezable. He's sometimes most sensuous in poster art, perhaps because its flat frontal-ness and inky high-keyed contrasts released something impudent and unequivocal.

As for impudence, in an anthology exhibition of this kind you have to be careful what you wish for. The pictures by Degas, Bonnard, and Manet diminish Lautrec's achievement. One small Manet, *Plum Brandy,* occludes what surrounds it. It hasn't the ebullient glamour of stuff Lautrec, Steinlen, and Ferdinand Bac produced, but as painting it's like a world-class tenor singing in a barbershop quartet. Manet's picture (of a woman drinking and smoking at a table) has an excited flair intensified by the subtle, sexy-painterly drama Manet lures from pink-white tones modulated along cigarette, hand, and finger, down to the tabletop. He's more driven by the mood and character of the *picture* than by the situation or personality of the sitter. Lautrec was caught up, I think, in the specific character of his subjects. Degas, too, whom Lautrec greatly admired, depicted the performing arts, but Lautrec was known for making likenesses of actual personalities. He wasn't so much preoccupied by a feeling for a type of entertainment, its temperatures and tensions (as Degas was), as by the actual style of a particular singer or dancer. His representations became a performer's emblem, and representation became promotion. At his best, he tweaked his own skills and proclivity for personality. One of his most moving paintings is of his close friend, the cancan dancer Jane Avril, walking alone on a street. You sense the existential pressure on one life alone in a big city, subject to circumstance, along with the exhalation of release from the pressures of performance. Her performing self is painted *down*, not primped or intensified: she's depleted of the zest we see in his theatrical depictions of her. Avril brought out something in Lautrec that other performers did not. In a lithograph, he poses her in a standard ta-ra-ra-boom-de-ay leg-lift (arm hooked under her lifted thigh) wearing a soulful hangdog look: her angular composure is kitty-cornered by the reverse angle of a bassist whose fat hairy

hand grips the fret board of his instrument, out of which streams a yellow-green vine that lassoes completely around her down into the orchestra pit. It frames and contains her, owns her, really, and most of the choking claim is made by that fat hairy hand.

Lautrec's mizzled veilings sometimes seem a vague caution (or contagion) thrown over all that gaiety. He had a tough-tender regard for appetite's corruptions; he wasn't judgmental, but his representations rasp with the cruelty a good caricaturist needs. The smiles on the faces of his pimps and johns are queasy-making predations, and yet in the brothel pictures, Toulouse-Lautrec sometimes achieves a meditative concentration not much evident in his other work. His rear view image of a prostitute bathing, one of his best things, opens up his feeling for the subject. Raw experience isn't being blatantly theatricalized or caricatured. Lautrec's bather has some of the tremendously condensed energy of Bonnard's little circus picture of a nebulous horseback rider in which nothing is held back. Sensual energy in both pictures is distributed throughout the image, though Bonnard's handling is so solicitous and grandly expressive that his little painting dominated the large room where it was installed. Even at his best, Lautrec leaned a bit much on dazzle and display. His work can be shot through with a sooty sadness or *ennui*, and we certainly sense the pathos scaffolding the glamour, but these shouldn't be confused with the tragic sense of life (and its perishable joyousness) that gives Bonnard's and Degas's work its specific gravity.

During the mid-1890s, Lautrec paid less attention to Montmartre's glitz, though he lived there until his death (from alcoholism and syphilis) in 1901. Local color had lost some of its fiery appeal. In 1889 he'd made a picture that wrapped up much of the ambiguous feeling he had for the scene and its life. The central figure in *At the Rat Mort* (a dance hall decorated with Leon Goupil's

painting of a dead rat) is a woman swaddled in chiffon ruff and scarf that boil ferociously around her head, tied off by a topknot that looks like a tourniquet to stop massive glamour loss. Smiling a smudge of ruddy lipstick, she's a crudely wrapped package of used-up goods. Brusque umber and gray brush-strokes make the top of her face look decayed. The lower jaw's mortician-ish pallor results from the footlight illumination Lautrec and his Montmartre cohort favored. And yet the dissoluteness calls keenly to us to share its kiss-the-devil exhilaration. Lautrec never painted the thrilling sick-making indulgences of the flesh and appetite with such ambivalent, cut-loose verve.

Left Unfinished

Some artists, no matter how often I see their work, refresh and astonish so often that I think some unworldly energy is passing through the artist's eye and hands, a fountaining of some kind, and all the artist has to do is pay attention and get it all down and done. Degas is one of them, and the wide-traveling exhibition *Degas in Bronze: The Complete Sculptures* was an exciting unveiling—yet *another* unveiling by this artist—of his dialogue with materials. The standing figure in *The Masseuse* leans over and into her reclining female client, rubbing the back of one thigh while pulling up her other leg. The nude's hands, planted on her buttocks, push her pelvis into the movement of the raised leg; the exertion forces her to contort herself, since she's lying sideways on a chaise couch, her torso twisting up the chair's back. She's a knot of compacted, complex actions. (To make things even more interesting, her discarded robe flows down from the chair away from both women.) The anecdotal content makes it an allegory of the artist's work, his hands coaxing from the material new possibilities and fresh plasticity. Degas models the masseuse as *she* models *her* subject. Expressive possibilities boil up as he kneads, pulls, and squeezes the medium, a compound of pigmented wax and plastilene, an unstable non-drying clay that has a tender, mercurial responsiveness. The masseuse is a kind of stand-in. Her work is to manipulate changeful flesh, which will go on changing after her work is done. A conventional 19th century sculptor would aspire to a final state where manipulation ceases and the wax or clay or plaster model is cast in bronze. But Degas left *The Masseuse,* like nearly all his sculptures, in a state closer to that of the masseuse's client—impermanent, self-shaping, unfinished.

It's one of the more compelling backstories in early modern art. After Degas's death in 1917, a journalist reported finding one hundred and fifty wax models in his studio that the artist never showed or had cast. These included fragments and broken sculptures along with works more or less completed, or abandoned. After the contentious settling of Degas's estate, the Adrien-A. Hébrard Foundry made bronze editions of the seventy-three wax models deemed sound enough for casting. Four sets were made under the direction of the Milanese caster Albino Palazzolo, whom Degas had known and admired. For years it was presumed the wax originals had been destroyed or broken during the casting, until they were found in 1955, more or less intact, locked up in Hébrand's cellar. Degas had the complete touch. (He worked in nearly every medium, including photography.) He began making sculpture in the mid-1870s and continued for roughly twenty years, until his failing eyesight began to slow him down, but the only bronze exhibited in his lifetime was *Little Dancer, Aged Fourteen,* shown at the 1881 Sixth Impressionist Exhibition. His reason for modeling in wax was "to give my paintings greater expressiveness, intensity and vitality." Modeling was, in other words, three-dimensional preliminary drawing, since he could change, correct, or destroy the maquette at any point. Degas anyway shied from the permanence and monumentality of bronze. "It is a tremendous responsibility to leave anything behind in bronze," he said. "This medium is for eternity."

Rodin, the celebrity sculptor of the time, made statues whose hyperactive surfaces pulse with an assertive, world-greeting robustness. We know at once that his forms were made for the ages. Degas admired Rodin, but his own sculptures are chamber dramas of non-fixity. He insisted that the models were "documentary, preparatory notions," necessary but expendable middle passages

which surprised him into realizations about the extension and movement of mass in space. As he advanced beyond the academic conventions of the 1870s, which valued figures that were static, strongly outlined, frontal, exuding a stillness not sacrificed to any hint of movement, Degas was assisted by the discoveries of the photographer Eadweard Muybridge, whose stop-action motion studies demonstrated (among many other facts of locomotion) that a galloping horse's four hooves were all off the ground simultaneously, tucked toward the animal's midsection. And while Degas did not replicate this phenomenon in all the models he made of horses, there's one from 1880 which, except for the belly tuck, is a three-dimensional realization of that fact—it creates the illusion of motion without progression through space.

As Degas re-worked his waxes, the body worked to find its equilibrium. The ballerinas and bathers, who sustain such delicate, chunky balance as they practice an arabesque or reach behind to wash a shoulder or step from a tub to dry, have *arrived*, if only momentarily, at the balancing point by virtue of the ongoing manipulations of the waxes. From figure to figure Degas tests, holds, then changes the pose, working to find a form *so that* he can pull it out of its provisional harmonies. And not only dancers. *Rearing Horse* and *Horse Balking* are about the subtle distribution of might and mass sustaining a motion-infused equilibrium. "My sculptures," Degas said, "will never give the impression of being finished." The exhibition was installed so that we witnessed him being true to his word. One vitrine contained five versions of a dancer touching her foot with her right hand. The long, spatulate layers of bronze that pick up the original wax modeling look like strips of papier-mâché. He made the wax models on twisted wire armatures and often had to construct exterior armatures—they look like miniature loading cranes or gallows—to keep a statue

upright or establish a perpendicular to observe or violate. The surfaces of the bronzes, which subdue some of the streaky wildness of the wax models, record Degas's inventiveness. We see his thumbprints and tool marks. He used all sorts of odd materials to construct armatures and build up surfaces: cork from wine bottles and mustard jars, sticks, rags, metal, and paper. *Little Dancer, Aged Fourteen*, was dressed in real clothing, doll's hair, and ribbon. He made a cluster of four standing dancers, nude but for one in a tutu: no matter the awkwardness of the pose, each retains a protective self-possession. Degas achieves this by expending much energy on the defining area of an adolescent girl's anatomy, the bulge that rises from thighs and pubic area to the waist. His dancers embody a psychology, a somatics of anxiety, calm, exertion, concentration, and self-regard.

His nudes are more sensuous and erotic than Rodin's, because the erotic is intensified by the privacy of the space in which the figures expose themselves. They lean over, stoop, grab a foot or fix a shoulder strap with no self-consciousness. Freed by that intimacy, Degas pushes conventions hard. *Dancer Fastening the String of her Tights* pushes contrapposto so far that the figure seems nearly corkscrewed, her left foot's extreme turn-out almost on a perpendicular with the akimbo right arm that twists around her back to fasten the tights. This, like *Draught Horse*, which heaves forward so massively that it looks about to slide off its base, has tremendous pitch—it's the action we feel, not its arrest. And yet for all that, the most innovative model Degas made has nothing to do with balance or movement. *The Tub* sits flat and froggy on the floor, the bather half-submerged in its mass. It's an extraordinary moment: Degas melts the vertical axis (and imagined pedestal) until the figure becomes its own ground. Woman, water, and tub interfuse and become a potent sexual medallion.

Victorian One-Hour-Photo

The first photographers weren't really that. They were preoccupied with other things. The Frenchman Joseph Nicéphore Niépce made the first extremely primitive photographic print in 1816 because he really aspired to be a lithographer but lacked drawing skills. Daguerre, pre-daguerreotype, was Paris's premier scene designer, famous for his fool-the-eye theatrical effects. The most interesting of these characters, the English polymath William Henry Fox Talbot, was a classical scholar, mathematician, chemist, botanist, linguist, and all around country gentleman, the sort of Victorian genius learned not just in crystallography, optics, and philology, but also able to decipher Egyptian hieroglyphs and Assyrian cuneiform writing. His passion for photography grew from his studies of the operations of light and may have been stoked by his desire to get a step up on his wife's natural artistic gifts. He spent much of his adult life and made many images at Lacock Abbey, a rural cluster of buildings in the Talbot family since 1539, about one day's journey from London.

The revolutionary negative-to-positive Calotype process Fox Talbot invented evolved from what he called the Photogenic Drawing Process. Sometime around 1835, he discovered that sensitized paper exposed to sunlight yielded a negative image of the object—leaf, lace, feather—laid on it. A fennel leaf he photographed looks dreamed into existence. The challenge was to liberate this process from its one-time-only-ness. Experimenting with different chemical solutions, he found that by exposing an illuminated external object on treated paper in a *camera obscura* (a box fitted with a lens), the latent image embedded in the paper, treated with more chemicals, emerged as a negative which, pressed to another

chemically treated sheet, printed a positive image. These procedures, which he worked on during the late 1830s and 1840s, have been foundational to photography ever since– the fixing agent hyoposulfate of soda (or hypo) is still used—though immaterial digital technology has now nearly overtaken traditional cameras and darkroom paraphernalia.

Fox Talbot pursued photography because it helped him keep accurate records of his botanical specimens. Most of his subjects, botanical and otherwise, possess a disarming innocence and neutrality, as if embodying the starting-out innocence of its practitioners. A photograph captured by his "little mousetraps" represented the unmediated encounter between image-maker and motif. (The art soon enough internalized a snickering witness, a heckler, of that relationship.) In *Articles of China,* which appeared in his first book, *The Pencil of Nature,* cups, tureens, saltcellars, bowls, and other bric-a-brac sit on cabinet shelves as if they exist not for use but as pure offerings to the eye, as if they've never been seen or owned by consciousness. And in a sense they hadn't, because the representations weren't contrived or constructed, only found and printed. The hand didn't make the image, it ushered it into existence. The china cabinet Calotype was better than a written inventory, Fox Talbot said, because if the collection were stolen or destroyed the picture would be "mute testimony" to its reality and contents, "evidence of a novel kind." Photography's evidentiary powers (and powers to fake or shape evidence) are now so refined that we know not always to trust what we see. Fox Talbot's work progressed from early, foggy, brown portraits he called "Rembrandtish" to later, higher resolution architectural studies. His own progress demonstrates the speed with which photography grew as a technical process and art, and his inventiveness was unstoppable. By 1842 he was already working to develop infrared

photography, the electronic flash, and phototypesetting. He was a key player in the Reading Establishment, the first photographic developing and printing facility.

Photography was recording its own progress. An image he made of the Reading Establishment shows photography as an open-air laboratory, which in a sense it still is. The stages of the photographic process are on full view: cameras, prepped negatives, motif set-ups, a posing chair, masters and apprentices, and miscellaneous instruments—a Victorian One-Hour-Photo.

Fox Talbot realized that his little mousetraps could vacuum up the world. He claimed whatever was available in local Lacock culture, especially the women surrounding him, whom he portrayed face front and in profile, close-up and distant, sewing, reading, musing, and tending children. (A few of the women wear megaphone bonnets that look like dog cone-collars.) He photographed woodcutters, fruit sellers, and other country types that frequented Lacock. Being a man of science himself, he conferred a particular nobility of intelligence on those who sat for him, posed with a microscope, camera, or book. His constant experimentation with chemical processes is illustrated by three prints from a single negative, three men in conversation (following fine art's trajectory from single portrait to figure group), in which the negative has been treated with three different fixatives: hypo, iodine, and salt. Tonality and mood differ dramatically one to another. And the negatives themselves look icily pure and spectral, like an X-ray, matter-penetrating, matter-evacuating. As if by some intuitive tropism, Fox Talbot was drawn to subjects that would occupy image-makers for the next one hundred and fifty years. His overview of a Paris Boulevard encompasses mansards, dozens of chimney pots, parked carriages, kiosks, gas lamps, windows and doors, commercial establishments, all familiar furnishings of

modern street photography from Paul Strand to Robert Frank to Joel Sternfeld. And what an eye he had. His compositional sense kills. One of his greatest images is *The Open Door*, a Wordsworthian scene of a straw broom leaning against a doorway, a spirit lantern hanging from a nail, and vines that braid up from the ground and set the picture's right margin. It's an image of the world of work at rest, yes, but its juiciest pleasures lie in the formal values, its abstractness emptied of social contents. Another tropism led him to record, with a discrete visual fanaticism, architectural forms: the Pont Neuf, Westminster Abbey, the gates of Christ's Church, *and* a Lacock haystack. He photographed lace as if it were an architectural ornament.

Like so many of his successors, he was a devourer. He wanted to own in imagery the world's many parts. So along with portraits, conversation pieces, and architectural motifs, he photographed still lifes (one includes a pineapple!), landscapes, weather, leaves and ferns and fronds, art objects like a marble head of Patroclus and *Rape of the Sabine Women,* whose rising multi-figured form Fox Talbot imitated, in a rudimentary way, in his image of a ladder reaching from ground to hay-loft, men standing above and below. Fox Talbot's practice and obsessions still live with us. Some curator should make a show of the homologies. His pictures of shelves of books haunt the "tome photography" of the contemporary Abelardo Morrell, and a photo of a page of Latin from one of those books has morphed only slightly into a huge digitalized image of a printed page by the young German Andreas Gursky. His photogenic drawings of nature's lacework are prototypes for the art of another German, the painter Anselm Kiefer, who collages actual leaves and ferns into his work. The American Alan Greene practices Fox Talbot's original Calotype methods, which may be the kind of nostalgic end game that precedes the displacement of

one historical process, rays of light on paper, by another, pixels on microchips.

Hard Times

Certain women artists make claims on the popular imagination that aren't related to the quality of the art. Viewers as fiercely defend Frida Kahlo for her physical suffering and self-punishing (often self-mocking) imagery, as the imagery itself is fiercely witty and scrupulous. Anyone who has felt a voluptuous charge from a Georgia O'Keefe flower painting is likely to love just about any of her pictures. In Dorothea Lange's case, many love her photographs because they're authentic representations, rich with sympathetic candor, of the *popolo*. Her most beloved and admired pictures, those she made in and around San Francisco during the Great Depression, create an intimacy with distress which, though bolted to its historical period, is a visual metaphor for extremity suffered by anyone at any time. Like Walker Evans, one of her heroes, she became a poet of American poverty, though her view of the human wasn't as bemused and patrician as Evans's. After high school, like many smart young women of the time Lange went to teacher training school but decided instead to become a photographer. She hadn't had it easy. A childhood case of polio left her with a limp, her father left when she was an adolescent, and she had to live with a demanding, hard-drinking grandmother. Her first professional work was in portrait studios in New York, where she pretty much learned her trade. By 1920 she had moved to San Francisco and established a successful portraiture business for the wealthy. When the Great Depression bit deeply into her business, she moved to Taos and for several months made moody images of the Pueblo and other Southwest locales. Returning to San Francisco, Lange for the first time stepped out of the studio into the streets.

Her very first street picture is now among her most famous, the 1933 *White Angel Bread Line, San Francisco,* where a dozen or so men malinger outside a soup kitchen, backs turned to us except for the central figure, an unshaven middle-aged man clasping his tin cup as if in prayer. Lange went on to bear witness to the troubles and massive demonstrations brought on by the general strike of 1934, which grew out of a strike by the International Longshoremen's Association that paralyzed West Coast shipping. From 1934 on, instead of well-heeled San Franciscans she exhibited photographs of labor leaders, strikes, and May Day demonstrators. Her portrait of Tom Mooney, the Irish-American labor organizer sentenced to death for murder but eventually exonerated, is heavy with stolid melancholy and haunted resolve. The casually arrogant copper in *Here Democracy Survives* stands before a crowd of demonstrators in his bull's frock-coat, brass buttons studding the front like rivets, and a star gleaming on his chest, puffy with the entitlements of authority, while the demonstrators make up a mongrel bunch of needy, earnest malcontents. One demonstrator's sign is blocked so that the key word is invisible: "Stop American Press Slander Against . . ."

From 1935 to 1945, Lange worked mostly for New Deal government agencies like the Farm Security Administration, the Bureau of Agricultural Economics, and the War Relocation Authority (she documented the Japanese internment camps), and out of these assignments came her most popular pictures, in particular the portrait of a destitute pea-picker and her children usually titled *Migrant Mother.* From the time it first ran in the *San Francisco News,* the picture, at various times titled *Human Erosion in California, Facing Starvation,* and *Starvation,* became a heroic American image of poverty and family cogency, a picture Americans feel quite proprietary about, strangely enough, for we are a country that

detests and fears the destitute. The circumstances: a blight in 1935 wiped out the pea crop in Nipomo and left hundreds of already poor nomadic people without work, and in one of the migrant camps Lange spotted and approached a woman. Her narrative: Florence Leona Owens, *née* Christie, born in 1903 of Cherokee parents, married at seventeen, by 1935 mother to eight children and the family bread-winner. She told Lange they had been living on frozen vegetables from nearby fields and birds her children killed. She had just sold her car tires to buy food. The thirty-two-year old woman looks fifty in the picture and holds her hand lightly against her jaw as if to help her focus on survival in an eternal present. She's surrounded, covered really, by her three children, one asleep in her arms, its grimy face close to her breast, the other two hugging her shoulders, their faces turned from the camera in childhood's gesture of shyness that in adulthood becomes shame. It's a lightning-strike image. No matter how often you've seen it, it slaps you awake.

Lange was a straight-on photographer. "Hands off!" she liked to say. "I do not molest what I photograph, I do not meddle and I do not arrange!" She did crop images for effect, though. An extreme close-up of a Hopi man from 1926 is very tightly cropped so that the man's scorched features spread throughout the frame, creating a visage that's both mask and reality. Lange wasn't nearly as caught up in formal values as were social documentarians like Walker Evans and Russell Lee. She was at her best with human subjects. Her landscapes have a bony, desiccated majesty but look too studied. When she photographed humans in distress, though, the lens became a highly sensitized, inflecting mediator of compassion. Complex compositions like *Stoop Labor in Cotton Field, San Joaquin Valley*, where a cotton picker hauls his bag through a field while long clouds roll up and over his bent back, have an awful,

provoking suddenness. They throb in consciousness even before we've begun to process the dynamic composition that enables the feeling.

Lange's migrant camp pictures were obviously models for *Bonnie and Clyde*. (And *she* had many models: the Federal Unemployment Census of 1938 reported ten million jobless.) Her image of an Okies camp in Bakersfield could have been lifted out of the scene when the outlaws visit Bonnie's mother in a similar dust-blown encampment. Great artists can provoke artists of lesser gifts to produce their best work. Inspired by Lange's example and by Steinbeck's novel about organized labor, *In Dubious Battle*, the California photographer Horace Bristol decided in 1937 to document migrant worker conditions. His pictures of flooded government-supplied tents are especially devastating; in one, a boxcar serving as a makeshift dwelling slowly disappears in rising waters. Bristol and Steinbeck traveled together in the winter of 1937-38, and out of that journey came *Grapes of Wrath*. Some of Bristol's pictures taken during the trip, long before the novel's publication in 1939, were re-titled years later. A portrait of an aged-looking young man (a ringer for a homeless guy in my neighborhood) with a long gray beard wearing what looks to be a pressed tin hat, originally titled *Migrant Camp, Near Visalia, Tulare Country, California*, in the 1980s was re-titled *Grandpa Joad*.

I've seen Bristol's Depression Era photographs alongside Lange's, and while he doesn't suffer from the proximity, differences jump out. Whatever it is that gives Lange's pictures their stabbing, almost unpleasant sensation of moral witness—it has to do with a feeling for the intimacy created inside the lens, something that can't be taught—isn't as apparent in Bristol's work. Intensity, snappy energy, a feeling for the imperious entirety of the moment, whatever it is, Lange had it and Bristol didn't, though he

made some very good pictures. My favorite is one of pea-pickers weighing barrels. Each picker approaching the foreman strikes a particular style of shouldering his burden. There's the one- or two-handed grip, the erect or tilted torso pose, the rolling or marching gait. Lange's pictures found at least one second life in *Bonnie and Clyde*. Steinbeck's novel found a kind of second life in Bristol's images, and Bristol's fame had its own second life. When John Ford filmed *Grapes of Wrath* in 1940, he used Bristol's photographs as a guide to costuming, casting, and sets.

Hot Chocolate with Chiles

Two or three times a year during the Vice Regency period that followed the Spanish conquest of Mexico, the *Flota Indiana* from Spain docked in Veracruz, bearing trade that would feed, furnish, scent, embellish, and glorify the aristocratic households of New Spain, occupied by already well-to-do Europeans and Mexican born descendents of Spaniards called *criollos* who would in time marry and breed with Zapotecs, Mayas, Mixtecs and other Indian peoples to create the finely inflected *mestizo* populations of contemporary Mexico. It was really a case of mestizos blending with mestizos, since Spaniards themselves derived from Arabic, Celtic, Iberian, and Roman bloodlines, and indigenous peoples had produced their own mixed-bloods. Add to these the hundreds of slaves brought from the Congo, Angola, and Mozambique— one of the earliest codex illustrations shows a black man amongst Cortés' entourage—and you get a sense of the fabulous genetic stew of that three-hundred-year period.

Along with their freight of slaves, the ships bore Flemish lace, German escritoires of fine wood with mother-of-pearl inlay, Venetian glass, mirrors from France, Cordovan leather, Italian tortoise-shell boxes, and cocoa beans from Venezuela. From the Philippines, recently annexed by Spain, came the Manila Galleon that harbored in Acapulco, bearing slaves from the Far East as well as high-end goods: Chinese silks and lacquer trays, Japanese painted screens, pearls, porcelain, healing plants, heady spices and perfumes, and ivory. In a sense, New Spain's biggest import commodities were *precedents*, since most of these artifacts would be imitated and developed brilliantly by New World artisans like the Michoacános who made dead-on imitations of Chinese lacquers.

The cocoa beans went to make the hot chocolate that New Spain's aristocracy consumed in staggering quantities. Concocted of hot water, sugar, cinnamon, vanilla, and hot chiles, it was the ritual beverage consumed at a *salón de estrado*, a kind of highbrow parlor party of polite conversation and gossip convened by women of the aristocracy. The *estrado* was a dais piled with pillows on which the lady of the hour sat. The backdrop for such occasions was usually a painted screen. I saw two of them in an exhibition titled *The Grandeur of Viceregal Mexico:* one screen unfolds a busy, detailed, maniacally violent illustration of the conquest and its aftermath; another, structured like a triptych, portrays New Spain's predominant socio-racial classes. The assembled elite are sipping their zingy chocolate from small coconut-shell goblets.

The paintings produced in the Viceregal period weren't much as paintings, but they provided endless social and cultural information. A 1782 portrait of a wealthy colonial woman, done up in aristocratic finery, is an index to the accoutrements of a certain kind of woman in New Spain. She wears a silk dress draped with lace and prickled with gems and gold threading; plumes sprout from her huge hair; a silver fan hangs from her hand; a filamented silver pendant glints from a black velvet choker; and she's finished off with heavy duty bracelets, rings, and earrings. She would have been so weighed down by her finery as to require, as did other ladies of her station, a sedan chair to schlep her from boudoir to waiting carriage. Viceregal Mexico's religious iconography can surprise. After 1745, the Counter Reformation in Europe insisted on a particular representation of the Holy Trinity: God the Father was an ancient, Jesus Christ a stigmatized young man, the Holy Spirit a dove. Previously, though, it was often represented by three physically identical figures—an "Anthropomorphic Trinity"—a format retained by counter-reformation Spain and

continued in the Americas. But there's a painting in *The Grandeur of Viceregal Mexico* that depicts three identical heads—it got confounded momentarily and grotesquely in my head with Andy Warhol's multiples—each backed by a triangular halo, which not only stands for the Trinity but replaces the doves that might have been interpreted as remnants of animist religion, a major matter because Franciscan and Jesuit missionaries, and the Native lay brothers they trained, liked to graft Roman Catholic teachings onto indigenous beliefs.

When I was a child, the monstrance, that sunburst locked-box housing for the consecrated host, always seemed the most expressive, celebratory liturgical implement, and there's one in the exhibition from Yucatán that's appropriately glamourous and glorious. Other Mexican 18th century metalwork wasn't so delicate. A couple of chunky silver candlesticks look like bludgeons. Most of the objects in the show touch different registers of public and private life. A chalice and folding screen and carriage are frontal, available, exposed. Yet some of the most intimate items that no person of a certain class would be without provided a kind of vest-pocket extravagance. Elaborately chiseled and engraved snuff boxes studded with precious gems, for instance, or match-box size gold cigarette cases that served the recently acquired appetite for the most popular New World plant, tobacco. Artisans even forged tiny silver pincers, the first New World roach clips, so that a lady's fingers wouldn't be nicotine-stained.

On a bigger scale, the sculpture New Spain produced was usually the festively polychromed wood we associate with Mission art. The most impressive is a menacing rendering of St. James, mounted, raised sword in hand, a chilling image of the companionship of imperialism and theology. The modeling is bluntly expressive, the splashy red and gold surface made by a process called

estofado, which involved incising polychrome to reveal a gold leaf undercoat. The saint's steed, outfitted with wrought-iron sword, stirrups, and bridle, would have had under its ramping hooves a Moor or Indian. Conquistadores were devoted to St. James, their patron-protector in New World broils, and referred to him as the Indian Killer. A statue of St. Michael, God's warrior prince in the struggle with Satan and his army, which we might expect to be as martial and warrior-like as St. James, is soft, seductive, almost mournful. The indigenous technique its maker used, modeling with corn cane paste (cornstalk pulp kneaded with plant-derived adhesives) and light, porous, cottonwood-like material, allowed artisans to fashion featherweight portable statues of practically any size. The statue's buttery ridges melt and roll gilded light along the lineaments of the armor—St. Michael looks modeled in wax that set about twenty minutes ago.

Black and White

Diane Arbus's images have a sealed-off, self-directed intelligence. A boy holding a fake hand grenade fakes a spastic stance. In a small Bronx living room (you can almost smell the cabbage cooking), a "Jewish Giant" stoops toward his parents; patients at a mental hospital frolic in masquerade across the hospital grounds like a Watteau *commedia dell'arte* scene re-imagined by Fuseli or Goya; a black cross-dresser in hair curlers pencils himself in, so to speak, with thin gull-wing eyebrows. In Arbus's work, the immediacy and buzz of the instantaneous that comes so naturally to photography feels remote, hermetic, vitrined. Her subjects—unlike, say, Dorothea Lange's or Paul Strand's—float in the medium, most of them loners or marginalized, shut off from public view or meeting it with a mask. They're not trapped in history, they're aloof from it, installations in the galleries of their surroundings. "A photograph," she said, "is a secret about a secret." The secrecies cauled around her work wrap cousin-secrecies around the careers of other photographers.

One of them is Roger Ballen. His picture of a white man standing, slightly stooped, in a room that looks too small to contain him and his seated, sullen black maid, comes straight out of Arbus's giant picture, though it has political implications Arbus's pictures never do. Ballen, an American who has lived in South Africa for over twenty years, photographs nearly destitute white and black populations in places most of us have never heard of: Ottoshoop, Carnarvon, Nieu-Bethseda, De Aar. His cast of characters consists mostly of forlorn oddities, but the material is so embedded in recent South African history—the pictures are rough, unseemly, dogged—that his moral regard for his world is

more blasted, flyaway, and complicated than that of Arbus or any of his contemporaries.

Born in New York City in 1950 to a mother who was a picture editor, Ballen grew up around the photographic arts. When he graduated college, after a few years spent wandering and learning how to take pictures, he settled in Johannesburg in 1982 to work as a mineral economist. The job took him to *dorps*, the Afrikaans term for poor villages, where he began to make straight-up images of landscapes, interiors, architecture, and the occasional portrait. The images weren't much more than anthropological documents. A 1986 photograph of a man shaving offers no intimacies. It has the sterling disinterestedness and stillness of a Walker Evans image, along with the kind of signage familiar in Evans's work. By the early 1990s, Ballen was working almost exclusively in portraiture, but he was shooting with his face pressed a lot closer to his material. He used a flash, which drained the softened shadowing of available light and made everything starker and more serrated around the edges. The pictures have an alarmed, confrontational directness. "It's a way of making a person into someone who can't get away from the camera," Ballen has said, "and thus can't get away from his own history—from his own shadow in a sense."

He spent considerable time with the disheveled, uncomely folks he photographed and became a familiar presence in their mean dwellings. In some of the pictures, every surface looks glazed with a thin film of grime. Apartheid, supposed to guarantee economic security for white Afrikaners, imposed on many of them degradation and despair. The white government predictably denounced Ballen's pictures, feeling that he presented as freaks a population it wished to present as well-bred, prosperous, and contented. The best known of these pictures, the sort of image that takes hold of the imagination and won't let go, is a 1993

double portrait of twins from Western Transvaal. These aren't pretty boys. Their thick, nearly identical frown lines roll like rhino skin, the noses are blunt and stony, the ears stick so straight out from their heads (like little satellite dishes) that they parallel the picture plane, and from the lips of each dangles a thread of drool. Ballen wants to present the twins' inbred ugliness as an expression of animal nature in intelligent beings. He's not exploiting them, he's using them as a motif to restore to us the realities of our nature. One of the people Ballen befriended, a factory worker named Attie, turns up in several images. In one, Attie holds up for our view a portrait of his grandfather, his pose clenched, defiant, "serious," quite unlike the dotty hilarity he shows in *Cat Catcher*: in one hand he holds a beefy cat by the scruff, in the other a wire cage around his head.

Even the grimmest interiors have wall decorations—corny home samplers, fading lithographs of rosy children, graffiti (names, messages, phone numbers, drawings of mice, stars, cars, houses), or wires, wires everywhere, like occult glyphs scribbled on bare white walls. Sometimes they're the sole motif. While Ballen's subjects are scruffily down and out, he photographs them not as grotesques but as inhabitants of a certain place. "My subject," he says, "is not only the people, but the entire construct as presented in the frame." In recent years, that construct has become even more constructed. Ballen now stages set-ups. He invites his subjects to barren locales—abandoned official buildings usually—and introduces animals and oddities. His models participate in the process, trying out poses or introducing props. In one image, a black man wrapped in a blanket cowers under a bulging hive of barbed wire mysteriously suspended above his head; in another, a fat white man sits on a bed holding, embracing really, a wild pig. Many pictures mix whites and blacks. One of Ballen's acquain-

tances, a poor farm laborer named John (dressed in sooty white shirt and trench coat) is so stunned by the moment of exposure that we can see the whites of his eyes. Standing on either side are his black roommates, wrapped in blankets. All seem terminally depressed, especially John, whose look is the result of shell shock from fighting in Angola. He eventually starved himself to death. Another of Ballen's regulars, "Tommy," appears with another figure in an abandoned school inhabited by squatters; he's stretched out because, we're told, he got depressed and had to lie down.

There's no depth of field in Ballen's work. In the newer pictures especially, each exposure is sheet lightning that fastens the subject to an unforgiving flatness. Flat as they seem, the pictures beg us to return and look again. They keep yielding complex feeling tones with a remarkable simplicity of means. They're also insisting we bear witness. A lot of dreary art these days wants to do our thinking (and draw conclusions) for us. Ballen's work is dangerously open-ended and ambiguous, but it's the sort of danger good art can't get enough of.

Montparnasse

Many years ago Al Pacino decided he wanted to star in a biopic of Amedeo Modigliani. A script was commissioned, rewrites ordered, directors and supporting cast considered. The project languished so long in the purgatory of development that Mr. Pacino, then in his late thirties, finally grew too old to play the role of a man who died at thirty-five. One understands the attraction. A feverishly handsome youth from Livorno, a port town near Pisa, shows an early gift for drawing, studies art in his hometown then in Florence and Venice where he's exposed to his grand predecessors, then goes to Paris to make his career, settling in the louche artists' quarter of Montparnasse (surrounded by film-worthy characters), where he quickly wins the esteem of his contemporaries Brancusi and Picasso, while showing his work, mostly portraits and nudes, at noteworthy galleries. By 1911 he has crafted a trademark style: oval head, slightly a-tilt, on a columnar neck; pasty aquamarine eyes; pinched or languid features; blushed flesh tones. He dresses (according to Picasso) better than anyone. He acquires women and a consuming taste for alcohol and hashish. He has three grand tempestuous loves, children by two of them. Jeanne Hébuterne, his companion when he dies of tubercular meningitis in 1920, kills herself two days later, nine months pregnant with what would have been their second child. Who needs to write a film "treatment" of such facts?

Although his style has become iconic, companionable and familiar like Chagall's—his paintings, like Chagall's, are instantly recognized even by casual museum-goers who keep in their cupboards mugs or coasters imprinted with those necky women— Modigliani had so little time to mature that he hasn't been studied

with the same scrutiny as, for instance, his friend Chaïm Soutine, not to speak of Picasso and Brancusi. Some of his salient work now looks a little too readily comforting, even decorative, not powered by the formal restlessness and crashing experimentation with space, volume, and line carried out by his contemporaries. The exhibition *Modigliani & the Artists of Montparnasse*, which I saw at the Los Angeles County Museum of Art, re-assessed the work and seated Modigliani's career in the matrix of his neighborhood.

What a neighborhood. By 1913, Montparnasse—one writer called it a "little international republic"—had a directory of artists who established the gene pool of early modern art. The Italian Giorgio de Chirico, the Spaniard Juan Gris, the Mexican Diego Rivera, the Pole (later émigré to America) Elie Nadelman, the Bulgarian Jules Pascin, the Dutchman Piet Mondrian and the Russians Jacques Lipchitz, Chagall, and Sonia Delaunay. The United Nations list goes on. Except for their practice of portraiture, not much connects the art of the Lithuanian Soutine, master of badly wrinkled nerves and rotting meat, to the carved, anointed clarity of Modigliani's pictures. Early in his career, in fact, Modigliani devoted much of his energy to sculpture. Roughly carved, squared off, totemic, his stone heads give evidence of conversations with his neighbor and friend Brancusi, who had worked briefly and unhappily for Rodin and whose double block of embracing stone, *The Kiss,* is near cousin to Modigliani's heads. Lipchitz, another sculptor friend, later reported what Modigliani was thinking: "He was very taken with the notion that sculpture had become very sick with Rodin and his influence. There was too much modeling in clay, 'too much mud.' The only way to save sculpture was to start carving again, direct carving in stone."

When I entered the LACMA gallery reserved for Modigliani's sculptures, six heads ranked side-by-side stared straight at me. I've

never felt so *watched* by art objects. They're like an impossible-to-please audience waiting for a performance, ours, to begin. The pouting and solemn vertical blocks look formed by a vise, the figures' plump lips and stolid physicality recalling the Cambodian sculpture and African masks Modigliani so admired. The confrontational sculptures shape how we re-see the paintings, which begin to look more hewn, their textures pumiced, physical features (brow and eye sockets especially) defined like cut rock. We begin to see less dash and quickness, more mineral fastness, pictures that are dense and dry rather than moist and fluid.

His colleagues were impressed by the psychological acuity of Modigliani's portraits. His men, with their pursed faces and sunken cheeks, seem preoccupied, skeptical, inquisitive. His women, who tend to shy or recede from our gaze, are the wonderers, always a little aloof but still capable of surprise. (I hate the word "gaze" because it sounds so hierophantic, but since that's what his women do, I suppose that's what we must do back.) There's not much revealed in the blotted or unreadably beady eyes of the figures, so the head's positioning and the rhythm of the body's descent to the hands calibrate the degree of melancholy or remoteness or curiosity. He angled the head on the cylinder of the neck to set the temperature of accessibility of female presence. His *Servant Girl,* her hands meekly clasped, is a portrait of servility and humbleness. The girl whose head and neck are neatly aligned in *Girl with Blue Eyes* looks almost happy, though Modigliani keeps the picture interestingly off balance by hanging two asymmetrical hanks of hair either side of her face. A woman wearing a black velvet choker, which breaks the continuity of the neck, looks terribly *wrong,* but the disruption is of course exactly the effect Modigliani wanted. The nudes are rather dry, but you can follow the serial touch as it constructs the figure, whether

with short, jabbing strokes or loose long ribbons. You almost feel the hand modeling the flesh.

The exhibition constellated around its Modigliani core the very good work of his Montparnasse neighbors—a dreamy, typically spooky Chagall; de Chirico's famous *The Anguish of Departure*, its shadows cast for eternity; two paintings by Léger, whose tubular solidities recall Modigliani's form language; and much more. The choicest thing on view (among many sweet choices) was Soutine's tall and hectic red *Page Boy at Maxims*, an image of physical existence as an anxious action. It's classic Soutine, the body rendered as misbegotten, runny, baggy matter. In his angular, crinkly, buttoned-up Call-for-Phillip-Morris outfit, the boy is embodiment in chaos, a nervous system shaken dangerously loose. But the biggest jolt came from a small head by Henri Gaudier-Brzeska. Gaudier was, in Ezra Pound's opinion, the most gifted sculptor of his generation. He, too, died young, in the trenches at Neuville-Saint-Vaast. In a letter to Pound from the front he described how, since the shape of it didn't please him, he carved his rifle stock into a more satisfying form. His 1912 bronze head titled *The Idiot,* with its bat's ears, twisted lips, and deep eye sockets, looks ravaged and lost. Its impacted psychic energy is stunningly unpleasant, not easy to study for any length of time, but nearly impossible to walk away from.

Throw It Away

Several years ago archeologists discovered in France a cave covered with Paleolithic drawings dating back twenty-eight thousand years. In addition to the usual aurochs, there were drawings of the human figure naked. The origin of making marks may be not just embedded in animist rituals, it may be formal, too, the impulse to give an imagined, unmirrored form to embodiment. There's a straight line between what those artists were doing in that scanty light and what the dozens of artists of all generations do at the two-week, work-till-you-drop drawing marathons at the New York Studio School in the West Village. See clearly and represent—mediated by touch—what you see. The body is a radical form: it makes images of what it is, or at least what we think it looks like. The tired phrase, "return to figuration," that gets tossed about whenever the curatorial commissariat decides to designate a new newness, should be banned from public conversations about the life of art.

I missed the big 1994 Lucian Freud retrospective in New York. Except for a few canvases here and there, I've never had the chance to survey the career until a recent exhibition at the Los Angeles Museum of Contemporary Art. It reminded me of the huge Bonnard retrospective at the Modern several years ago. Not because these two artists have much in common. Bonnard is a painter of the south: pliant, drippy, florid, slyly casual, outdoorsy even when indoors. Freud is all north: cool, dour, controlling, and studio-bound, his palette a baritone register of slates, mossy greens, and boiled blues. The last room of the Bonnard contained late self-portraits that were scrutinizing, blunt, witty (he dresses up for a few), and beautiful in that raw way only a master can achieve with age.

Freud's self-portraits have a similar potency, a magisterial merci-
lessness wrinkled with bleak British humor. Canonizations come
and go. Critical tidal actions elevate now Freud, now Francis Ba-
con, though never quite Frank Auerbach, whom Freud himself
admires more than any living painter. Some writers rank Freud
with Bonnard, even though history teaches us that declarations of
greatness can fast turn to pixie dust.

In any case, the L.A. exhibition fanned out Freud's long career
from drawings of animals and literary personalities he did as a very
young man, to a self-portrait finished in 2002 for this show. His
working life has been a frank, tight-wired confrontation with the
body's presence in space. In the picture that first brought him seri-
ous attention, the 1951 *Interior in Paddington,* he's testing a theatrical,
contrived oddness that stays with him throughout, though this pic-
ture's smooth old-master-ish finish would later erode into broken,
irregular surfaces. The outside-the-studio world in this picture
visible through a window seems completely other, not a context
or continuation of the airless parlor interior where the young man,
a Bohemian intellectual prince stands next to a droopy like-sized
plant. The high finish, peek-hole landscape, and characterizing de-
tails—mussed hair, wire-rim glasses, rumpled Macintosh and ciga-
rette—recall Renaissance portraiture, where an astrolabe, sword,
or book bespoke the subject's station. An earlier picture, *Girl with
Roses,* went even farther. It's vaguely allegorical. The birthmark on
the girl's thumb signals imperfection or fatefulness, the thorny rose
clasped to her bosom a troubled compact with life and love, the rose
in her lap something (sexual innocence maybe) lost or fallen. She
has the broad eyes, mashed brow, and drowsy unforthcoming stare
common to Freud's early portraits, her face shut in tense alarm, like
a fairy-tale girl fearful of abandonment, and her homely head glows
with gold high-lighting, a modernist halo. In both pictures the flesh

is blue-tinted, pouchy, and inelastic.

In his youth Freud worked hard to figure out how to construct a picture with ambitious pictorial elements. His 1942 *The Village Boys* is awkwardly composed but contains multiple figures, studio paintings, and rags, like pictures he would make in his old age. By the early 1960s the compositions begin to open up, passages become less stable, the handling rougher, more excitable, and he has learned how to construct a complex scene, to put a hand *here*, teeth *there*, tabletop or potted plant *behind*, and he pushes the paint around, playing with new skin tints, ruddy carmines and bruised blue-grays. Anatomies become more sculptural, with separable elements. He's carrying more paint on the brush, using broader strokes, making the surface a more unpredictable site where wristy mechanics create, spontaneously it seems, all sorts of effects, from a dazzling fluidity to stubborn knobbiness. Of these and other portraits he said: "I don't want to be sensational. I want the pictures to reveal some of the results of my concentration." Freud is obsessed with the body as assemblage. By the 1970s, his way of posing his models in unnatural or aggressively exposed contortions becomes not just a set-up but part of the action of the picture. The anatomical wholeness of earlier pictures becomes bone-and-sinew joinery. He uses Cremnitz white, a heavy lead pigment that creates lumpy effects. The figures sometimes look like they've been posed with a T-square—arms akimbo, wrists and elbows at cockeyed angles, hands wired into position. The loose, runny handling can make skin look flayed, the muscles and veins raked through. As Freud developed, the flesh became more and more a garment worn by an exhausted spirit. His figures seem to bear too much weight of the past, and the burden bores them. They look like ideal sitters because it would be more difficult for them to move than to sit still for long periods. It's the

skin and its vestiges of conscience that distinguish humans from the plants that Freud sometimes paints into their scenes. When a discrete flower picture like *Cyclamen* turns up amongst the portraits, it pops with a carnality and sexuality missing or suppressed in the human figures.

In recent years, Freud's surfaces have gotten even rougher, pricklier, and more abraded. The skin, nearly ashen, looks like fatigued, used-up matter, hopeless but grimly enduring. Though his style has remained fairly loose whenever he's made portraits of his aging mother, with whom he had a distant, difficult relationship, the psychological mood is clenched, and the paintings throw off a cold fire. Although hardly any of Freud's subjects look directly at him or at each other, it's she who most decidedly and frigidly turns from her son's watchfulness. These psychologically complicated pictures squirm with ambiguous feeling, and Freud is certainly, as he says, "making the painting do what you want it to do." I don't entirely understand these pictures yet, but there's something psychically loaded and animal at stake. The late portraits, especially figure groups, have a cultivated stiffness and gracelessness that create an eerie, rictus-stricken beauty. In some canvases he includes studio rags that look like seedy bunting and stand in for the velvet backdrops of Renaissance princes and Venus's bed sheets. The stiffness melts away in his pictures of the campy, two-hundred-thirty-pound performance artist Leigh Bowery. In one now famous rear view, Bowery's corpulence pumps with a life of its own and floods Freud's usual controls—the expansive flesh buckles and undulates like heavy fluid. Freud paints fatness as if it doesn't belong to a consciousness, and yet the picture moves us because it's a complete account of physical fact. The portraits of Bowery, and of another enormous person named "Big Sue," remind me of something I once heard on a streetcar: "The meat will inherit the earth."

Freud insists that such work is purely autobiographical: "It is about myself and my surroundings." The portraits certainly don't give up much of their subjects' inner lives, except for an occasional work like *Bruce Bernard* (1992), one of Freud's best pictures, where the pained, contemplative figure, so deeply inside himself, is an occasion for painterly inquiry into self, work, and experience. And his meditative scrutiny is acute in the 1981 *Reflection (Self-Portrait)*, where a close-cropped mirror reflection of the artist's face is a mask of hawkish, melancholy self-awareness. The most intense picture in the exhibition is a crusty full-figure portrait of the artist standing naked before his mirror and canvas, wearing only lace-less painting boots. The fateful humor lies in the pose: one hand wields a palette knife like a stubby Roman sword, the other a palette-shield. The confrontation and stupendous solitude—brittle space has contracted around him—give the figure a gaunt, aging-hero dignity, though the picture wears no self-heroizing aura.

Since Freud's most moving pictures are the self-portraits, it's fitting that the show ends with an extraordinary thing he finished in 2002. Like the aged Bonnard, the eighty-year-old Freud exercises the conventions of self-portraiture to meditate on the nature of incarnated consciousness. The head, face, and eyes have been lived into. Contingency has worked them over, but the treatment is freer than ever, and more driven by raw feeling. One sees in much of Freud's work the influence of Northern painters like Breughel, Vermeer, and Jan Steen. The self-portraits display the most important lesson he got from them. I'll illustrate with an anecdote. In the Metropolitan, an aging painter friend and I stand before a typically over-the-top, carousing scene by Jan Steen next to a exquisitely serene household interior by de Hooch. "De Hooch is really good, but next to *that*," my friend says, "he looks academic and tight, because Steen is fearless, he just throws things away."

America! America!

Some distinguished early American painters had inauspicious beginnings, earning their bread as sign painters, dance instructors, coach decorators, tinkers and odd-jobbers. The colonialist John Smilbert, Scottish-born and professionally trained, started out as a house painter. In a pinch Gilbert Stuart, by the 1780s the premier portraitist of his time, worked as an organ grinder. Charles Wilson Peale, Philadelphia's most sought after portrait painter and sire of a large brood (from three marriages) all named after artists—Raphaelle, Rubens, Rembrandt, two Titians, and let us not overlook Sophonisba Anguisciola—ran a saddlery, a clock-repair business, and founded the first natural history museum in America. As for *really* unlikely beginnings, the Ashcan painter George Bellows, a gifted ball-player, was wooed by the Cincinnati Reds.

American Beauty, an exhibition that featured works from the Detroit Institute of Arts, was a fever chart of the spiking ambitions of our art from 1770 to 1920. It showed a culture discovering its own freshness, exploring indigenous materials while negotiating the squalling latitudes of 18th century English and 19th century French painting. The Peale tribe produced hundreds of pictures of very varied quality. One of the finest, a self-portrait by Rembrandt Peale presumed to have been a gift to his wife, is a primal jolt of Romantic subjectivity. You feel the buzzing alertness of his attention: cheeks flushed, hair swept dashingly back, eyes ardent behind thick spectacles. Rembrandt also made a portrait of George Washington much different from Gilbert Stuart's familiar representation of a dignified, stoical chief-of-state. Peale's Washington is a fatigued leader, one eye squinty with headache and depression, his skull and skin visibly pressured by nation-building

responsibility. Washington's dignity is palpable, but it also looks lived-in and slightly beaten-up.

Our artists kept pace with the new facts of a young United States. While still life painters like John Francis and Raphaelle Peale adapted the manners of Dutch baroque to New World motifs, others pursued a thrilling, hard-edged, fool-the-eye realism that possessed true-blue homeliness and speed. On the table top of William Harnett's *American Exchange* sits an ink pot, a book, a tattered banknote lolling off the table edge, another bill rolled up next to a folded letter (its envelope weighted down by the ink pot), and a gold coin. It's a picture about currency, commerce, and contractual agreements, but even these tokens of stalwart business look squirmy. If *American Exchange* bears more than a hint of business anxiety, John Frederick Peto's *After Night's Study* represents pure intellectual melancholy, the habit of reading books in order to read oneself. Peto's picture could be a cover image for Emerson's writings, and Emerson's notions about the individual soul dissolving into Nature's undifferentiated Oversoul haunt the work of two "pure American products," as William Carlos Williams might have called them: Albert Pinkham Ryder and George Blakelock. Ryder, a famously reclusive New Yorker obsessed with a sea he seldom saw, worked his canvases so hard, painting layer on layer of the same scene with dense unstable pigments, that his pictures began to crack and fade almost immediately. The incised vein-work and spooky tints now seem essential to their form. In *The Tempest* you feel the inner life, *visionary* life, being disclosed in small-scale effusions. It has Ryder's signature blowsy tones and swells with yearning sublimity: Prospero embraces a wilting Miranda as he surrenders his magical powers to the wild sea air and Caliban's dim muddy shape elbows up from the waters.

Ryder's pictures teem with the sweeping energies of sea and

sky. Blakelock's landscapes possess a preternatural stillness registered as flickering concentrates of color. His touch made nature's subtle deposits of matter into immensities. Whenever I look at a prime Blakelock landscape, I feel I'm just this side of a spiritual abyss, a deep but not necessarily unhappy drop. Blakelock lived and worked, I think, *right there* on the interface between material reality and a spirit world that sizzles through it. His *Landscape* (dated 1880–1890 but like most of his pictures re-worked endlessly) renders the unseen visible and tactile. A depressed and divided soul, Blakelock spent years in an asylum, delivered finally—it's one of the stranger stories in American art—by a tireless benefactress and protector who turned out to be a high-end con-artist.

Bellows is best known to most of us for his ferocious pictures of boxers, especially *A Stag at Sharkey's,* where two bloodied underground fighters—prizefighting in New York was still illegal—pitch into each other with murderous force. But Bellows made all sorts of pictures. He and his fellow Ashcan painters—George Luks, John Sloan, Robert Henri—shoved Impressionism and Post-Impressionism toward a bravura American realism, shadowy, rakish, and brave. Henri said artists "must feel within themselves the need of expressing the virile ideas of their country and undoubtedly there is a great deal to be said in America that has never been said before in any other land." Along with club fighting, Bellows was attracted to seedy urban scenes like boys ("river rats") swimming in the East River, and yet his rather atypical *A Day in June* from 1913 is a sheer pleasure-giver. It's a standardized impressionistic view of urban outdoor leisure: Central Park, parasols, balloons, girls in creamy white smocks, women in ankle-length crinolines, their hats as green as the hilly swards around them, men smoking cigarettes, couples playing ball, girls dancing and skipping. But the entire scene has a distinctly Ameri-

can, gutsy-sweet energy, played out in Bellows's whippy, loaded brushstrokes.

The Ashcan guys were quite a bunch. The scrappy Luks, who once said "Guts! Guts! Life! Life! That's my technique," died in a bar fight. Sloan, whose populist sensibility and love of working people's lives hang loose and lively in *McSorley's Bar*, where workers turn drinking and conversing into hardy sport, had frequent rows with his alcoholic wife, Dolly. *Wake of the Ferry, #1* records one of her post-spat leave-takings from New York to Philadelphia. We see her from behind, arm akimbo, dress soggy with rain and spindrift, a desolated insulted creature looking out on waters tossed by tugs and garbage scows. It would make the perfect illustration for an American anthology of poems about the woe that is in marriage.

Casta Painting

It had become so difficult in 18th century Mexico to track racial mixes that the colonial archbishop remarked: "In the Old Spain only a single caste of men is recognized, in the New many and different." The three main groups of New Spain—*criollos* (full-blood Spanish born in the New World), Indians, and Africans—interbred to produce a socially wobbly variety. Marriage between mixed-race offspring enlarged the permutations and blurred the picture. The more diverse the blood-compounds, the more the Viceregal government worried about the stability of what had become a thriving commercial center. Without some racial index or demographic taxonomy, governmental control was at risk. Intermarriage between Indians and Africans, for example, was worrisome because such a unified entity could threaten the political order. One expression of these anxieties (and an instrument of racial categorizing) was a type of painting I knew nothing about until I saw *Casta Painting: Images of Race in Eighteenth Century Mexico*.

Criollos made up the oligarchy and high society. Indians were considered cheap unskilled laborers and *campesinos*. Africans were slaves and therefore occupied the lowest station in society and had no rights, but because of their work discipline they were preferred to (and appointed overseers of) Indians. Casta painting systematized racial patterns and illustrated how social power and prestige were keyed to bloodlines, but the colony was developing so quickly that caste characteristics and prerogatives slithered and slid in uncontrollable ways. It was hard for Africans to achieve social status, for example, and yet one of the most distinguished casta painters, José de Ibarra, was mulatto, and some canny Africans took advantage of the colony's imperfectly policed social mobility

to achieve prominence in the professions and polite society. Certain combinations reassured criollos of their purity: because converted Indians were considered "New Christians," three generations of Spaniard-Indian unions would produce, hocus-pocus, a full-blood Spaniard!

Most casta art was produced in sets of sixteen paintings on canvas or copper plates; a few single canvases incorporate sixteen scenes, like little windows on the racial tidepool. Each picture records a formula, literally written into the scene like a legend: "Spaniard and Indian Produce a Mestizo," "Spaniard and Black Produce a Mulatto [from the hybrid nature of mules]," "Spaniard and Mestiza Produce a Castizo [from *casto*, pure, i.e., a light-skinned mestizo]," "Castizo and Spaniard Produce [hocus-pocus!] a Spaniard." Other matings might produce a *morisco* [a light-skinned mulatto, i.e., Moorish], and African-Indian unions produced animal-like progeny—"From Mestizo and Indian, Coyote," "From Black and Indian, Wolf." Early in the century, rather stiff stylized tableaux illustrated social and racial dynamics within family units. As casta art developed, it spent more energy on scenes from daily colonial life and, borrowing from 17th century Dutch genre painting, featured domestic objects, implements, food and drink, architecture, décor, customs, and costumes.

Some artists took a special interest in indigenous culture. Pictures of "savages" became a genre of their own, though this interest came dressed in conventional European perceptions. Manuel Arellano's portrait of a Chichimeco tribesman shows a ripped, sun-bronzed, half-nude warrior defiantly waving his bow and arrow—the kind of New World hunk colonizers wrote home about. Arellano's 1711 *Rendition of a Chichimeca* is really a classic Madonna and Child depicted in a "savage" matrix. The Mother looks meekly down at a colorful bird (in a Venetian painting it

would be a dog or monkey), while a squirmy, worried Christ child holds a rattle (instead of a pomegranate or globe).

Our modern eye sees some types not as they were intended. In Juan Rodríguez Juárez's *Spaniard and Indian Produce a Mestizo*, the Spaniard seems a caricature of 18th century affectation and artifice. He literally looks down his long, straight nose (a planar extension of his impossibly high forehead) at his child, his lightly rouged face drained to the fleecy white of his massive peruke. Yet his touch upon the child's pudgy head is genuinely affectionate, if proprietary. His brown paramour, gorgeous and self-contained, has a marvelous dark clarity, face discretely tucked beneath her headpiece, and her gesture toward the child says: "We made this." Most casta sets were made between 1760 and 1790, when Spain's Bourbon monarchy was trying to shore up its stewardship by establishing reforms intended to control social relations among people whose bloodlines had been compromised far beyond Spanish origins. Along with the reformist mentality came a more explicit moralizing in casta art. Indians were especially chastised for their use of *pulque*, that heady concoction fermented from the maguey plant, but colonials were also checked in their use of wet nurses (which confounded racial admixtures) and gambling, especially cockfighting and cards. One unnerving picture depicts a soused husband, badly in need of reform, being dragged home by wife and child.

One doesn't expect much painterly sophistication from this kind of prescription art, yet some of the work shows a fine touch. Important painters such as Miguel Cabrera, José de Páez, Francisco Clapera (author of the wretched-husband picture), and the always prominent "Unknown Artist," had a certain academic finesse. They applied techniques of Dutch genre painting and portraiture to 18th century Mexican materials. Their imitative facility

is striking, and the details sometimes transcend the facility: the sumptuous, swirling dollop of ice cream in a picture by Ramón Torres is as exquisitely observed as any detail in Chardin. At the same time, the pictures occasionally offer the charming asymmetries and exaggerations of Primitive or Outsider art—awkward foreshortening, a head too big for its torso or cocked at an angle nature never intended, or a child rendered as a miniaturized adult. The sets aren't too concerned with the depth-of-character effects we expect from fine portraiture. The figures' eyes aren't windows to the soul or reflectors of the world. They look vacantly into the space of the picture or fix blandly on some object, the equivalent of our commercial ID photographs. In casta art it wasn't the gaze that characterized intelligence or consciousness, it was the configuration of race, social position, and cultural practice.

Beginning in the 1860s, artists made a conscious effort to display the dazzlements of Mexico's booming economy. Some pictures are like produce stands boasting New Spain's fecundity, its endless supplies of *xicamas, ciruelas,* and *zapotes blancos.* The hottest commodity, so to speak, was tobacco, and the home production of cigars and cigarettes, which cut across caste lines, was a favorite subject, as were markets and households piled high with tortillas, meats, textiles, shoes, and haberdashery. Artists also loved depicting women's costume and appearance, especially the elaborately woven *huipil* (the kind of jacket-blouse later favored by Frida Kahlo and featured in her pictures), the *manga,* a long skirt draped from the neck, and the *chiqueador,* a velvet dime glued to the temple to simulate a beauty mark and, they said, to cure headache.

Toward century's end, casta painting's moralizing gets ponderous. A Spanish-Indian union is industrious and harmonious, but a Spanish-African mix produces violent discord—a black woman whacking her man with a wooden spoon or stabbing

him in the head. In casta coding, criollos are the foremost bearers of piety and Enlightenment reason, but extensive uncontrolled interbreeding induces avarice, murderousness, sloth, thievery, and dim-wittedness. Casta painting, in graduate-school-speak, is about the "construction of identity." The phrase, shopworn and academic, really does fits the work, which demonstrates how the desire to represent human society sometimes can't be distinguished from the desire to exercise power and control beyond the painted image.

Spiritual Diaries

In the mid 19th century, northeastern America was a rank stew of bloodshed and spiritual yearning. Civil War slaughters and draft riots roiled alongside Emerson's Transcendentalism and the religious revivalism of the Second Great Awakening. A feverish subjectivity drove literature, theology, cultural philosophy, and the fine arts. Emerson published his foundational essay, "The Transcendentalist," in 1843. In 1855, Walt Whitman, who later nursed wounded Union soldiers, published his first edition of *Leaves of Grass*. The biggest intellectual influential of the time was someone nobody reads now, Emmanuel Swedenborg. Emerson profiled him in his 1849 *Representative Men,* Whitman read him and absorbed his ideas into *Leaves of Grass*, and William James's father was a tireless propagator of his teachings. Born in Sweden in 1688, Swedenborg became a respected scientist and engineer but at age fifty-seven began to experience terrifying crises of selfhood he called "vastations," accompanied by visions in which God told him to dish science and devote his life to explaining "the spiritual meaning of Scripture." He spent his remaining twenty-seven years writing about spiritual experiences and elaborating his metaphysics.

His influence was even felt by several 19th century American landscape painters who believed painting could reveal divine presence, or at least spiritual potency, in the natural order. ("Every natural fact," Emerson wrote in "Nature," "is symbol of some spiritual fact.") The most prominent painter to adopt Swedenborg's ideas was George Inness. Born in 1825 and more or less self-taught, as a young artist Inness painted in the manner of the then dominant Hudson River School, constructing complex coun-

try scenes by more or less assembling compositional segments. In the early 1850s he lived in France and was changed by his exposure to the *plein air* landscapes of Corot, Théodore Rousseau, and Daubigny. He began to shake loose from the tight, elaborately detailed Hudson River style and make brushwork more spontaneously responsive to spiritual sensation. He followed Rousseau's mandate that artists should represent natural objects not for their factual presence but "in order to embody, under a natural appearance, the echoes they have placed in our souls." Inness fancied himself an amateur theologian and took over Swedenborg's idea of "spiritual influx," the process of God's love flowing from the spiritual world (the "world of causes") into nature (the "world of effects"). In painterly practice this meant that art's purpose was, Inness said, "not to imitate a fixed material condition, but to represent a living motion." Landscape represented not the details of material phenomena but nature's inner life. The aim of art was "to awaken an emotion [which] may be one of love, of pity, of veneration, of hate, of pleasure, or of pain."

Inness's early work is a little mechanical. We see him learning to build a scene, to control, rather than release, atmosphere. Spiritual value, so subtly inflected in the late work, is simply painted in, like an additive. The 1866 *Christmas Eve (Winter Moonlight)* blends German Romanticism and its exaltation of the individual absorbed in nature's sublime with a classic Robert Frost-ish country moodiness. A full moon pierces a jagged oval of clouds and cuts a wide swathe on the ground, where a figure in silhouette, throwing a long gangly shadow, practically crumbles into the scene, though it isn't completely overtaken by its sublime surround. Human presence holds its own—solitary, mildly heroic, a little forlorn.

Two pictures, early and late, dramatize Inness's progress to-

ward a wilder, more subjective pursuit of spiritual realities. The 1877 *Landscape with Cattle* is neatly segmented: the foreground all shaded meadow, the middle range sunlit foliage and grazing cows, the upper third cloudy sky and treetops. It's satisfyingly unified and balanced but also genteel and resolute. *Early Moonrise, Tarpon Springs*, on the other hand, is a painterly enactment of Emily Dickinson's "route of evanescence." Its elements shiver with instability. Lanky trees, stream, footbridge, distant farmhouse, and a wobbly pinkish sun on the horizon are in such a tremulous state that material reality seems a deity's hazy dreamscape. The dense tonalities of the earlier pictures are combed out to a finely whisked consistency, with a fizzing internal turbulence. The countrywoman carrying firewood down a path is merely a smudgy mark. She looks like a rural haunter, a wraith.

In his explosive late work Inness pressures himself and his materials until they yield a volatile purity of sensation. He repainted canvases endlessly and the erosions became part of the textures. He was already practicing, in the interest of spiritual influx, modernism's cult of revision-as-finish. His solitary figures in woods, fields, and farmland have a distinctly American character: melancholy, inward, yearning for vague visitations of spirit from some vague place. The light in much of the late work looks scoured, scraped to a crispy autumn-harvest essence. In the 1888 *Moonrise,* moonlight and its wobbly source become lumpy deposits modeled into the scene. The moon looks uncertain, changeful, lunatic. In *Indian Summer,* which Inness painted in 1894 just before he died, liquid planes of color and the flaky ambers and rouges of late autumn light interfuse in a way that makes it hard to separate the ethereal from the concrete. This is partly a function of place. West coast light crushes what it falls upon. The eastern light of Inness's Pennsylvania and Jersey landscapes emanates and oozes.

In *The Home of the Heron,* land and trees emerge from a crushed-embers halation, and the substance of the heron is all shadow. You don't have to know the northeast to appreciate Inness's work, but it helps.

His *Indian Summer* is not just particular to a region, it expresses a certain American mood. In early to mid- autumn, after the first toothy frost and maybe hazy snow, there's that held-breath period when the air goes balmy and soft, though fall is in full flare, leaves turning color and falling, wind winding up. It's a season of mysterious, privileged grace when different states or conditions co-exist in tensed, contented balance. Inness's picture is the most seductive visualization I know of that condition, that weather of world and spirit. In a field partly covered with green-going-to-gray grass and smudgy orange highlights, two trees are turning, one yellowish, the other a crackling red. But the "things" of this world, rendered as succinct curls and daubs of pigment, are barely referential. There are two figures: a woman in white blouse (the only whiteness in the picture) is a brief reminder of May flowers; the man lying beside her, dressed in seasonal browns and oranges, looks already loamed into the ground. It's a dreamy state where hard, bright material reality disintegrates while we watch. Fact and illusion spill back and forth into one another. Inness's early pictures still hold historical interest, but the later pictures, like other expressions of American Romanticism, restore us momentously to contingency and history while dramatizing what it just might be like to transcend them.

Reality Under Construction

In the last scene of Steve Kloves' *The Fabulous Baker Boys* Michelle Pfeiffer stands atop a grand piano on New Year's Eve singing "Ten Cents a Dance." The camera pans 360 degrees, wrapping her in its adoration, while light fizzes around her like a vaporous aura. She looks exhausted, and for good reason: the shot was so complicated (lights had to be covered while the camera's crane rotated) that it took eight hours to set up and was finally finished at 3 A.M. A shot of that shot appears in a book of his own photographs that Jeff Bridges has made. The core of Bridges's image is Susie Diamond (Pfeiffer's character), sagging a little from life fatigue, but around that invented film reality is the mother reality of set, crew, props, extras, lights, and cameras. Bridges has taken thousands of pictures on location—he's made over fifty films—and it would be easy to say that as a photographer he makes a very good actor, except that he has in fact a scrutinizing eye and formal instincts savvy enough to throw skeptical viewers off balance.

Every film set could post a sign saying REALITY UNDER CONSTRUCTION. It's Bridges's subject: the staged completeness of the film image and that image in its capacious, messier ambience. His photographs show us the image breaking down into its preliminary or constructive parts. Each picture is a moment's essay on artifice. Sometimes it sneaks up. In one taken during the fantasy production number in *The Big Lebowski*, Julianne Moore strikes her Valkyrie-Bowling Goddess pose (her enormous breast cups are bowling-ball hemispheres) while pushed to the margins of the frame are her cockamamie maidens wearing gigantic starburst bowling pin headdresses. The girls are so nuttily glamorous and Moore so goofy-sexy that it takes several moments for our eye

to be drawn finally to the far left corner where a bluejean-clad leg bulks into the frame, a spiral bound notebook (probably to mark continuity) at its foot.

Bridges's pictures move us into and out of the hermetically sealed actuality of the film frame. We see actors constructing or breaking from their characters. Being "made up" takes on a sharper meaning. For an interior car shot in *Arlington Road*, the wide-angle lens Bridges favors holds together a broad band of visual information. The celestial Hope Davis (who plays Bridges' girlfriend) and Joan Cusack (wife of a demonic Tim Robbins) are already in character, primed to be other than who they are, Davis particularly, whose look is flirty, astonished, and a little fearful. But reaching into their reality, checking and fashioning it, are Cusack's hairdresser fixing something behind the actress's ear, and Davis's make-up man powdering her chest. On the seat are scene pages, complete with crossed out lines. Bridges is our most charming actor, a true natural who, even when playing callow, disagreeable characters in *The Fabulous Baker Boys*, *American Heart*, or the downbeat, underrated *Wild Bill*, draws us in with his self-aware sourness, though his sweet roguish boyishness is still available to him in elder statesman roles like the president in *The Contender*. As an actor he projects, as easily as drawing breath, the sort of populist American enthusiasm and sincerity we hear in the intro he wrote for his collection of photos. Its "Gee whiz, aren't movies magical!" ingenuousness sounds almost delusional, given the complexity and occasional unpleasantness of the images. "Acting is a lot like playing pretend when you were a kid. I did a lot of that, and it was always great to find someone to play with, who'd play as if it was REAL." This appears next to a picture of Nick Nolte, whose REAL life has punched and collapsed his once pretty-boy face into misshapen papier-mâché. Prepping for a

scene in *Simpatico,* his concentration is self-devouring, and with crew members lurking in the background, his body, which fills the front of the image, looks miserably isolated.

To some viewers these pictures will seem to be all about movie magic. To me they're about tedium. In picture after picture we're looking at people who are waiting for something to happen. The actors, already in character before a scene is shot, seem haunted, aloof, or spaced out. Gaffers, lens-pullers, assorted assistants look or scramble in different directions for different things, and nearly everyone seems bored or blandly preoccupied. And yet the storytelling that emerges from all this torpor thrills us with its urgency and immediacy. The falsified reality of a movie image possesses greater immediacy than the really real. The fanatical desire to make pictures feeds on itself. Image-making of all kinds goes on during a shoot: Polaroids for continuity; stills for publicity; digital motion for documentation. The busyness is apparent in a picture of Edward Furlong getting his hair cut for *American Heart.* The superb Mary Ellen Mark (whose photo essay for *Life* on Seattle street kids was one source for the movie) is right in the boy's face, and behind her is yet another photographer taking pictures of her taking pictures of the boy who himself is being made picture perfect. Jeff Bridges, ringmaster, watches them all.

I saw the Bridges pictures in tandem with those of a drastically different image-maker. There's nothing second hand (or secondarily real) about Andreas Feininger's photographs. His pictures blast hard and raucous facts at us. Son of the German painter Lionel Feininger, he was born in Paris in 1906 and began making photographs while working as an architect. He used the camera as a visual aid—a mechanical sketchbook—for his designs, and his later photographs are held together by an architectural discipline. He fled the Nazis and ended up in New York working on

assignment for the Black Star photo agency. His pictures have a breathless awe similar to Bridges's, but his scope is wider. When he wasn't on assignment, he roamed New York's streets and documented the city's nerves. "I see the city," he once said, "as a living organism: dynamic, sometimes violent, and even brutal." He adored the city's exclamatory energy and the patriotic tone of his times. (He loved flags, parades, and raucous good cheer.) And, like Walker Evans, he was in thrall to the vernacular of signage, especially movie marquees. One image announces Wallace Beery in *MUTINY UNDER THE LASH* (THIS DRAMA OF MADDENED MEN!).

Architectural intelligence shaped Feininger's vision. Two companion photographs of the old 9^{th} Avenue Elevated show off that intelligence in different weathers. In one, the snow-covered ties and rails look like silvered staples; in another, they look like a desiccated animal skeleton. His pictures of skyscrapers are nearly mythic in their vision of industrial aspiration. He had a special eye for buildings under construction and for the steeps and reaches of the Manhattan skyline. In one image, laborers pushing wheelbarrows along exposed girders look like notes on a stave. Maybe because he was a displaced person who hopped country to country before landing stateside, he created yearning pictures of the city seen from the water and made the photographic image an act of crossing or migration. He caught the Brooklyn Bridge in its changeful moods, the Queen Mary passing 42^{nd} Street in 1945 (Manhattan's towers look as if they're saluting), and a breathtaking 1942 picture of midtown seen from Weehawken, New Jersey, in which skyscrapers seem to be inhaling the great gobbets of steam crowding the harbor. The excitability is sometimes dampened or complicated by Feininger's sense of exile. His image of ducks strung up in the window of a Lower East Side Jewish

poultry store—"L. Moscowitz" is stenciled on the window—is all mixed tones, comic at first because the birds look about to come to life and do a little old soft shoe, but with their broken necks drooping from nooses and feet touching the draining pans, it suggests another order of experience that's not at all jaunty.

Zoot Suits

Any good exhibition of Chicano art is bound to splash visions on its walls that occur in places real and imagined. The real places are East L.A. and the "Third Coast" (Texas, specifically San Antonio), where much Chicano art has been produced since the 1970s. The imagined locale is Aztlan, mythical homeland of the Aztecs. It's told that in the 12th century, Mexican people of the Southwest followed the man-god Huitzilopochtli to central Mexico, where they founded the city of Tenochtitlan and Aztec civilization, bringing with them a memory of a place they called Aztlan, "place of herons." The myth lives in Chicano culture as a narrative of spiritual and ethnic identity and as a culturally unifying force. A lot of Chicano art folds together Aztlan iconography with the imagery of contemporary Latino culture. Mel Casas, whom I'll come back to, has made a picture that includes a Girl Scout, a Navajo in traditional dress, a mountain range of chocolate brownies, an Aztec serpent god and, riding the back of a Pre-Columbian *calavera* (skeleton), Frito Bandito. All sorts of influences collide to shape contemporary Chicano work. No contemporary can ignore the three monsters of Mexican mural art: José Clemente Orozco, David Alfaro Siqueiros, and Diego Rivera. Some Chicano artists started out, in fact, as self-taught taggers making their own kind of wall art. Legend has it that the first graffiti appeared in East L.A. one melt-down summer in the 1930s when kids dipped ice cream sticks in liquefied street asphalt and started signing with tar. By the 1970s, walls all over East L.A.—not a hot spot for advertisers—became, especially for poor kids, a blank to be filled with self-expressions and self-definitions. Graffiti artists who went on to make conventional easel pictures continued to build on the de-

clarative, historically aware style of the Mexican muralists.

One event that burns through Aztlan consciousness is the Zoot Suit riots of 1943. The Zoot Suitor was a barrio version of the 19th century Parisian dandy, symbol as much as style, or style *as* symbol, of theatrical selfhood and independence. With their greased pompadours, high-wasted gabardines, gaudy watch fobs, and collars that covered two counties, *pachucos* put "identity politics" on parade. When the media began stoking public concern about juvenile crime in East L.A., bored American troops stationed nearby, most of them already hard-wired racists, ganged up on *pachucos*. They beat them with bats, shaved their heads, and stripped them naked of their fancy threads right there in the streets. Chicano painters still feed off the fury and anger of that memory. What happens when a historical incident like this is abstracted from cultural context? The most grotesquely arbitrary movie scene in recent years was the Zoot Suit riot sequence in Brian de Palma's *The Black Dahlia*, where the street chaos and public beatings were staged as a brief incoherent footnote to L.A.'s most notorious murder case. The riots took place only because the script so dictated. It was local color.

Not every comic entertainer is a holy fool without historical conscience or consciousness. Cheech Marin, he of the big bong, is an enthusiastic and knowledgeable collector of Chicano art who has reminded us that to read this art intelligently we have to be aware of "code switching," the technique (and talent) bred into Chicanos which allows them to switch between two languages, two cultures. It's illustrated in another Casas picture, *Kitchen Spanish,* in which Anglo adults and children, like the gleaming double sink that dominates the picture, are rendered in a realistic Pop manner. (Several Chicanos have developed styles out of Pop artists like Robert Bechtle, Ed Ruscha, and Richard Estes.) Another

figure stands in the kitchen, a cut-out of a brown housemaid wearing a Smiley-Face, a mask really, just as her "discourse" in the cartoon balloon above her head is a verbal mask, a mechanical litany of subservience that says *Sí* to every member of the household, even the cat and dog. Artists like Casas like to construct competing actions in their pictures. Leo Limón's slashing, diagonal bubblegum pinks and watermelon reds create a washy membrane between celestial rowdiness and earthly goings-on. Figures shoot up and away or through some other zone of existence, zones marked by icons both sacred (crosses, the Virgin of Guadalupe, Aztec deities) and profane (fireworks, sombreros, guitars). Whatever grimness leaks into Limón's work explodes in festive piñata colors.

The most mysterious iconographer and one of the best Chicano painters, the L.A. born John Valadez, is a kind of senior eminence (he got his Fine Arts degree at Cal State in 1976) and loads his pictures with visual information. Even when his smooth photo-realist surfaces gleam pristinely, they teem with actual and impending violence. In *Pool Party*, two contented teenage girls stand by a suburban backyard pool: one runs water into it from a garden hose, the other soaps down a dog. Behind that contented cultural stability and casual waste of water, a grass fire races down a hill toward the house. Valadez's huge, disturbing pastel, *Getting Them Out of the Car*, depicts what seems to be the aftermath of a beachside drive-by shooting and spreads out to include bloody sharks washed up on the sand and a kid mugging a businessman. Valdez is a southern California guy, so the risky sensuousness of car culture puts an edge on his pictures. In *Car Show* he deftly congests the picture space with several figures and cars; they all glow with young, sassy, vaguely dangerous sexuality, from the girls' hot-pants-encased flesh to the low-riders' chrome-blue sheen.

Carlos Almaraz takes even bigger formal risks. His touch can be explosively clotted, or breezy and swept. He has a thing for car crashes, though it's not the anecdote that interests him so much the formal possibilities it frees up. His *Flipover, Sunset Crash,* and *West Coast Crash,* all from the early 1980s, are some of the most viscerally exciting things I've seen in years. (These artists are a solar system away from the cool, knowing stuff that fills galleries in Chelsea.) The meaty pigment and feisty, firecracker handling keep the imagery at a safe distance from illustration. Almaraz's brushwork and surfaces later on got more feathery and curvilinear. And he isn't afraid to let his dealings with predecessors show. Wayne Thiebaud's touch lent something to the car crash pictures, and in the more recent *California Natives,* where he's dealing with more or less indigenous materials, you can see Almaraz negotiating with Cézanne in the way he lays in shingled color, and Chagall in the way he rotates imagery across the picture plane.

I love the lyrical energies that shoot every which way from Chicano art. It has a special feeling for disorder and beefy glamour. Adan Hernández's midnight-blue mood pieces—Cheech Marin calls him the master of "Chicano Noir"—vibrate with splintered overhead light. Vincent Valdez's *Kill the Pachuco, Bastard,* a lurid re-imagining of the Zoot Suit riots, looks as if it's tearing itself apart. George Yepes, whose eerie *La Pistola y el Corazon (The Pistol and the Heart)* became the cover for a Los Lobos album, puts his own macabre street-outlaw spin on the *calavera* motif so familiar in Mexican art. Margaret García's tender, stoic *Un Nuevo Mestizaje Series (The New Mix)* is a contemporary re-visioning of the casta painting I've written about elsewhere. Like a classic 18th century casta painting, García's picture consists of sixteen "types," but instead of categorizing and moralizing, it celebrates the wild, stubbornly handsome varieties that racial blends create. Chicano

lyricism sometimes rakes political observation with wire-brush humor. To appreciate the satiric edge of Romero's *The Arrest of the Paleteros,* it's not essential but it *helps* to know that not long ago Mexican immigrants who worked as ice cream vendors were often rousted by the L.A.P.D. for not having permits, in the very dicey environs of Echo Park in East Los Angeles, where plenty of real bad guys could be found, if the cops were looking.

Field of Dreams

I'm not a barfly, not yet anyway, but I am a connoisseur of bar environments. I'm an equal opportunity appreciator. My favorites run from select dives and honkytonks to swankier hotel joints like the Old King Cole Room in New York's St. Regis and the Pied Piper Room in the Palace here in San Francisco, each of which takes its name from the large Maxfield Parrish murals hanging behind the bar. Neither of these appears in *Maxfield Parrish: Master of Make-Believe*, but the exhibition does include a color sketch of the Old King Cole triptych. There he sits on his throne, bespectacled, pigeon-toed, and hapless, chagrined because, as the leers and wrinkled noses of his jesters and guards attest, his majesty has just broken royal wind. Maxfield (née Frederick) Parrish, born to Quaker parents in Philadelphia in 1870 and supported heartily by them in his artistic ambitions, by 1901 had become the most famous illustrator of his time and, to judge by his astonishing commercial success, America's favorite painter, as Norman Rockwell would become a generation later. Like Rockwell, he's been the subject of exhibitions meant to rehabilitate his reputation as a "mere illustrator." But Parrish himself didn't see the point of the big 1964 exhibition, *Maxfield Parrish: A Second Look,* that tried to position him in relation to postwar abstraction and Pop Art. "I'm hopelessly commonplace," he said. "How can these avant-guard people get any fun out of my work? I've always considered myself a 'popular' painter." (Rockwell, too, had no delusions about his populist ambitions and success.) The "popular" in his work is indeed what makes him fun. Within his limits he made what many viewers find sensuous, pretty, otherworldly images. The work may not be exciting to a grouch like me, but it's authentic in what

it offers—facsimile dreamlands.

Parrish was the artist of choice for lithographic illustrations of famous children's books like *Mother Goose in Prose* and *The Golden Age*, and many of us long ago internalized his 1909 *Alphabet*, that jungle gym of hooked-together letters with a rather worried looking boy reading his abecedarium while seated on a huge "F." His paintings feature glassy, nearly transparent images of coy damsels and swains, tentative, sexually harmless beings inhabiting a "magical," story-bookish, mooncalf kingdom, where the light is always penumbral or crepuscular and in the background swell alpine heights and divinely serene lakes. He was kissing cousin to mid 19th century Pre-Raphaelite painters, who looked back beyond the Renaissance to the Middle Ages for their decorative, space-flattening patterning and faux-chivalric subject matter. Like them, Parrish paints high finishes and in some of his murals strives for a Giotto-esque fresco look: sandy light tones played off against ruddy darker ones, with figures that look cut into the wall with an Exacto knife. The King Cole and Pied Piper images— the latter disturbs with its expression of music's darker, insidious charms: during my second martini the Piper begins to resemble Fagin—are different in that they aspire to the more painterly effects Parrish sometimes achieved in his illustrations for books by Frank L. Baum (of the *Oz* series) and Washington Irving. In his larger murals, though, he had a hard time deploying multiple figures, especially in the one he made for the Vanderbuilt mansion, where the figures look cut and pasted in, because they were, sort of, since he used pencil cutouts to shape his figures before "modeling" them into a scene.

The pictures' high finish results from Parrish's assiduous technique. He started out with a sketch done in pencil, crayon, or color wash, then laid on several veils of very even oil glazes,

between each of which he spread a skin of varnish. This allowed him to get those depth-of-field, hyper-illusionary, fairyland effects. His paintings, unlike many of the illustrations he produced for *Collier's, Harpers,* and *Ladies' Home Journal*, are mood pieces, like musical tone poems. Characters may appear engaged in some sort of action (even if they're just lying around—delicately, yearningly) but mostly we're meant to feel a titillating transport to a realm of experience normally unavailable to mortals. It's escapist, but an escape to what? A tamed, becalmed world, I suppose, where nothing threatens happiness and humans are free to indulge their every yearning, uncomplicated by sex. (If you're thinking, "What world would *that* be?" you're not having fun.) In a large exhibition, the pictures start to bleed into each other. Their temperatures don't much change, whether the dominant tone is mood indigo, ethereal cerulean, or moist amber. It's a curious phenomenon that a popular artist should become so wealthy and famous making imagery that hardly exists in any shared modern reality. Even his landscapes are stranger than nature. He was certainly a strategic manipulator of the interplay between art and commerce but never pretended to be otherwise. He knew that even once he wearied of making what he called his "girls on rocks" pictures, prominent among the lithographs he made on commission for the Edison Mazda company, all he had to do was leave out the girls. Sales wouldn't dip.

Like the Pre-Raphaelites, Parrish valued good craftsmanship and even built a workshop where he designed and constructed architectural columns and other props for paintings. Crafty florid and filigreed pattern-making mattered, as it did to the Pre-Raphaelites. He used stencils at different stages of composition, and we see the silhouette effect in the crispy luminosity of his mountains and foliage. The illusionism was compelling contriv-

ance. Landscape painting became finally his great passion, and his best pictures come late. (He lived to be ninety-five.) The Hopper-esque *Plainfield, New Hampshire Village Church at Dusk* from 1941 captures the celadon calm of an eastern winter sky and the shut-in quietude of small town winter life. Parrish didn't lose much when he eliminated the figure, he only lost the pictorial agent of never-never land nostalgia.

Parrish was one of many painters who, instead of being in-timidated by photography, relished its uses. (His son, coinciden-tally, helped to develop the Polaroid Land camera.) He entered the Pennnsylvania Academy of Fine Arts several years after the great Philadelphia painter Thomas Eakins, a notoriously impudent teacher, was forced to leave. Eakins had already experimented with photographic models for pictures, and Parrish pursued that experimentation. He photographed his paintings in progress, blew up the print then painted the photograph with quick-drying oils and watercolors. Photography helped him develop crisp ef-fects; he knew that faux-realism can heighten the feeling of make-believe, and heightened illusionism is popular because, like most mainstream movies, it's immediately grasped. Parrish knew, as popular artists do, that we take pleasure from the artificial because we *know* it's artificial, inauthentic, unreal. This isn't entirely a bad thing. Fantasy is essential to complete consciousness. It deludes but it also cleanses. Parrish, in any event, had some historical rea-sons for the escapism his imagery offered. He worked through two world wars and wanted to provide passing respite from bad realities. His viewers weren't reminded of a time that once was, a more innocent time, but of a time that never could be, so far re-moved was it from the life of contingency we actually live. Parrish had no delusions of grandeur. He knew the use his images were put to. One of his admirers wrote of his fantasies—nubile nudes

seated on rocks in the middle of a nowhere lake or landscape—as places "where impossibilities are treated as realities." For many, the emotional market index of the pictures hasn't dipped at all. The impossible, in a bad world, always shines brightly. Parrish went one better and glossily prettified the attraction.

More Meat

In the bony, parched pictures he took of destitute southern tenant farmers in the 1930s while working on assignment for Fortune Magazine, Walker Evans's purpose was to expose the circumstances these people endured and also to create an essay on family interactions. We saw the family posed on the porch of a ramshackle shack, or in a room papered with old newsprint, or handling the cheapest galvanized-tin farm implements. Evans's purpose was to expose, not to disclose. His pictures aren't about giving away secrets: they exist to bear cool witness to a culture of impoverishment. He doesn't try to stir our passions or get under the skin of family feeling. Many of his images look like anthropological evidence.

In 1986, Andrea Modica, a Brooklyn-raised photographer who once had ambitions to become a painter (but found the medium "too loose") stopped in a small town in upstate New York called Treadwell. She made a picture there of two children held by adult hands. A thick arm crosses the chest of one child, as if shielding her heart. Another adult hand covers the ear of the other child, as if to protect her from the world's worst news. Then you see other hands: the child whose ear is cupped covers her *own* heart, and in the background, just barely visible, hangs another pair of adult, idle hands —idle but ready to come to help. The image is a ferocious little essay on caretaking. The formal balance is perfect: each child fills half the frame, and each looks too aggrieved for her age. As she spent more time with the family of thirteen she found in Treadwell, they became more tolerant of her presence and eventually became friends. Modica uses an 8 x 10 view camera, so her pictures aren't candid snaps. She seems to catch family

members in surprised, off moments, but nearly all of them are set-ups created in collaboration. Though these folks lead precarious lives, Modica isn't interested in the anthropology of poverty. She's looking for a compact of secrets between the photographer and her subject, and between them and us.

Many of the pictures are about children and sexuality. Modica has a longstanding passion for the 17th century painter Caravaggio, and her image of the budding sexuality between two pre-adolescent boys suggests how Caravaggio might have treated the same theme, though he would have included more debauched energies. In another, a tubby girl happens on a couple cuddling on the ground outside a tar-shingle house. They're wearing jackets so it's hard to see exactly what's going on, but the girl looks giddily embarrassed and privileged to be there. I've seen this picture many times and only now notice that the girl holds a cat, standing on its hind paws, between her legs. The cat's genitals are exposed in order to cover the girl's. Many of the pictures were in fact taken not in Treadwell but in other places, though all document a twiggy, coarse-edged rural ambience. Her pictures aren't as crowded as Evans's, but they communicate the airless oppressiveness of too many people with too little money living in too small a space. Modica's favorite subject became an obese young girl, Barbara (she of the cat picture) who later died of adult-onset diabetes. She and Modica collaborated on a series of pictures where Barbara "strikes a pose." She's a pin-up girl, an irascible ruler of an unidentifiable (but very barren-looking) kingdom, a Hopper-esque lonely girl in bed by a window, or a dreamer whose features melt into one yearning mass of flesh.

Since 2001 Modica has been working on another project, a photo essay about a small family slaughterhouse in Fountain, Colorado. At first she intended to cover the meat industry but,

when refused access by the big slaughterhouse operations, she approached a family in private business and was eventually admitted into their lives. Her intentions were documentarian: since she's a meat-eater, she says, she wanted to know where her food came from. But of course that's not what she's done, though expected images of tools and carcasses occur in the pictures. *Fountain* isn't as intimate as the *Treadwell* images, either. If anything, they're more contrived and theatrical, and here, too, the subjects collaborate in the construction of scenes. Modica is the first to admit: "These are fantasies, fables and fairy tales."

Sometimes issues about our relation to the animal world, how we use (ingest, wear, display) the animal world, are boldly put. Next to a dead bird on a tabletop rests a child's head, his mouth open, as if awed by the deadness of this common thing or trying to breathe life back into it. *Fountain* puts plenty of livestock on view—alive, dead, butchered, skeletal—but they're not really the point. This isn't an exposé, it's an inquiry into gains and losses. In one image, next to a recumbent female figure lies a plastic body brace, like a chrysalis case the human had just slipped free of. Or a spreading amoebic spill of jam on a tabletop is watched with bemused curiosity by a boy. Modica probes the ways children choose to expose themselves. But the Fountain pictures are more animated by formal curiosities and inquisitiveness than the Treadwell pictures. She calls more attention to set-ups, textures, and lighting. In one spectacular piece, a girl standing on a mattress—uncovered, dingy mattresses are a recurrent prop—looks above at an exposed light bulb that splays light down her front, but her head is cocked in surrender and expectation. She looks about to be abducted by a UFO, or assumed into heaven. (Modica's Catholic upbringing has obviously shaped her imagination.) There's even a trail of lights slanting up beside her toward the

bulb, as if illuminating the way to heaven. A second girl lying on the mattress lightly locks fingers with the illuminated seer, as if to keep her tethered to the earth, though "earth" is an unfinished, junked-up garage space of some kind. Modica's most transcendent (and daunting) pictures are extreme close-ups of Treadwell's twenty-something Barbara in the late stages of diabetes. Her features nearly flatten in the tightening balloon of her face; her gaze dissolves into a mass of thin, airily soft flesh; mortality thins out to an ethereally milky floating-ness, as if the camera is actually capturing the imminent release of a spirit from its body.

Rembrandt's Religious Portraits

The late 1650s were a hard passage in Rembrandt's life. The distinguished social standing he'd worked for decades to achieve, grounded in his remarkable early success as a painter, had been damaged by a liaison with his housekeeper, who was censored by the Dutch Reformed Church for "living in sin like a whore" with the painter. By 1656, because of his social climbing and the high living he'd become accustomed to, an accumulation of debts forced him to declare bankruptcy and auction off his house and household effects, which included a very choice collection of art by other artists. And his late style of loose, rugged impastos that defied academic notions of "finish" wasn't the thing among ascending artists and collectors. Rembrandt matured into a jostling, jolting manner just when smoothness and refinement were returning to favor, so the painter who had long dominated the Amsterdam art scene found himself in the 1650s and 1660s more isolated and marginalized than ever. During these years, Rembrandt made numerous pictures of apostles and other biblical figures. He'd always painted such subjects, but his late pictures have a crisp, jumpy energy— their whiplash technique races with the physical manifestations of belief, spiritual attentiveness, and devotionalism.

Post-Reformation assumptions about representation affected Rembrandt's (and virtually everyone else's) treatment of religious subjects. Both Catholics and Protestants believed saints to be intercessors between the faithful and God, but for Protestants, faith was more critical to salvation than good works or obedience to law. Dutch Baroque artists translated these notions in different ways. Rubens, a Catholic of secular humanist bent, usually depicted saints as wise, superbly self-possessed personages. His

apostles are *authorities*, strong-willed pedagogues. Rembrandt, member of the Dutch Reformed Church, showed the apostles as plain, humble, earthbound types, seekers and curious students of the divine. His saints are troubled souls, still pondering mysteries of faith, who haven't yet quite arrived at the truth Rubens's figures so sturdily embody.

Consider their different treatments of St. Paul. Rubens's Paul is a massive patriarch, a fortress of conviction and faith armed with a sword (one of his attributes—he was beheaded) and hefty Bible, staring straight at us from behind his bushy beard. Rembrandt depicted Paul several times (as early as 1627) and three of his finest treatments are from the late period. His saint is a conflicted, scholarly, weary man. In *The Apostle Paul* (in the National Gallery), he sits slumped at his desk, his writing hand and quill drooping at his side. This isn't an inspired initiate writing letters to convert others to his faith, he's just a writer who foresees the martyrdom awaiting him. In *An Elderly Man as the Apostle Paul*, technically a *portrait historié* (where a contemporary subject is depicted as some historical figure), he's lost in contemplation, or dazed, and squeezes his hands as if trying to wring truth from his meditations. He's an inward-looking man whose violent conversion and blinding on the road to Damascus shaped his subsequent experience of God and the world, here engaged in private unmediated conversation with deity. His face expresses not judgment but concern for the fact that man is by nature a sinner and that redemption, as Calvinism taught, depends entirely on God's grace. In the great 1661 *Self-portrait as the Apostle Paul*, it's tempting to see in Rembrandt's own face and posture a clenched worriment and almost debased humility: here's a man who has seen much of the good and the worst the world has to offer.

A lot has been written about "interiority" in Rembrandt's

portraits. I'm not qualified to say what a 17th century Dutch-
man would have defined as "the inner life," apart from religious
reflection. Our Age of Psychology inclines us to retrofit remote
historical periods with our own preoccupations and categories.
But I think it's fair to say that Rembrandt's pictures express im-
manence and contingency, and *these* any thoughtful person in the
Dutch Golden Age would have pondered. Rembrandt makes the
body a tense zone of affliction and passion, and these pressures
are right there in the action of the paint. He relied more and more
in the later pictures on craggy, gravelly striations of paint that
give flesh a turbulent rawness, and he used churned-up impastos
to make the picture surface a ground for modeling a new kind
of human presence. His material and handling make the alive-
ness of a human being's accumulated experience into a deposit of
flesh. And the deposits are substantial. (A contemporary, seeing
one of Rembrandt's late portraits lying on the floor, said he could
have picked it up by its nose.) His grace-note brushstrokes turn
color into electrical current. In the picture of Paul at his desk, the
brief stripe, the *strike,* of vermillion at his collar looks like lique-
fied embers. And in his portrait of the apostle James, the strip of
glistening chrome yellow on his jacket cuff (about the length of
my pinky finger) looks still wet.

Rembrandt paints piety as a fever still burning in old age, a
fervor that registers as fatigue, as irregularities and diminutions
of flesh and bone. Life isn't so much *lived* in these pictures as it
is lived *out*: light carves up or collapses the face, and skin thins
out. Rembrandt exposes with tender delicacy the vascular spot-
ting and maculation on fingers and backs of aged hands. Hands
in these pictures are implements of faith: they beseech, withdraw,
inscribe, and possess, especially in repose, a quivering power mo-
mentarily laid to rest. If we concentrate only on the hands, we

acquire a deeper sense of how mental and spiritual experiences model us from the inside out. It was believed that an angel dictated or guided Matthew in the writing of his Gospel. In *The Evangelist Matthew and the Angel*, Rembrandt depicts this with a literalism that results in weirdly crossed implications. The angel, modeled on his son Titus, leans over Matthew's shoulder, his lips by his ear. He looks like a less pouty (and less lipstick-ed) version of a Caravaggio angel or Bacchus: the whisperer dictating the word of God is an androgynous presence with long soft hair and feathery features. His representation of Jesus in *The Resurrected Christ* isn't inflamed or aggrieved or drippingly devout. It may be the most self-contained Christ in art history, demurely yet defiantly aloof. This Messiah, modeled (like many of Rembrandt's religious portraits) on a Jew, may or may not choose to speak, but he will *choose* to redeem the race, his divine nature expressed not by humility but by a benevolent hauteur.

Rembrandt's late formal adventures were unstoppably aggressive. His touch varies from brushy and light-handed to patchy, scaly, crusty. It looks like work done by a man in a hurry who works best in a hurry, who creates sculptural effects with muscular chiaroscuro and tenebrous theatricality. Light cages or swaddles or exposes the head of a figure, not to illuminate or decorate but to animate formal dynamics. Light crafts expressiveness and ambiguity of character. One of Rembrandt's most moving images, *The Virgin of Sorrows*, is a meditation on the iconic "Mater Dolorosa," the isolated Mary suffering the prediction, spoken by Simeon at the presentation of her infant son in the Temple, that "a sword shall pierce thy heart." Her hand covers her heart, yes, but it also clutches the breast that fed the child. The broken, swatchy surfaces of her hands and face, set off by the more faintly tissued textures of her garment, compose a presence so destroyed

by grief, so inside herself, that the light of her face lumping from the murky background seems to be coaxing from her a finality of sorrow.

Angry Kid

Wall labels in most exhibitions are toxic. Their breathless instructiveness is largely a result of the didactic mission museums have taken on in the last fifty years. It's one thing to inform an audience, it's quite another to tell us what we're supposed to think. It was a breather, a consciousness-scrub, to go through a huge Aztec exhibition at the Guggenheim in 2004 and receive only identifying information about each object—"Coyolxauhqui, ca. 1500, diorite"—but frustrating, too, because the culture is so alien from our own that I *wanted* a few details to explain the figure's significance. (She was a moon goddess.) The worst is when, by tacit collusion between curatorial enthusiasm and art-market handicapping, wall labels hammer us with delusional or ludicrous claims. It would take a super-heavyweight argument to persuade this museum-goer that Gauguin and Van Gogh have serious competition in Jean-Michel Basquiat, the 1980s art world darling, whose reputation has been kept on vigorous life support by sales, critical attention, and two huge retrospectives in the past ten years. He's a culture hero now, and it's unseemly to call his achievement into question. Nobody wants to be left out of the party.

But artists (and critics) keep each other honest by telling the truth about what they see, and the grandiose retrospective of Basquiat's career that I saw at the Brooklyn Museum of Art shows off an artist possessed of authentic but narrow gifts, mostly those of a draughtsman who sharpened his talent as a downtown graffiti artist who signed himself SAMO. The mechanics of his career were complicated and compromised by his desire to be a star. He announced when he was nineteen that he wanted to become one (a star, that is, not a good artist), and at first it didn't matter which

kind. He started as a musician then took to the streets and left
his marks in select locations near hot clubs and galleries. He was
soon scooped up by dealers and till his death in 1988 at the age
of twenty-eight produced a prodigious amount of art. To judge
by the evidence, however, he was surrounded by cohorts and
clingers who rode the comet's tail and never bothered to tell him
what in his art was sound and worth exploring, and what was
puerile, arrested, and limiting. He became hostage to a style and
iconography at a very young age, when other artists—some, like
Picasso, Modigliani, and Giacometti, prodigiously gifted in their
youth—are still testing the boundaries of what they already knew
how to do. Basquiat, who made a dozen or so exciting pictures,
wasn't a failed artist, he was an underdeveloped one.

He painted like an angry kid. His gouging imagery had proto-
hip-hop swagger and aggressiveness. In the beginning he was
more writer than tagger: he painted walls with words, not with
the smoke-roiled, hell-on-wheels imagery of standard graffiti art.
His street style was jabby and spellbinding. Like most tagging,
it was mural art meant to look like something rolled or stabbed
onto a surface, not (like traditional fresco) breathed by the surface.
When street signing is brought over to other supports—Basquiat
used canvas, board, linen, and paper—it finds itself in a kind of
exile, in a country that encourages meditative pause and scrutiny.
His art drew on the hit-and-run speed of the streets. And he used
street instruments: spray paint, paint sticks, plus more traditional
materials like acrylic and silkscreen. His work looks stark—the
visual equivalent of a holler—in part because he didn't mix colors
or blend tones. He wasn't interested in using paint (or drawing)
for nuance, depth, or dramatic texturing.

I look at most of his pictures and am grabbed by a piece of
canvas here, a chunk there, and my eye lingers, but only on this

or that hyperventilated passage; I'm not drawn or led passage
to passage, and I don't feel I'm watching someone building up a
whole-picture sense. (This sort of discontinuity, like his use of
writing and scribbling, probably derives from Cy Twombly.) The
slashing "look here!" effects of paint stick, its un-modulated asser-
tiveness of stripped-down color, also give the pictures a childlike
exuberance. Basquiat made every picture, happily, as if it would
be his last, so every one had to be a house on fire. His imagery and
emotional registers trigger alarm, bewilderment, and querulous
hilarity. Nearly every picture attacks you in some way, usually
the same way. There's the high-contrast signage technique, the
recurrent motifs—crowns (regal or thorny), blocky heads with
gutter-grate teeth, messages that proclaim or beseech or appeal,
and mysterious little hieroglyphics. He loves black (which has to
do with his subjects: I'll get to that) and his blacks are like pul-
verized, paved anthracite. He made some sensational pictures,
mostly when he seemed less rushed to create effects that came
easily to him. In the triptych 6 *Crimes* the handling is more deft,
less frenetic and collar-grabbing than in other pictures, the paint
more complexly loaded and controlled. It bears signature motifs:
each panel shows two mask-like heads with the spiked dreads Bas-
quiat himself sported. The heads are squared off, scarified, jug-
eared, with gridded or rounded mouths, and over each dangles a
lopsided halo. The letters S-A-M-O are scattered about the central
panel, his nod to the conventional painterly gesture of including a
past composition in work that's pushing into the future.

Much was made of Basquiat's art-outlaw status. He had an
aura of primitive authenticity, his Prada threads notwithstanding.
He was a street kid (though born to a middle class Haitian-Amer-
ican father and Puerto-Rican-American mother), a junkie, and,
in short order, a wealthy artist. He became an art world insider

precisely because he was perceived, and fashioned himself to be, an *outsider*, and his practice shares characteristics with work by other outsider artists (like the Naïf, asylum-bound Swiss, Adolf Wölffli), above all a fussy, over-concentrated repetitiveness that seems not only not quite under control but not even self-aware. Basquiat made sets of nearly identical doodles (or photocopies thereof) on sheets he glued to his pictures. And his stick figures and crosshatched skulls recur like an obsession. I'm not suggesting his art was pathologically bent, but like much outsider or Naïf art, it was busy, nervous, and compulsively repetitive. The pictures groove on incoherence and word salad. Letters and broken words bang against each other to create pictorial noise, but there are few finished sentences, so to speak, or statements. Like his floating heads, picket lines, and occult icons, they create a lyrical din. Basquiat wanted figural articulation without curvilinear volume, and many of the pictures look unfinished because they don't provide the formal terms or code that would convey a sense of what a "completed" Basquiat would be. The pictures are like the color-jammed, ritually scarred faces and skulls that appear in them—they're gaga with information overload.

Among Basquiat's best pictures are those that direct tragic-comic fury at pieties and misrepresentations, especially of race. *Jim Crow* is a ferocious elegy for lynched blacks. (A lot of heads in the pictures, in fact, look caught in lynched poses.) Black heroes are a favored and fond motif, especially athletes like Joe Louis, Jackie Robinson, Jersey Joe Walcott. Though their affect can be jagged and agitated, the pictures featuring these figures (or repeating their names, the equivalent of pictorial chanting) are already part of the lexicon of African-American painting. From West Africa and his distant Caribbean origins he brings over masks and folk motifs associated with Vodoun and Santería. Toward the end

of his short life, he became more and more some kind of religious artist who wanted his objects to possess their own gris-gris. See his 1988 *vanitas* self-portrait, *Riding with Death*, where a skeletal pale horse is mounted by a brown-skinned, black-headed rider. The later works summon power presences—the kings and griots never take their leave, either—not merely as motifs. You feel that Basquiat was trying to make a picture into a charmed, leering space, spicy and risky with magic.

Black and White and Color

Here in San Francisco, whenever I ride the Stockton Street bus from downtown up through Chinatown to North Beach, I wonder when the contents of the legendary melting pot are ever going to melt. I hear the languages: Russian, Chinese, Italian, Spanish, Arabic. I observe the manners: the Chinese pushy, the Russians disapproving, the Italians vigilant. What a fantastic mess of a people we are. We may be one nation under God in some laboratory of the political imagination, but the reality is sloppier, crabbier. Out of our roughhousing diversity come conflict and violence but also weird harmonies. I was shocked when in the early 1960s one of my high school teachers, an Italian-American priest raised in my own racist neighborhood, said that in time the most physically gorgeous Americans will be those from "mixed marriages." Faces *have* been changing, racial blends creating fresh forms of gorgeousness. I'm not mush-headed about these things. The deepest lesion in the American psyche is race. Enforced social blending like integration and busing incite bloody divisiveness, and the imagery that came out of New Orleans during and after Katrina begged us again to scrutinize race consciousness.

Such issues are gathered, sorted, and analyzed in *Only Skin Deep: Changing Visions of the American Self*, a grab-bag show with big themes on its mind. Its general subject is the way photographic arts have represented changing perceptions (and misperceptions) of what Americans look like, and it's divided into thematic sections that can hardly contain the sprawling variety of imagery. The section titled *Looking Up/Looking Down* tries to prove, as the curators put it, "how racial hierarchies can be either based in truth or subverted through irony and parody." Another, *All for One/One for*

All "presents photographs that suggest an 'ideal' American, while others represent specific ethnic or racial types." As if we needed instruction, but never mind. The show includes daguerreotypes, vintage postcards, film stills, conventional prints, and digital images that arc from the late 19th century to yesterday and are the photographic equivalent of Whitman's exclamation: "I contain multitudes." Though Whitman also wrote: "Do I contradict myself? Well, then, I contradict myself."

Lying with a straight face comes naturally to photography, which traffics in manipulation, illusion, rhetorical bullying, and dissembling, especially in its representations of race, ethnicity, historical event, and ethnographic facts. Consider an image from the exhibition: a blond Asian-esque mixed-race (and very pretty) woman cuddles in a living room with a militia-type redneck holding a rifle; on the wall hangs a confederate flag that declares "I Ain't Coming Down." Nothing indicates if the picture is authentic or staged. (The woman looks like the sort of "racially corrupted" person her boyfriend would shoot.) The most reproduced Depression Era photograph is Dorothea Lange's *Migrant Mother*. The woman, Florence Thompson, whose name Lange didn't note at the time, holds a hand to her face in worriment and uncertainty, her children huddled close. Her pose and isolated suffering intentionally suggest the *"Mater Dolorosa"* of Western art—she's poor, white, but vaguely holy. Thompson, it turns out, lived a long life resenting the way Lange chose (from several exposures and with careful cropping) to present her and her circumstances. She didn't *feel* as the photo made her seem. And she wasn't white but Cherokee by blood and looks abandoned only because her husband had gone off briefly to repair a radiator. *Only Skin Deep* slaps us into awareness of our cherished sentimental regard for this kind of manipulated, manipulative imagery, especially of people of color.

An apparently anthropological document like Laura Gilpin's 1932 *Hardbelly's Hogan, Arizona,* in which an old Navajo lies ill inside his hogan, ministered to by a white woman, was stage-managed: to establish the "purity" and noble "ancient-ness" of Indian life, Gilpin removed from the scene, as set designers do on movie shoots, modern objects and house-wares that would have tainted the purified illusion.

An exhibition of this sort risks hypocrisy. The catalog and wall labels are threaded with accusations, however oblique, of the moralistic motives behind many images, but the critique some-times indulges its own kind of fundamentalist moralism, agnostic in spirit but righteous in conclusions. That said, most of us really are to some extent fools for imagery and that while aesthetic appreciation comes easily enough, if we suspend skepticism, or wariness at least, we're liable to be suckered. Item: In the 19th century, Parisian police used photography to document crime scenes. Cops and forensic teams still hose down murder scenes with photos and digital camcorders. The practice was recently pulled inside-out when a Los Angeles performance group called ASCO blocked streets in east L.A., marked off a mock crime scene with flares, and photographed (in hellish, corrosive blue-greens and reds, like a scene in Michael Mann's *Collateral*) a person play-ing dead. You or I could write the Evening News copy accompa-nying the decoy image: "Another victim of L.A.'s Chicano gang wars was found dead tonight . . ." ASCO in fact circulated these photographs (by Harry Gamboa) to the media, one of which was picked up and aired as a news story by a local TV station. Who of the millions viewing the "proof" of the event would have doubted its authenticity?

Early photographers peddled erotic postcards and stereo-graphic images, but I'd never known about the thriving 19 century

business of anthropological pin-up girls. In the 1860s the Maine photographer Will Soule photographed bare-breasted Wichita women whose faked drop-in-and-see-me-sometime poses don't differ much from what we see in everything from mainstream Hollywood movies to toney hard-core porn (which has been so normalized that its variants are joked about in sitcoms). Even distinguished ethnographers like Franz Boas weren't indifferent to the commercial appeal of photographs of indigenous peoples, especially females naked from the waist up.

The 1890 *Pima Beauty* photographed by Henry Buehman is just that, an extraordinary beauty in her late teens, but *Only Skin Deep*, while allowing for a more or less neutral aesthetic view, tweaks us into considering how Buehman's image is scrutinizing *us*, our preconceptions, cultural formations, and norms of beauty. This sort of big-tent exhibition can throttle along from such early imagery through modern classics like Walker Evans and Man Ray to contemporary work by Glenn Ligon and Cindy Sherman. As a people we're always in process of puzzling out the ambiguities and instabilities of American identity. We've accumulated a formidable archive of abrasive, dissonant rhyming images eager to titillate and encourage intellectual smugness but that bear hard witness nonetheless. Carleton E. Watkins's picture of a new rail line opening the far west to the promise of prosperity is jangled by an anonymous snapshot of an exhausted black prison gang lined up next to rails they're laying while in the deep background stand two armed white guards. Whenever we look at a photographic representation of a human being, we have to be wary of colluding with fabrications and shifty truths. The act of looking, to be fully humanized, has to be an act of unruly, bristly, subversive criticism.

And because the archive is growing at a rate nobody can even guess at—how many cellphone cameras at a wedding, birthday,

orgy, political rally, wartime skirmish, terrorist event?—I think we're probably all looking sooner or later at one another.

Snap Shots

The first box camera made by George Eastman in 1888 came already loaded with a 100-exposure roll of film. You shot the roll, returned it to Eastman's processing plant, and they sent back the prints. The Kodak was a populist image-making implement. Middle class folks could easily afford one, and anyone could learn to use it, no expertise or training required. The Kodak's slogan: "You press the button, we do the rest." The first box cameras didn't have viewfinders, so those first mass-produced photographic images were "snap shots," like wild pistol shots. You pointed the lens at your desired object, the one you wanted to remember and possess, snapped the shutter, and made a wish.

The snapshot became a souvenir for the masses, a little shrine to our presence in the world, something done on the run but personalized: a picture of a person or object—people seldom took pictures of empty spaces or landscapes—was a safe-conduct pass to the country of another self or world. Snapshots were portable and traveled along in wallets, purses, shoeboxes, and albums. They're sexualized, too: when we're smitten, we swap pictures with the one we're wooing. Content matters more than style. We snap pictures—these days with a cell phone—not so much to make an image, as real photographers do, but to own something or someone or take possession (we think) of time in its speed-freaky passing. They materialize our fantasy of arrested time. The snapshot has also become a mini-mania for collectors, who assure us that only about three percent of what we think of as candids are truly so, and major exhibitions like *Snapshot Photographs: A Snapshot of Your Life* are dedicated to this unassuming but precious object.

Snapshots are evidence—authentic, cooked, or planted. When we know we're being photographed we craft a version of self for the lens. Photography has taught us much about our own plasticity. Because snapshots are evidence of our existence, we're inclined to jury-rig them. We costume ourselves, wear two (or more) identities at once. Kids in front of a camera feel safe dressed as cowgirls or hula dancers. Adults assert a chosen identity or cross boundaries, like men posing in women's hats and vice versa. (Image-makers like Cindy Sherman take the ironies of photographic self-construction all the way to the bank.) Some of the pictures in *Snapshot Photographs* have a sneaky ambiguity. One from 1935, of a young blond girl carried piggyback by her black nanny, doesn't tell us we're in the Jim Crow South—we're as likely to be in Philadelphia, Pennsylvania, as in Philadelphia, Mississippi—but the image graphs the fine fracture lines of racism that still ramify everywhere in our culture. The woman, at any rate, seems content to be bearing her burden. Close to that image is another, comic one about shared cultural foolery, a hula-hoop contest, among male adults, in *suits*.

We must be born with compositional or pattern-finding instincts. I once saw a show of pictures by kids in a homeless shelter who had never handled a camera. A grant-sponsored professional gave them cameras, taught them the basics, then set them loose. Even the gag shots had a visual punch that comes from getting the balance of elements right, and while the kids clearly had some sense of their out-of-the-ordinary surroundings, their pictures didn't plead for admiration or pity. Instinctively, they wanted first of all to have fun, to take or give pleasure, but they also wanted to put on record certain details about their shared shelter culture and the privacies of kids' antics. *Snapshot Photographs* puts a variety of cultures—public and private, usually familial—on view. The

subjects know they're being photographed, which gives so many of these pictures an aching sweetness, and the compositional instincts behind the camera are dead-on. One stunt shot features a guy doing a hand stand in a one-piece bathing suit (snapshots are couture's fossil collection): he arcs in one direction while in the background, across the river behind him, a tree arcs identically the opposite way.

We're all camera-conscious, and one cluster of pictures in the exhibition shows off that self-consciousness without giving up surprising intimacies. My favorite has a thrilling offhanded sensuousness: one woman washes another's hair outdoors in a small tub. In others we see nearly the entire range of human touches. Is any image as sexy as that of a couple kissing on a beach? The seashore couple we see wrapped around each other may not have the animal force of Burt Lancaster and Deborah Kerr bedded by surf in *From Here to Eternity* but it's as hot as it gets. I said "nearly" because we don't see violent gestures, and there's not much sadness or rage or sourness on view. We smile for the camera, which corroborates our little lies. I once saw a photograph of handsome parents and their several gorgeous children posed joyously, like the von Trapp family, hand in hand on a hillside, though I knew the family was in fact shredded by different sorts of abuse. So when in an exhibition like *Snapshot Photographs* we see pictures of smiling, grinning kids, we can be pardoned for speculating on the fragilities, psychological lesions, physical bruises, and night- terrors perhaps masked by those smiles.

Serial family-album snaps offer complicated evidence of communal bonds and rituals. Thumbnail photo-essays of gay male and lesbian groups suggest that what older generations would have judged a degenerate secret society is normalized when photographed and thus recorded as a social actuality. The serial im-

ages titled "Roger and Frank and Friends," taken between 1947
and 1956, represent a communal life as "normal" (and loving and
content) as that of the Stankard clan, with their rather cloying log
of events composed of baby pictures, yearbook photos, film-booth
strips, and shots of the family dog. Amateur photographers are
drawn to rituals of communal bonding: baseball games, Christ-
mas celebrations, picnics, birthday parties. Their pictures assert
self-display as (sometimes comic) self-fashioning. In addition to
several cheesecake and beefcake snaps included in the exhibition,
there's a lardcake pic of tubby guys mocking muscleman poses.
Some of these anonymous photographers were compelled to
capture forces of nature: a double rainbow (matched by smoke
bowing up and away from a smokestack), a dust storm, a sinkhole.
There are hardly any landscapes in the show (a landscape can't
fake its identity), but one stands out for its homely, small-voiced
celebration. In what looks to be a Midwestern scene, a Chinese
elm is just coming into leaf, and in the upper corner of the image
is written in smudged ballpoint: "Spring Arrived."

A commonplace of art photography now is the shadow of
the image-maker falling on the field of vision. Lee Friedlander
has made stunning, phantasmal "self-portraits" of this kind.
Amateurs, even before Friedlander, following their instincts for
composition, produced the same sort of picture. The long narrow
shadow of the photographer appears in a whole series of images.
In the best of them it's clearly no accident that the woman be-
hind the camera photographed her own shadow stretched on the
ground alongside her young son posing in a cowpuncher get-up.
To judge by the frequency of these pictures, the instinct to stamp
or impress our own anonymous identities on pictures has run in
our bloodstream since Paleolithic artists 30,000 years ago left their
handprints around pictures of deer and bison. Seeing any exhibi-

tion of snapshots is a little like finding a lost billfold jammed with crimped or ragged snapshots in sepia, dishwatery, or miasmic yellowish tones, pictures of total strangers whose poses we recognize as those we ourselves once struck. Or it may be an image of a nude lover, or of a car or house, something lost, something found. (It's amazing how many snapshots are of auto owners posing next to their prize beauties.) In that billfold we maybe happen on a socio-economic class strange or repugnant to us, or secrets never meant to be shared with strangers, meant only to be in the locked desk-drawer of the owner and his or her loved ones. And here we are now with volatile knowledge on our hands.

Lords of Creation

I've seen three big exhibitions of Maya art in recent years, and several objects that appeared in all of them have become familiar to me. Familiar but still utterly remote, not because their meaning is unintelligible—one can comprehend why the Maya identified kingship with maize, their sustaining crop, and the Maize God—but because there's no continuity between the Maya vision of the cosmos, which determined the meaning of every piece of reality, and our own. I've read a short shelf of books, including canonical works like Charles Gallenkamp's *Maya* and Michael D. Coe's *The Maya* and *Breaking the Maya Code*, which is really about the DNA of language (and should be required reading in MFA poetry writing programs). Yet the more I learn about Maya culture, the stranger and more *other* it becomes. More on this later.

The most recent exhibition, *Lords of Creation: The Origins of Sacred Maya Kingship*, tracked and illustrated the development of the idea of divine kingship from Olmec culture of the first millennium B.C. through the classic period of Maya civilization that flourished in the Yucatan, Guatemala, Honduras, and Belize between 200 A.D. and 700 A.D. It's hard to keep pace with the information unearthed practically every day at archeological digs, but this exhibition seems to be as current as possible in its scholarship and coverage. There's much to be learned here, but it takes an effort to absorb the complexities of the Maya world-view. The simple visual thrill of all those electric blues and ochres, and the sculptural genius on display, certainly can suffice for most viewers, including this one. We can take pleasure from these artifacts and even comprehend their import for the Maya, but we can't really *experience* their meanings. Our Western European formations impede us.

197

The city-states that composed the Maya kingdom shared a vision of the universe as a tightly drawn network of sacred relatedness. That vision was expressed in artifacts, in bowls, censors, jewelry, masks, and other ritual objects. At the center of it all was the lord. Maya lords possessed secular and divine authority, and the survival of Maya society depended crucially on their successful intercession with the gods to secure agricultural fertility. Often dressed in the guise of the Maize God, with elaborate headdresses featuring cobs, corn silk, and the trefoil that symbolized the plant, lords performed rituals that opened channels between human and divine orders. The rituals, which involved trances induced by hallucinogens or bloodletting, were often danced, and the dancing lord is a recurrent Maya motif. One bright, earth-orange bowl depicts a king, legs spread wide, feet stoutly planted in the ground, performing a propitiatory dance. You can practically visualize his feet stomping up dust.

The Maya depicted their vision of reality in objects of every size and shape, from monumental statuary to ear ornaments and amulets. Their cosmos was a porous vertical column in which elements—animal, human, vegetal, and celestial—are in a more or less constant state of transformation. Animal power was everywhere. The Maya envisioned the earth's surface as a turtle's carapace or crocodile's back, the shells or plates floating on a body of water barely visible through the cracks. Kings used as divination tools mirrors made of polished stones, set in a mosaic pattern that imitated a turtle's shell; such mirrors were also trance instruments and were buried with lords to assure their rebirth. A lord's life cycle followed that of the maize plant: insemination, birth, death, and return. One of the many stunning objects the culture produced is a seven-foot-high granite stele from Guatemala: a lord costumed as the Sun God, essential to the maize plant, stands on

the watery underworld and rises, via an elaborate winged head-dress, to the supernatural overworld. Carved in ropy, tubular relief like much Maya sculpture, the figure is at once artful, sacred, and archival. A much smaller object, a 3 x 3 inch tablet of mottled greenstone, bears an incised, coral-red inscription, a column of signs which, read top to bottom, depict the cosmic order. The square greenstone is the ocean; its corners mark the cardinal directions. Topmost on its surface is the "sky-house" of the north, under which stands a maize plant. At its root is a stepped mountain symbolizing the earth; the stepped structure also resembles the architecture of Maya cities. That maize stalk, which connects earth to sky and holds the universe together, is the *axis mundi*, the vertical column or "world tree" common to many early cultures. The delicious finishing touch are three little circles under the tree that represent the stones of the cosmic hearth where the gods first erected the tree at the center of creation. The tablet, no bigger than a BlackBerry, expresses the Maya vision that everything is connected to everything else.

The expressions of physical transformation we're accustomed to in pop culture can give us the willies or shock us, but they don't induce a terror rooted in shared religious pieties. The closest we've come may be the scene in the 1941 version of *The Wolf Man* where Lon Chaney, Jr., is transformed into his animal *other*. We certainly don't have a shared culture of belief in ongoing transformations that are essential to the coherence and continuity of our civilization. For the Maya, the central human transformation was that of the lord, who in his trance states became another order of being, sometimes supernatural, sometimes animal. Usually he turned into a jaguar, *the* power creature. A fist-sized carving designated *Transformation Figure*, most likely a lord in process of changing into a crouched jaguar, raises the hairs on my neck. It's

a bundle of concentrated formal energy, like a Brancusi sculpture (who constructed his own *axis mundi* in his carved *Unending Column* in Romania), but its sacred meaning seems like a terrifying force coiled inside the stone. These artifacts are unattributed, obviously, and the anonymity contributes to the massive communal conviction encoded into even small turtle-shaped ornaments, or censors mounted on legs shaped like peccaries—peccaries were associated with the pillars supporting the cosmos and were the Maya equivalent of our Gemini constellation. How far did anonymous production extend? I've seen tile-sized bricks discovered at a brickworks in a city-state site in Guatemala. They were incised with drawings—a sun, a face, a glyph of some kind, and a parasol (!)—sketched by the brickmakers, who knew very well that their drawings would be forever covered once the bricks were laid.

Lords of Creation is concisely structured and instructive in all sorts of ways, even if, as I said earlier, the closer you get to Maya consciousness, the stranger and more remote it seems, because we've lived for so many centuries in a tradition that atomizes the world. For us, individuation rules, and nothing is more contrary to Maya belief. What we do bring to these objects is an aesthetic sense, and the pleasures to be gotten are many. A seated divination figure, eyes bugging from his head, leans forward, pitching himself into a trance state, tongue protruding between his lips. He has jaguar ears, as if in process of transformation. On an oblong jadeite slab floats a king dressed as the Maize God, as if suspended in a trance state or positioned for supernatural flight. And there's a death mask that sums up the Maya concept of human existence and death. In the beginning, gods made humans by pasting together yellow and white maize and sacrificed their own blood to infuse humans with life, which is why a king's self-blood-letting was the ultimate act of reciprocity. The gods gave humans

a "breath soul," what we would call the life force. A funerary mask
from A.D. 200-600, a mosaic of jadeite tiles, shows—in the form of
tiny carved shells curling out from the sides of the mouth—the
breath soul leaving the body. It's one of the few objects in the
show that immediately break down in meaning and spill over into
universal human experience. Anyone who has sat vigil has heard
the breath soul leave the body. We can also in a small way share
Maya consciousness at the next full moon by looking up and see-
ing there not the man in the moon but, as they did, the profile of
a rabbit.

What's Left

In the photos Lewis Hine made in the 1930s of the Empire State Building under construction, the workers he called Skyboys (many of them Mohawks, who had a peculiar, valuable gift for working high steel) stand at the ends of girders forty stories high, where heaven starts, grinning with brash, ingenuous pride. Hine's Left Coast counterpart was Peter Stackpole, who recorded the building of the Golden Gate Bridge, the suspension bridge with the tallest towers of its time, as the Empire State was the tallest building. One image of a welder shinnying up a stanchion has comic, mythic force: he's climbing toward Paradise, or at least the Industrial Revolution's version of it. Those Daedalean projects and pictures were produced during the Depression. Out of such loss, winged ambition. Other kinds of manufactured glories have long since been corroded by age, misuse, neglect, waste, and obsolescence, which in turn have become the salient subjects of more recent photographers of industrial landscapes. The most ambiguous poet of post-industrial landscapes is the Canadian photographer Edward Burtynsky, whose large views of quarries, rail cuttings, oil refineries, shipbreaking yards, and other industrial sites compose a ravishingly unsettling exhibition, *Manufactured Landscapes: The Photographs of Edward Burtynsky*.

Albert Speer, Hitler's architect, devised a notion he called "the architecture of ruins." He wanted to build structures that, once destroyed, would possess their own memorable sort of wrecked classic beauty. Burtynsky's pictures suggest that we've seeded our own industrial landscapes with a similar notion. The locales we've carved up, scraped down, scooped out, and shoved around to accommodate consumerist needs, in their grotesquely

ruined or deteriorated conditions possess a savage beauty. The most overwhelming of Burtynsky's pictures are of shipbreaking yards, tidal shelves in India, Pakistan, Bangladesh, and other corners of the third world where obsolete single-hull tankers are beached then carved up and either sold for scrap or used by local culture for their own new-industry needs. These gigantic, hectic red, sawed-off chunks of plate metal look like beached sea wrack of a faraway culture. One imagines a pre-industrial civilization's puzzlement: What could people have used such things for? (They also look like maquettes for Richard Serra sculptures.) The light, especially twilight, lies softly on the twisted, chopped surfaces of these huge busted pillars and picks its way along the details of the serrations and breakages.

When British photographers journeyed to India and Egypt in the 1800s to photograph ruins scattered throughout the Empire, they placed a human figure in the scene to establish the awesome scale of ancient temples and monuments. Burtynsky, in his own way, honors that tradition: Near the jagged hulks of sun-rusted steel are hundreds of footprints in the sand. We're far from Crusoe's discovery of Friday's footprint on the island. The prints remind me of lines in a poem by G. M. Hopkins: "And all is seared with trade, bleared, smeared with toil; / and wears man's smudge and shares man's smell: the soil / Is bare now, nor can foot feel, being shod." We see some sort of human print—usually left by industrial extractions—in most of Burtynsky's images. The pictures aren't polemical, but they narrate a tale of shared global conscience, or lack of it, that we haven't traveled lightly through our world. The ship carvings look like huge diseased broken molars or specialized machinery for disassembling big things. And we see Hopkins's "bare soil" in Burtynsky's pictures of rail cuttings razored across the side of a mountain or rockface. In the 19th

century, Carleton E. Watkins and William Henry Jackson gave us the first pictures—pictures of quiet, serial astonishments—of new railroad routes being carved through the west. The rails were nearly always photographed moving away from us into an unseeable distance, into promise and future and expansion. Burtynsky, who like Watkins and Jackson uses a big view camera that requires long exposures, photographs cuttings flat on, horizontally. They end where the image ends. There's no futurity in the vision, just a hypothetical repetition of ruined soil and infinitely elongated cuttings.

Burtynsky's technique encourages the ambiguity that gives his work its visual and moral complexity. Thanks in part to the view camera's capacity to absorb masses of visual information in hairline detail, he corrals enough for us to meditate on how the human hand has created these new landscapes (often by destroying or reforming old ones) but the pictures make no judgments and engage in no special pleading. He can achieve in one image a deep focus that mysteriously creates a stand-up sheeted-ness that presses forward to coat the picture plane. The parched, low-ceilinged, epic expanses of California oil fields cant toward us, though they're at the same time overrun with rigs that look as if they go on forever, continuing their jackknifing extractions beyond the horizon.

Burtynsky's pictures of granite and marble quarries in Vermont, India, and Italy (Carrara, where Michelangelo and Canova found their materials) are disorienting because there's usually no stable point of view, so flatly and evenly the pictorial contents are spread and impacted up and down and across the picture plane. A couple of overhead shots of Carrara gave me vertigo jitters: my head spun a little because Burtynsky makes depth seem like a blocky expanse coming *up at you*. The first quality of beauty is

that it surprises with the familiar: one beautiful winter shot of a granite quarry in Barre, Vermont, makes the pit look like a sci-fi version of a library in deep freeze. Burtynsky's pictures push questions about the "second nature" manufacturing debris creates. He photographs ferrous bushings to look like fallen leaves or tree bark or sea shingle. Such pictures suggest not so much that we've ruined nature as that we've been for centuries in the act of trying to create a second one, a manufactured support system of life.

As I've said, this photographer is no Jeremiah. He's making images of processes that happen to entail the biggest job of all—earth stewardship. There's wit in the enterprise. A close up of what looks to be a telephone dump made me gag, because the wires and handsets and busted dial pads look like gristly guano dropped by some flying plastic Leviathan. Among the most stunning things industrial culture has produced are those bales of junkyard scrap metal we usually see in noble exile at the edges of our cities. (I have deep but awkward affection for these gaudy, blockhead jewels.) And who has ever seen a levee or ridgeline of discarded tires that didn't stir up some twisted affection, usually veined with disgust? Burtynsky carries on the tradition of recording the American vernacular that so possessed Walker Evans, Dorothea Lange, and Paul Strand, though the big difference between their time (the 1920s and 1930s) and ours is that the planet has since been gouged and drilled to within (possibly) an inch of its life. Burtynsky's pictures of nickel tailings—the ambiguity of his work lies in the ravishing beauty of the ravishment of resources—the streaming tangerine-red runoff from mining operations looks like a liquid underground fire that has surfaced, still afire, running fast, whose course once begun can't be stopped.

HARD SHADOWS

ॐ

2006–2008

The Scream

Whenever I visit the Getty Center, that travertine-and-aluminum shrine high above Interstate 5, I nod to Mantegna's mineralized *Adoration of the Magi* and Masaccio's mournful *Saint Andrew*, then speedwalk to Edvard Munch's *Starry Night*, the most sumptuously dire nocturne I know. Expanses of blue-green space—Norway's summer nights are said to be bluish silver—nearly erase the small smears of stars and planets. The mountainous tree rising by the sea is a loamy hump riven by a seam of violet starlight. As our vision strains to see the stars, what really beckons is that forbidding mass which to my eye expresses a fast-failing desire to rise beyond the gravities we live with and are. It's a picture without agonies but fat with muffled, one-day-at-a-time anxieties. It might be better titled *Just Barely a Starry Night*. It's not standard issue Munch-ish emotional extremity but a sober essay on the boundaries separating land from sea, planet from cosmos. Munch made it in 1893. In 1889 he'd attended the Salon des Indépendants in Paris where Van Gogh showed *Starry Night, Arles,* and the Getty picture is a tensed-up, baleful answer to Van Gogh's rolling crests of pulpy celestial matter. His energy floods and storms, Munch's lids and contains. Compared to the great moderns, Munch has been assessed if not quite in baby steps, at least in a sluggish catch-up. *Becoming Edvard Munch*, which I saw at the Art Institute in the spring of 2009, followed upon MoMA's 2006 *Edvard Munch: The Modern Life of the Soul*. An exhibition at the Berkeley Museum of Art in 1996, *The Artist and his Models*, cracked open the overlooked later period of Munch's career, when he spent enormous energy examining the relationship between himself and his models. We forget that this artist so associated with trauma, dissoluteness, and derangement

actually lived a very long life. Born in 1863, devoted to painting by the age of seventeen, internationally successful by 1902 and included in shows with Cézanne and Matisse, Munch lived to see his work in Germany's exhibition of "degenerate art" in 1937. (He died in 1944.) Yet he remains for many an artist arrested in a narrow range of moods established early in his career: sexual fears and voracities; sorrow and depressiveness; the terrifying immediacy of unreason. In the copious diaries he kept throughout his life, he wrote: "I do not believe in an art which is not forced into existence by a human being's desire to open his heart. Art is your heart's blood." An 1898 woodcut, *Blossom of Pain,* illustrates those poetics: a scarf of blood runs down the chest of an emaciated naked figure and waters ground from which rises a plant topped with a rhyming red bloom.

No modern has been held so hostage, in so many silly ways, to one image. *The Scream* expresses what Kynaston MacShine, in his MoMA catalog essay, calls the "existential agitation" in Munch's work. Fair enough, though Munch didn't hold copyright on the soul's griefs and grievances. He did publicly identify himself with such agitations, however, not just because he was authentically alarmed by his own off-ness but because it helped advance his career. (More on this later.) *The Scream* fashions a new nervous sublime in nature and the human order. Munch reconstructed the occasion: "I was walking along a path with two friends—the sun was setting—suddenly the sky turned blood red—I paused, feeling exhausted, and leaned on the fence—there was blood and tongues of fire above the blue-black fjord and the city—my friends walked on, and I stood there trembling with anxiety—and I sensed an infinite scream passing through nature." In the picture Munch separates himself from his companions because the sublime isn't a condition of solidarity: it's the global, near-annihilating experience

of one consciousness. The rubbery figure claps hands over ears not because he's screaming but because the scream lives in the swathes of orange, red, white, and turquoise squalling across the sky, a wrathful coursing of color continued in the fjord and sea.

In a snow-storm, rain-storm, leaf-storm, we sometimes sense ourselves not *in* an extreme event but *of* it, defined by it, and the skull in *The Scream* registers, in its crimped rotundity and light-bulb loops of pigment, the racy circulatory rush of the entire scene. It's all in our heads, indeed. The figure is an embodiment of the galvanic surge Munch said he felt that evening. If this embodies the modern soul, it's a post-Romantic soul: the self lies in thrall to something larger and fiercer than itself, even while it remains mercilessly aware of itself as a discrete entity. The more we try, at whatever cost, to know ourselves, the more treacherously oceanic the not-us comes to feel. Like Munch's best work up until around 1908, the picture doesn't open up or breathe, it encases and pressurizes.

We tend to think Munch's career faded around 1908, but the existential rattling never really quieted, even when it didn't rule. We see it in late work where he experimented with a peculiar hybrid of the floating commas, dashes, and archipelagoes of color he learned from French painting and the swift, beefier style he developed in his early years. The pictures he made during long stays in Paris in the late 1880s are pretty but morally unconvincing— he's enthralled by formal issues and a revised, brighter, jumpier palette. Munch was a quick study and had good hands. He could turn out on demand lovely pastiches of Monet or Seurat. His *Karl Johan Street in Rain* is blatant homage to Caillebotte's famous rainy street scene and its consecratory umbrellas. The most compelling quality of Munch's Paris pictures is their flirtation with abstraction, which titillated him for years. His *Rue Lafayette*, where a figure on a balcony oversees the waspish street scene below, is

structurally a stencil of Caillebotte's *A Balcony, Boulevard Hauss-mann*, but Munch's picture is more purely impressionistic, less constructed and resolute, than Caillebotte's: whipped-up colorist confetti blows like rain lines across the picture plane.

In the great stretch of work through the late 1890s and early 1900s, he was translating Impressionist and Symbolist construc-tions into his own Nordic form language, into Munch-ness. Work-ing out of the Impressionist motif of human figures out for an evening stroll, he makes his Norwegians look like nerve bundles transmitting signals of imminent panic or fright. He mastered the French illusion of light as movement, but in his darker, more em-bodied signature pictures, light becomes the medium for dark en-thusiasm about inner pain. Light looks stoppered, asthmatically compressed, and Munch makes perspective a rivering action, not architectural but kinetic, runny. His firm, scooping line is a dense, barely elastic container of matter, whether flesh, foliage, or furni-ture, as if it's working to contain an otherwise expansive, chaotic energy. And his figures don't just look out, they *confront*—they prac-tically dare us to contemplate their fates. Munch made the head and face an articulation of the skull. Every such picture was a *vanitas*: the skull in the living face bulges as if to escape its fleshy wrapper.

Blossom of Pain is one of many self-portraits. In a painting made at age eighteen, he's a haughty, ripening Young Werther type. Some years later he makes a stark frontal self-portrait: holding a cigarette, dressed in a stylish suit, he looks like a nervous banker or professional gambler. The spectral articulations of his cloth-ing wash into a blur—he applied paint with the palette knife and scraped the canvas so that it looks clawed—and he lights his face to look startled, as if caught in a photo flash. One of his last pictures is a self-portrait where the stiff old man, survivor of all

sorts of psychological trouble, stands between bed and grandfather clock as if incapable of movement. Like most artists worth the small song of their lives (count poets among them), Munch kept kneading the formal possibilities of self-representation and self-exposure. The self-portraits are blatant and close enough to likeness to seem like diary confidences, and Munch was in fact a fanatical diarist who published excerpts that reveal or—the line is wooly—purport to reveal versions of himself that would fix in people's minds a carefully crafted damaged-artist image that he used as a promotional tool to sell pictures. Not that he wasn't a wreck. While working on a compilation of writings titled "Diary of a Mad Poet," he checked himself in for one of several stays at clinics for neurasthenia, depression, and alcohol abuse. Up until 1916, when he bought and settled quietly into a country estate in Ekely, he poured his daily psychic ache into his best work. His famous declaration late in life, "Without anxiety and illness, I would have been like a ship without a rudder," means all those rocky, menacing passages in his life were in fact stabilizers: they gave his art direction and purpose. His 1903 nude, *Self-Portrait in Hell*, advertises his torment: the small face, about to be subsumed by a mysterious ballooning shadow, whorls with rouge reds and bruised yellows that run up his head and torso as if they were a wall on fire.

The Chicago show positioned him among his cohort and proved he had much in common with Norwegian naturalist artists. Like them, he took up conventional subjects—death rooms, romantic couples, street scenes—but his execution, when working his signature style, was something else. His colorism's gravitas bears the force of agonized feelings: his greens aren't fructive or voluptuary; the blues, tamped down by violet, don't vibrate or breathe. His warmest registers don't invite or seduce or caress us. And he made subjectivity—*his*—the actual subject. From the dia-

ries: "Why was there a curse on my cradle? Why did I come into the world without any choice? My art gives meaning to my life." This bandwidth was broad enough to pick up assorted distress signals. Here's a start-up directory:

Death and Dying: Munch's mother died of pneumonia when he was five, his sister of tuberculosis when she was fifteen and he fourteen. His sister's wasted, strangely yearning visage in *The Sick Child* (1896) became a recurrent motif, and it stops your heart. Her drained look, "pale and spectre-thin," lent itself to Munch's stringy drawing: her hair seems wafted by draughts of mortality. (Her grieving mother crushes herself into the bed.) His obsession with the motif extended to deathbed scenes that reveal the torpor and soul paralysis of mourners; Munch paints their pallor as a mask, as if they're trying on their own cadaverous visages.

Disillusion and Despair: Especially regarding sex. In *Ashes* (1894) a woman in an open, disheveled bodice (theatrically illuminated in a darkened copse) pulls back her long hair while the black lump of a male, head in hand, lies slumped against a tree. Like *The Scream*, this picture shows the natural order streaming through the human: her flyaway hair disintegrates into forest foliage; his sorrowing head, cowled by his arm, folds into the tree's bole and roots. The picture exposes sex's raw, saggy, messy after-moments.

Embodiment and Peril: In Munch we can practically feel flesh filling out clothing. Impressionists and Post-Impressionists, for all their excited brushwork, were brilliant at painting the body stilled, whereas in Munch the flesh is sleekly astir and anxious. He shows humans agitated or in some fore-moment of movement. In *Dance of Life* (1900), his most thrilling statement of the rhapsodic ambiguities of sex, several dancing couples measure degrees of lust, enchantment, indecision, and isolation, and the swooning outlines seem

just a momentary stilling of the stirred-up instabilities Munch so gleefully painted.

Public Life and Normalized Trauma: The Kristiania crowd of *Anxiety* (1894) and *Evening on Karl Johan Street* (1892) may be a social aggregate of Norwegians on winter promenade, but their shared quality is the astonished life-fright registered in their faces. Munch, in this sort of picture, doesn't paint eyes as organs of perception; he doesn't paint the act of seeing, he paints eyeballs, beady orbs, stunned receivers of external stimuli and faint beacons of inner travail. Only in the more intimate pictures does he paint the eyes as deliberative faculties, instruments that observe or reflect.

Now, back to McShine's suggestive phrase, "existential agitation." Existentialism insisted that we're authors and issue of our actions, that we live with excruciating self-awareness, uncertainty, and fraught decisiveness. Munch configures these in the carnal. If he's a more existential artist than most, it's because he returns so remorselessly to the theme of exposure—of sexuality, psyche, society. The *Madonna* pictures are his spin on Salome, breasts bared, lost in a vortex of sexual transport, all-inviting *and* sensually remote. There's no odder image of a working painter than a 1920s photo of Munch in his open air—that is, roofless—studio in Ekely, where, he joked to a friend, he was finally free of alcohol and women: he's shin deep in snow, bundled in an overcoat and fedora, palette and brushes in hand, surrounded by pictures of nudes. It's a summative expression of exposure—the artist to nature, the nudes to him and to us—by the visual diarist of trauma and conflictedness.

I've been finicky about assigning dates to pictures because it helps to remember that Munch's great pictures from the 1880s till around 1908 weren't the finish of his career. The late work that issued so prolifically from Ekely wasn't a retreat from conflictedness. In 1916 he paints the iconic *Vampire*: a woman's long

red hair streams down and around a man whose head and neck, receiving some sort of siphoning kiss, is buried in her lap. His subjects, however, are no longer primarily the wracked humans his reputation had been built on, but everyday motifs—rural genre scenes, landscapes, portraits, bathers. The handling and tonalities change, too, and his palette becomes jumpier, more radiant, his touch more gestural. The compressed masses of naked or clothed bodies are shaken loose, thinned out, their consistencies more aerated, as in the 1923 *Self-Portrait: The Night Wanderer*, where he leans into the frame as if suspiciously (or paranoiacally) spying on us. It's a painted confidence, the equivalent of a diary entry about insomnia's dreary, quotidian inescapability.

The manner is still confrontational, and the handling makes us aware of the separateness of things and persons about to give up their definitions, as if giving up agency. He had always been obsessed with liminal encounters—sea to land, man to woman, communal life to solitary death—and the late work obsesses over the loaded encounter between artist and female model, which he paints as an embodiment of his own vexed desires about women, painting, and the act of seeing. The space separating him and her practically warps with checked predation. He stands behind as if appropriating her, or situates himself as the studious voyeur, or positions one to ignore the other. He sometimes sets them in a garden, the air so choked with flowers and fruit that he makes this imagined Eden a field of wanton release. The painter/model pictures remind us that Munch's compulsive themes were encroachment, estrangement, and perilous fusion. Even when painting a landscape of water streaming through a wood, or a genre scene of local workers, or portraits of friends, those themes still excited him. The later pictures, if less dire in mood, aren't much less serene or nervous than what had come before.

Pressure Zones

The most intimate, mysterious performance photographs are of jazz musicians because two things get exposed at once: the expressiveness of the body (Mingus knitting his brow, Charlie Parker sweating, Roy Haynes grinning) and the interiority of improvisation. A Roy DeCarava photo of Coltrane shows both but adds, far left in the frame, a wraith that is Elvin Jones's nebulous shape. The gleaming highlighted neck of Coltrane's tenor sax runs our gaze from Jones's ghost to the picture's darkest part, Coltrane blowing in half-cropped profile, his face like a mask. A random moment caught by the lens? Yes, because that's what comes naturally to photography. A concentrate of orphic power passing through mortals? Absolutely, because this is a slice of time exposed and seized for its revelatory power.

The photographic image becomes a "picture" the instant when "the flux of changing forms and patterns is sensed to have achieved a balance and clarity and order." Those were John Szarkowski's words in his catalog essay for *The Photographer's Eye*, a foundational exhibition he mounted in 1964 at the Museum of Modern Art. It's also the title of a peculiar exhibition I saw not long ago. Before I get to the peculiarity, let me get to Szarkowski, who during his 1962–1991 tenure as director of the department of photography at MoMA, curated career-making exhibitions of Robert Frank, Walker Evans, Lee Friedlander, William Klein, William Eggleston, and other now-canonical photographers. His taste and judgment crafted an official version of modern photographic history the same way MoMA's first director, Alfred H. Barr, shaped our view of the course of 20th-century painting. Szarkowski's transparent, unfussy, vernacular writing imitated

the qualities he most admired in photographs. He was himself a pretty good photographer: by 1958 he'd already published a stately photo-essay on Louis Sullivan's Chicago architecture and another on Minnesota life and culture that, strange to say, ended up on the *New York Times* best-seller list. He didn't entirely give up photography during his many years at the museum, but he produced virtually nothing for public view until he retired, when he picked up where he'd left off.

The Photographer's Eye configured patterns of relatedness among photographs by Paul Strand, W. Eugene Smith, Edward Weston, and other major figures, along with the less exalted, including that all-terrain snapshooting bumpkin, "Photographer Unknown." The five sections of Szarkowski's brief text were a Pentateuch of straight photography: "The Thing Itself," "The Detail," "The Frame," "Time," and "Vantage Point." He said things that, though now commonplaces, remind us how and why photography is an art. He said, for instance, that every photograph "describes a discrete parcel of time; this time is always the present." One section of his exhibition proved how the present could be stretched by long exposures, when "if the subject moved, its multiple image also described a space-time dimension." Thus, a dog in a Civil War photo appears to have two heads.

In a show at The Museum of Photographic Arts, the curator Carol McCusker reconsidered and illustrated Szarkowski's five categories with images drawn from the museum's permanent collection. Only a few of them appeared in the original 1964 show, and the connection between Szarkowski's precepts and the images they direct us to is over-conceptualized. That said, McCusker's eye is so unerring that this doesn't detract from the quality of what she's chosen. In the room elucidating "The Thing Itself," a photo of a chewed-up, corroded War Department license plate rhymes

with its adjoining picture of a wrecked ancient typewriter whose few remaining keys look like busted teeth. Next to this rhyming couplet are three pictures of clusters bursting at the seams: scruffy boys brandish (to William Klein) their baseball cards, while the girls with them blow bubbles; Anthony Friedkin's *Four Convicts, Folsom Prison* features the hardest guys I've ever seen for real, complete with Illustrated Man tattoos and You-fuck-with-*me?* attitude to spare: one con wears a zipper scar down his breastbone (heart surgery or knife fight?); and a saloon photograph by Michael Smith (American photographers love taprooms) rubs our noses against a New Orleans back-bar shelf choked with a motley line-up of bottles, vintage snaps of tipsy patrons, and a forest of dollar bills Magic-Markered with the names and places of origin of those who spent them ("Donald Ridge: Terra Haute, IN"). Each manifests Szarkowski's claim that "[a photograph's] most fundamental use and its broadest acceptance has been as a substitute for the thing itself— a simpler, more permanent, more clearly visible version of the plain fact."

Under the rubric "The Detail," Szarkowski exhibited pictures of hands belonging to a stout American Legionnaire, a stockade prisoner, a zoo visitor feeding an elephant, a mourner at an Italian shrine, and Jean Cocteau, along with war photos about which he said, "From the reality before him [the photographer] could only choose that part that seemed relevant and consistent; intuitively, he sought and found the significant detail." Under this category the MoPA show includes DeCarava's Coltrane picture plus some constellated images of people's backs. The most comic (and enigmatic) is Joel Meyerowitz's extreme close-up of a plump, well-dressed man whose neck seems not to belong to his body: it's just a piggy cylinder connecting hat to coat. "The Detail" includes the strangest image in the show, Eugene de Salignac's *Painters on*

the Brooklyn Bridge Suspender Cables, October 7, 1914, which depicts
workers like insects caught in crosshatched webbing that bells
out at us from a distant point: the painters shrink into the photo-
graph's depth like figures in a Magritte painting. At first I didn't
know what I was seeing, then I couldn't tell if it was actual or
manipulated. It's something surreal that's not surreal, like Terry
Etherton's weird pseudo-diorama shot of fluorescent light (a per-
fect Ben-Gay green) washing poisonously over gas station pumps.

Szarkowski, as I said, was a photographer, though his images
lack the cranky pushiness and hell-bent voracity of work by pho-
tographers he championed. McCusker honors him by including
five elegant images in her show. She follows his predilections in
her own choices and reminds us that while a photograph's edges
constrain an instant's debris flooding through time and space,
it also pressurizes its contents into a stark coherence. Some art-
ists create pressure zones within pressure zones. In 1982, while
Times Square was being rehabbed into the mini Las Vegas strip it
is today, Jan Staller took a fabulous picture of an abandoned apart-
ment room smeared with bordello reds. We see a worn lounge
sofa, a big square wicker basket, a fatigued Christmas tree, and
LP albums spread on the floor like a collapsed house of cards.
The windows, frames within the picture's frame, concentrate our
attention on their own contents, which are (framed) neon bill-
boards. This feverish image, stuffed with stuff, pressures into ex-
istence an insufferable emptiness and soured good cheer. Danny
Lyon, who became famous for the best biker series ever made, the
1960s' Bikeriders, rattles our nerves with different means: he situ-
ates us at the near end of a New York subway car in 1979, before
the IRT cleaned up its act. The walls and plunging perspective
scheme squeeze the contents of the frame, seats packed with the
messy variety of New York faces and every surface choked with

fat, assaultive graffiti. It's a coherent image of a city hostage to incoherence.

A few photos offer time stilled and time streaming. We see seasons mocked by long exposures, humans blurred to look like clouds amassing. One uncanny color picture, *Birney Imes III's 1986 Riverside Lounge*, issues straight from Friedlander's, Frank's, and Evans's vernacular interiors, especially those above-mentioned honky-tonks and bars. Next to a pool table in a garishly lit, keenly detailed room stands a translucent specter of a (very real) patron holding a cue stick, and next to him stands an even ghostlier *doppelgänger*. For a different sort of eeriness, see Stephen Shore's image of a small Montana town. Four people stand around an intersection; the streets look abandoned, as if emptied by an epidemic; store signage teases us to ask who comes or goes. No moving traffic; only one parked vehicle; vacated parking meters up and down the street like trail markers to a long-since-departed band of travelers. It's as empty an image as can be, yet it's both fraught with something about to happen and saturated with depletion—a dead town that doesn't yet know it's dead.

Hard Shadows

My kitchen doubles as what a friend laughably refers to as my "study." It's where I write, eat, go online, wash dishes, and cogitate. It hasn't been upgraded since the original 1920s house was carved up into one-bedroom rentals many years ago. It's not decrepit, quite, but it's not cuddly, either. For the past several days I've kept open, here in my study, one page or another in the catalog of a Harry Callahan retrospective I've just seen. Today it's a 1984 color close-up of a woman in a ruby dress standing on a street corner. We see only the torso, its creases and quarter-moon slices pleating down the fiery fabric that billows out at us. My kitchen never looked so good, not since I began exposing it to Callahan's imagery, because a great photographer's work sharpens attention, teaches us to re-examine the familiar—spanked clean of habit's dust. The tones and textures and tints the eye takes for granted become revivified, juiced. I appreciate the cool, softened lines of my antiquated Hotpoint fridge more now than I did a week ago.

Callahan's achievement in photography is deep and enduring, but unlike Stieglitz or Minor White he never wanted to be a Druid. He was a reserved, grounded, plainspoken man whose statements about photography were as unassuming as his photographs are extraordinary. He believed that if you do your work assiduously, even when there seems not much work to be done, something's bound to happen: "[I feel] just like everybody else. Trying to figure things out." But he brought to his work a crystalline ardor. He was a visionary of the familiar ("Nature, buildings, and people are my subjects.") who *also* made visionary pictures using double and triple exposures, image "implants," and darkroom manipulations that transformed commonplaces into newly-minted visual

facts. His style throughout is subdued and elemental. Unlike Lee Friedlander or Walker Evans, he didn't busy picture space with information. Every print he chose to exhibit was a crisp, pristine product of enriched reductions.

I've also exposed my kitchen to Callahan's spare, wiry images of nature in the city. The inventor of photography as we know it, Henry Fox Talbot, believed that photography draws nature as the eye actually records it. Roughly a century later, Callahan began working his own intense variations on that originating concept. Witness *Weeds in Snow,* a Detroit picture from 1943: triangulated inky shoots lope across a perfectly blank white field. Twenty years later, in a shot of ferns curling up through snow in Providence, he's still using the camera to record nature's hieroglyphic narration of its comings and goings. Throughout his career Callahan revisited old negatives. Whenever he played with the one for *Weeds in Snow,* he had to pave smooth the textures of the snow, otherwise he'd lose the sketchy spontaneity he toiled to achieve. The spiritual and material dynamics of chiaroscuro mattered supremely. Black bites into white, or vice versa: *Sunlight on Water* throws fluorescent white threads across velvety black archipelagos. These pictures, like *Cattails Against Sky* (the semi-translucent cattails look like one-time-only, long-meditated calligraphic brushstrokes), stare hard at clarity and contrast. They practically re-invent the world's definitions.

Callahan's methods fold austere formalism into chance discoveries. Late in life he said: "I find pictures in grass, but I don't look at grass because it's line. It's just grass. But then these things can come out intuitively and naturally: I don't force my brain." Well, it may just be grass, but it's also, finally and above all, line. Callahan had an extraordinary gift for intuiting patterns in the natural order (as well as patterns that situate *human* nature there)

that restore to us a sense not of fragmentation and separateness, but of connectedness, of forms streaming into forms. A contact sheet of snapshots he took in the Georgia mountains in the late 1980s shows tall grasses so tossed, matted, and cranked by wind, that they begin to look less like grasses and more, mostly, like hanks and braids of long womanly hair; like, in fact, his wife Eleanor's hair as it appears in the hundreds of pictures he took of her.

His career is a straightforward story of pursuit, tenacity, and steadiness. He discovered photography in 1938, at age twenty-six, while working as a clerk in the accounting department of Chrysler Motors in Detroit. In those days workplaces all over America had amateur camera clubs, so Callahan joined Chrysler's. Many years later he said that those years fully formed him and in a way fixed forever his poetics: "I just felt this was as good as I'd ever be. So then my idea was that I'd make the statement in terms of experiencing my life, and then it would change; and my dream would be that it would end up as one big body of work, the beginning just as strong as the end, but changing throughout it all in some way, just because of life." His contact with Ansel Adams, whose workshop he attended in 1941, decided him to devote his life to the art. And by 1946 he was well-enough known to be offered a teaching job at the Institute of Design in Chicago. His work was already drawing on the experiments of Bauhaus refugees like László Maholy-Nagy, who was responsible for hiring him at the I.D., so that while his work never strayed far from representational motifs and Adams's straightforward, mineralized manner, he also developed a passion for the luminescent abstraction of Bauhaus photography. His stint at the I.D. marked the beginning of a long teaching career. In 1961 he was hired by the Rhode Island School of Design and worked there until retirement in 1977. His students have testified that he taught mostly by example: in a time of bigmouth shaman types

and critical theory savants, Callahan in his statements sounded like a Zen cornhusker. Do the work, live your life, pay attention, and it will come to you. Believing as he did in the confluence of photographic practice and the inner life, his pictures have no histrionics in them.

Callahan wasn't interested in painterly effects, especially when he worked in color, which he did virtually from the beginning. He especially didn't want the sooty, crepuscular tones of black-and-white Pictorialism. He makes birches look carved into a dark, snow-bound wood, lighted from inside as if their pith were wire filaments, their twiggy outreaches raked skyward. "The mystery isn't in the technique," he said, "it's in each of us." Though he never ceased refining his darkroom techniques and experimenting with things like developing prints not from contact sheets but from slides and other supports—had he lived, he certainly would have played with digital reproduction—the image was a compound of selectivity, perceptual acuity, and what I can only call a spiritual neediness to somehow see into what he called "the moment that people can't always see." The result was a mysterious, high-finished variety. Consider the supremely nifty 1943 photo of a car on a Detroit street. The fender, with its steely reflective sheen and chrome-trimmed skirt, looks descended from *The Victory of Samothrace.* His most comprehensive urban image, *Wabash Avenue,* of pedestrians stepping across a concrete platform of light under a garage's PARK sign, creates such a stage-lighted effect that while it looks theatrical, it's also a hyper-true rendering of how light, especially in the endless flatness of Chicago, isolates and defines planes of reality. It gives amorphous light a structure. Whether it's the glass and concrete piles of Chicago and Detroit, or the clapboard vernacular of Yankee propriety in his color pictures of Providence, Callahan was pulled toward archi-

tectural definitions. He photographed houses so that we see them as constructed things, not as forms that contain an inner space. His color tends to be restrained but tensile, wakeful to tonal variety and equilibrium. John Szarkowski said of Callahan's work and life: "The search for equilibrium was a lifelong task."

But he was also enchanted by the mysteriousness of flesh. His many nudes essay how the eye represents flesh to consciousness. He photographed Eleanor endlessly, and in time added their daughter Barbara to his motif horde. In 1953 he made very brightly backlit, overexposed nudes that turn Eleanor and the child into cursive, ectoplasmic emanations. Their two forms often serve as elements in an image's compositional rigor, counterpoised to a lamppost or alleyway or tree. The Eleanor nudes really push the dynamics of light and form, but each is also homage to something he finds beautiful in or about her: he wants to illuminate her, as we speak of spiritual or intellectual illumination. One of his most beautiful images is a rear view color shot of mother and child facing a bright window. The light makes them glow. Flesh never looked so rosy and translucent and precious.

Getty's Stuff

As I write this, in April, 2006, newspapers are reporting more troubles in the House of Getty. Greek authorities have seized ancient artifacts from a villa belonging to Marion True, a former curator of the J. Paul Getty Museum in Los Angeles, because Greek law requires possession of antiquities to be reported to the government. Ms. True had quit her job when it was revealed she borrowed $400,000 to buy her villa in collaboration with one of the museum's principal suppliers of ancient art. As if she didn't have enough to worry over, she's also on trial in Rome for conspiring to traffic in stolen artifacts. Quite apart from Ms. True's problems, in the past year Greece and Italy have both brought legal action against the Getty to recover items they believe left those countries illegally. These and other woes—Barry Munitz, director of the J. Paul Getty Trust, resigned in February and is under investigation by the California Attorney General's Office for alleged misuse of expense accounts—have coincided with the re-opening of the Getty Villa in Malibu.

Mr. Getty bought his first piece of ancient art in 1939 and by the early fifties had built the foundation for the finest private collection of Greek and Roman antiquities. (More than a few of the holdings, most famously a superbly preserved *Statue of a Kouros* dated 530 B.C.E. are very possibly modern forgeries.) Getty was at the same time collecting Old Master and modern paintings and in 1954 decided to make all his holdings open to the public in his Malibu Ranch House. In the late 1960s, he wanted a separate structure to house his collection and decided to construct a replica of the Villa dei Papiri in Hercolaneum, an opulent seaside home and, like Pompeii, a casualty of Vesuvius. Since the original villa

was still mostly buried in mud and lava, the Malibu replica was based on speculative designs derived from what had already been excavated. When it opened in 1974, it immediately became one of America's odder destinations: a mock-up of an as yet unearthed Roman villa, built in Los Angeles (symbol and reality of speed-demon modernity), that tumbled together antiquities, Old Master paintings, and modern art, in addition to anachronistic, heavy-handed decorations: French furniture, damask wall-coverings, elaborate candelabra, and fool-the-eye murals. It had the stuffed-bird ambiance of Charles Kane's Xanadu.

In 1997, the Getty Foundation closed the villa for remodel-ing. (The J. Paul Getty Center, in the meantime, was built on its fortress hilltop in Brentwood to house everything except the antiquities.) When Getty died in 1976, he left most of his oilman's multibillion-dollar estate to the museum, which overnight be-came the most cash-rich art institution in the world. Whenever something desirable (and absurdly over-priced) came to market, the Getty usually had first dibs. Two-hundred-and-seventy-five-million dollars later, the villa has finally re-opened, though it's now the centerpiece of a much larger campus-cum-theme-park that includes parking garage, entry pavilion, shop, amphitheatre, auditorium, and café, all of them modern in design, though the passage to them is, luckily for us, a cobble-stoned "Roman road." The architects, Boston's Rodolfo Machado and Jorge Silvetti, have done more than simply restore the old place. They've re-concep-tualized the original and worked their own rigorously pristine, modernist changes on it while honoring the appearance and spirit of Imperial Roman architecture. They've installed new floors of mosaic, bronze, and marble; reorganized the "traffic routes" so that you can negotiate your way fluidly through the many galler-ies; and added fifty-eight windows and three skylights. The savvy

remodeling welcomes crisp natural light that streams the interior, as a seaside villa should, into the bright air and mildly salty breezes outside. The villa gleams so majestically inside and out, and is so perspicaciously executed down to the smallest details, that it looks built from a kit.

Machado and Silvetti have created spaces that let the art exercise its own energetic life. And what a life it is. I'm not qualified to comment on the authenticity of anything, but the Villa's collection is historically comprehensive, edifying and, item for item, splendid, beginning with figurines from pre-classical Cycladic art of 3000 B.C.E., flattened and practically featureless. (These figurines make up part of Brancusi's and Henry Moore's backstories.) The centerpiece of the pre-classical materials is an airy harpist of carved marble whose head is lifted as if in song, appropriate in a pre-literate culture where the continuity of knowledge depended on oral traditions. By grotesque coincidence Marion True's suspect villa is on one of the Cyclades Islands.

The collection also includes things from ancient Greece, Rome, and Etruria. From Greece comes a roundel with the head of Dionysus. (Rooms are organized by themes: Gods, Goddesses, the Trojan War, Dionysus and Theater, Funerary Sculpture, and so forth.) This furious deity, who led his women followers on nocturnal, torch-lit, roaming raves, lurches from his round support, shoulders tensed, mouth half open, silver eyes alight in a bronze head, looking mercilessly powerful and deranged. Antiquity expended as much energy and genius on ornaments and household utensils as it did on "fine arts." A Greek water jar displays an owl with precisely scalloped and notched feathers: olive branches on each side recall that Athena (the Roman Minerva), one of whose representations was the owl, gave Athenians the olive tree, a mainstay of their agriculture. The ornaments always rub against

myth or the natural order. A horn-shaped, silver wine cup (called a rhyton) has a handle carved in the form of a snarling lynx.

The Etruscans who settled along the northeastern margins of the Italian Peninsula around 900 B.C.E. were said to be a happy people. They fought to preserve and extend their territory, of course, but their statues smile. Everything the Etruscans made testifies to life's intensity and exuberance. A storage jar depicting Odysseus's men blinding the Cyclops stands about 3 feet high, and the episode burns with vengeful brio: the warriors pitch all their force into pushing an ember-tipped pole into their captor's eye. And a terra cotta roof ornament used to mask wooden joints shows a maenad dancing with a satyr. She wields castanets—Dionysus' followers were real noisemakers—and wears a gown that would have been painted splashy vermillion and indigo. She's *stepping out* with the satyr but also giving him the cold shoulder, turning her head from his. And for good reason, since the satyr, with his bulging eyes and drinker's lit-bulb nose, doesn't get the pulse racing.

On the unusually smogless day when I visited, the basilica (a room Romans reserved for private gatherings and worship) felt as it should—an enchanted, charmed place. Modeled after one found in Pompeii, the Getty's basilica is covered by ceiling friezes and has a crazy-puzzle marble floor copied from exemplars in Herculaneum. Opaque, yellow-onyx panels thin as glass panes let through a honeyed light that makes the basilica feel like a sacred place. We've come so far from the stories and mores of the ancient world that the didactic materials provided by explanatory panels and wall labels are essential. They're deftly written to inform us without bullying us into awe. It's impossible to re-create in a museum context any culture's sense of the sacred, but the Getty succeeds better than most. When you look at a vase that shows in exquisite

detail the frilled, wiggly drapery of a goddess's gown, you may feel some flashing recognition of the immediacy, the immanence, of deities in Greek and Roman culture. The episode of Zeus in the form of a swan raping the mortal Leda narrates all the dimensions of the gods' arbitrary interventions and violations, and it's remained a vital motif. (The young Cézanne treated the subject.) A vase painting in the Getty dating to 330 B.C.E. shows Zeus gently smooching—beak-ing, really—Leda's lips, but around that tender gesture spread powerful, imperious wings. The God is claiming her, and we're reminded that, however gentle the gesture, the offspring of that union, Helen, would occasion a long, awful, unnecessary war.

The Internationals

I recently sat on a panel—before I sat I should have had my head examined, but that's another subject—and the topic was a mouthful: "The International Style and the Influence of Globalization on Art." One globalizing thought I had right away was what a person like me will do for money. Immediately garish was the rift between my fellow panelistas' notion of style and my own. They're involved in the day-to-day operations of the art world. I'm not. Their remarks on style had to do with the market-driven Rolodex of mannerisms that turn up everywhere these days, from Shanghai to Melbourne to Burbank. For me, an international style is a contradiction in terms: style is idiosyncratic and specific to a temperament-driven practice; it's the shape of feeling created by a medium. Style volatilizes mere concepts and remakes them as expressive means. One panelist argued that art generally was tending toward homogenization, toward a shared set of aesthetic assumptions pressured by what sells. What I see when I view contemporary art, or what I look for anyway, isn't a global mixmaster-ing but a lexicon, growing by the day, of different languages and energies, a voracity to appropriate new materials and ideas, and a working assumption that everything is, possibly, art of some kind. Whether this is a good thing is arguable. But an exhibition I've just seen makes wrinkles in any notion that contemporary art is approaching a sameness of appearance and effect.

The show, *Transactions: Contemporary Latin American and Latino Art*, showcases several mediums: photography, easel painting, installment, performance, video, and sculpture. And within each medium the artists work serrated variations. Consider this: In one of David Cronenberg's early movies, the drolly hideous *Video-*

drome, James Woods plays an over-the-edge TV producer who hallucinates pulling a lurid videotape from a vaginal slit in his belly. (TV, in the movie, is realer than reality.) The American-born artist Daniel J. Martinez has always been a prankster provocateur. He started out by going public, distributing buttons at the 1993 Whitney Biennial that said: "I can't imagine ever wanting to be white." His recent photo essay, a gallery of autobiographical grotesquerie, narrates "self-interventions." Mutilations, that is: he manipulates images so that he seems to be slitting his wrists, or shooting himself in the head, or, as in the 2001 picture in *Transactions,* eviscerating himself. He's bare-chested, his hand plunged wrist-deep into a slit beneath his sternum, where we catch a yummy glimpse of guts. This image, titled *Self-portrait #9b, Fifth attempt to clone mental disorder or How one philosophizes with a hammer, After Gustave Moreau, "Prometheus", 1868; David Cronenberg, "Videodrome," 1981,* is a finger down your throat, but it's also pretty clever. This grisly physical activity is about reproducing out of oneself, *excavating* from oneself, mental disorder; Martinez's intellectual cronies are the mad Nietzsche (who said he philosophized with a hammer), Moreau (whose paintings depict stories of the murderous Salome and of Prometheus, who had his liver picked at by a vulture), and the Canadian filmmaker whose gleeful brutality won't let us forget the inseparability of psyche and corpus.

Martinez's picture *does* announce at least one global preoccupation: identity—nationalistic, racial, cultural. The corollary to contemporary art's axiom, "Anything goes," is "Art makes arguments about identity." Item: the Mexican-born American, Salomón Huerta, makes portraits of men's heads and bodies, but he literally turns the genre around—we see his subjects from behind. His *Untitled Figure* depicts a stumpy male on a metal folding chair, his back toward us, facing not so much a wall as the ochre space

of the painting. The blocky physique, heavy shoes, khaki pants, flamingo-pink t-shirt, and shaved black skull, even the chair, all look cut and creased, painted with a sharp Renaissance clarity of line. But the higher the definition, the more indeterminate the sitter's identity. African-American? Brazilian? Cuban? His garb is so "GAP"-ish universal that, unlike Renaissance portraits, he has no specific identifying data. It's a portrait of affectless recondite anonymity.

Transactions puts all sorts of expressive means on parade, from "modified" baseball caps by Rubén Ortiz Torres (one a riff on the "Rodney Kings") to a flat, floor circle constructed of stitched-together rubber re-treads by the Mexican Jaime Ruiz Otis which, even if it is a one-liner, triggers suggestions of migrant life: wheels, huarache bottoms, and traction in *el norte*. The richest vein is photography. Rochelle Costi, a Brazilian, has made images of bedrooms in São Paulo as cribs of socio-economic identities. One is an overstuffed airless cave of sensual pleasures with bed canopy, ceiling baldachin, faux Tiffany ceiling shade, lace-covered vanity, and bedside wall-length mirror that repeats all that pasha junk. Costi's image of an adolescent's room, florid with posters, floor mattress, inflated animals, books and CDs lying around the walls like floor molding, has the same foreshortened concave space of the other, as does her cramped depiction of a mean shanty in one of São Paulo's *favelas*. Every picture looks like an embrace of someone's absence; each bedroom in its way, no matter the social class, is a kind of softened, form-fitting bathrobe. They "contain" people we never see.

The sheer weight of information borne by an art object sometimes overcomes the object's autonomy. This isn't always a bad thing. Silvia Gruner's installation *"El Nacimiento de Venus (The Birth of Venus),"* ostensibly a saga about soap making, is a layered

meditation on public and private histories. One video monitor shows soap-making machines from Mexico, stamped with swastika designs, cranking out Pepto-Bismol-colored goo; others show the hands of the artist's grandmother and mother, who were rescued from concentration camps. On a factory scale sits a sack overflowing with hundreds of tiny, fragrant soaps shaped like Pre-Columbian statuettes, each with a number (or tattoo) on its back: the sack's weight equals the artist's. These mixed materials, spread around the room, create a resonance chamber: each element speaks to some other, and once you enter its energy field you want to follow those lines of connectedness between the Reich's industrial power, the holocaust, and the legacies of Latino family histories. Gabriel Orozco's photos fuse information and object with tightly coiled efficiency. A "homeless futon" slumped-over like a dummy, a melted popsicle that streaks the pavement with a mandrake-root shape, bicycles ranked outside a cotton factory with wads of cotton (placed by the photographer) on each carrier rack—such images stream human actions backward into the forms they leave behind. And his shot of a trash-choked riverbed—more human traces—reminds us that an intimidating archive is being built by photographers worldwide recording the transition of a marginally healthy biosphere into an irreversibly poisoned planet.

The most arresting collaborative process included in *Transactions* is practiced by Francis Alÿs, a Belgian living in Mexico City, who puts his own counter-spin on art made from revisions. Fascinated by Mexico City signage, he makes paintings of buildings topped with, say, a Coca-Cola sign or election campaign billboard then has the original sign-painters copy his work. He in turn copies their copies of his originals, with spooky results that blend documentation, authenticity, re-fabrication, and the oldest

of representational practices: re-imagining the motif. The finished pictures, by the way, themselves look like billboard paintings, flat and garishly lit. To remind us we're watching the highest kind of play, Alÿs plays the optical trick of curling the hem of a curtain fluffing from an upper-storey window down and into the window below. In an exhibition that wears its earnestness on its sleeve, in which some artists take their ideas more seriously than the objects they make, Alÿs's paintings are a buoyant tease. To these I'd add the sassy pictures of the Chicano muralist John Valdez, whose work I'm very keen on and whose paintings and pastels of Southland youth culture—low-riders, sex, hot-pants fashion, gang life—have the passion for personality, lived experience, and cultural identity that we'd expect from Dutch baroque art, not from a local, hip visionary of the down-and-dirty real.

That panel discussion I started with was attended by a motley gang of artists, critics, dealers, and panel-goers (who must have nothing better to do). During the discussion, the participants re-peated variations on where the center of the art world was—New York, Shanghai, Beijing, even Berlin, were contenders. The arbitrariness was glamorously obtuse, because the centered-ness had more to do with money, deals, and art fairs than cultivated taste or judgment. Two of the panelists who claimed to be artists never talked about making, invention, or the life of form. During the Q & A, an artist in the audience spoke with quiet exasperation: "I think you're all out of touch. The center of the art world is, on any given day, my studio."

What Suffices

A strand of floral wire squiggles from a gallery wall and follows a pencil trace to form a nervous oblong shape. The wire performs a kind of *Me and My Shadow* dance with a thin dark line created by the bright overhead lighting. The solo act becomes a perky chorus line of a dozen or so contorted wires protruding from the wall. They possess a hearty fortitude, these frail objects and their shadow lives. Their maker, Richard Tuttle, originated his *Wire Piece* series in 1972, but like much of his art, they're re-invented whenever he installs them in an exhibition. Each re-invention is the improvised result of a Zen-ish discipline: Tuttle stands shoeless before a wall, pencil in hand, meditating on the space, then draws a line, nails wire to the line's foot, and un-spools it to overshadow the extended line. It's a kind of prayer, an act of seeking and finding, never the same iteration twice. Tuttle's work—from these earlier pieces to the large, tented sculptures he made in the 1980s and the miniscule 1992 series *Fiction Fish* (painted forms, smaller than cigar boxes, suspended from wire practically to the floor), to recent multi-paneled wall hangings swabbed with acrylic polychromes and decorated with metal hooks, cardboard tubing, and other media—strikes us with its stark physicality *and* its ephemerality.

The impulse behind Tuttle's art is to find whatever suffices to satisfy expressive needs, and these needs entail inquiry into the material expression of contemplative states. Those unfamiliar with his work will be struck, before anything else, by the protean shapes and dimensions and materials. Many critics and artists regard him as a frontiersman who forty years ago started forging amalgams between painting, sculpture, installation, printmaking, even book-

making, and who cleared a broad swath for artists playing with hybrid forms. Because his work is seldom only one thing (*Wire Piece* combines sculptural finesse with design and engineering), it looks mercurial, flashy, adroit.

The scholar Madelaine Grynsztejn likes "the radically ambiguous nature of [Tuttle's] work, which is neither sculpture nor painting nor drawing, neither two- nor three-dimensional, but a vivid and always-changing combination of all of the above." The ambiguity was there from the start. His first solo show in 1965 contained what he called "constructed paintings," plywood forms sheathed in dyed canvas sewn to the wood. (Add handcraft to Tuttle's methods.) Shortly after, he did away with canvas and applied as many as twenty coats of monochrome directly on wood cut to patterns with oscillating edges that imitated the wavering sweep of the paint. He sometimes hung them on walls, sometimes set them on the floor: they could be sculpted paintings or painted sculptures. In the late 1960s he was hand-cutting canvas (based on preliminary drawings), balling it up, dipping it in the common household dye, Tintex, then hanging the swatches out to dry like laundry. The color-drenched cloth was indistinguishable from the surface wrinkles. The process, as in so much of Tuttle's work, depended on the bobbing cork of chance, on the artist's relinquishing of certain controls. He puts his creations on walls or floors without specifying orientation. Nearly everything in a Tuttle show has this handmade, thrown-up or thrown-down immediacy.

Born in New Jersey in 1941, Tuttle grew up in a fairly pious Protestant family of poetry lovers; his early years were shaped by spiritual conversation and literary expression of feeling. The alphabet later figured importantly in his art. During his early 1960s college years, he spent weekends in New York just as Pop and

concept-driven art were in ascendance. Happenings were happening. Tuttle's first interest was drawing, which still grounds his art, but like many artists who came of age in those days, he had little interest in conventional figuration or Abstract Expressionism. The traditional model of art as a subjective representation of a shared reality, or in the case of Abstract Expressionism, an extremely idiosyncratic internalized reality, was being matched, and to some critical minds out-stepped, by a model traceable back to Duchamp and his one-off, art-is-whatever-you-call-art aesthetic. The new art—whether it treated imagery and language for its iconic jolt (Jasper Johns, Robert Rauschenberg, Andy Warhol) or made art entirely of the "irreducibles" of line, color, and volume (Frank Stella, Richard Serra, Ellsworth Kelly)—emphasized autonomy, materiality, and a squared-up experience of art objects without any intervention of metaphor or "meaning." These artists, like Tuttle, aspired to eliminate illusionism, not just the illusionism of depiction but the illusionism of spontaneous authenticity practiced by Pollock and de Kooning. Stella coined the new precept: "What you see is what you see." This, anyway, is the canned, oversimplified version of late 20th century art history; history is never so straight cut. Tuttle's particular ambition, at any rate, has been to make objects that have an unmediated presence. He says he doesn't want to get in the way of his work, that he wants it to have, to *be*, its own primary reality; he wants "to brush aside everything that veils reality from us, in order to bring us face to face with reality itself."

Tuttle's art gives us pleasures that Minimalism's stripped-down, cool, poker-faced reductiveness worked hard to avoid. Many of his titles—*Fountain, Drift, Yellow Dancer, Old Men and their Garden* (which looks back to Rembrandt's *Susannah and the Elders*)—conjure illusionism or reference of some sort. Resem-

blances jump out at us. *House*, a painted panel, resembles: a) a fence; b) a Siamese twin "H" joined at the hip; c) an architectural motif—while it remains a sign that refers to nothing except itself. And his brushwork is often so sensuous that we can't ignore its human authorship. For all the conceptual apparatus of his practice, Tuttle is anything but a de-personalizing artist. His interest in poetry, in language, in the alphabet as a set of hieroglyphs, is evident in *Letters (The Twenty-Six Series)* from 1966. In its original installation, twenty-six forms bearing a hit-or-miss resemblance to the alphabet were spread on a table, and gallery visitors were encouraged to handle them; this looseness conformed to the rending of what the avant-garde of the time, following Duchamp, believed to be the invisible veil that kept traditional art at an inviolable remove from observers. Later, in 1975, when he returned to the series, Tuttle constellated the same forms across a wall; yet another time he spread them on the floor. The different deployments suggested: a) set of signs as painted forms; b) sculptural objects; c) floor mosaics. Some of the "letters" gesture to other things: the "L" looks like a carpenter's square; the broad flat "U" could be a canoe's hull; one indeterminate form *looks* like a letter but isn't—it may be a petroglyph copied from an Arizona canyon wall, or that cool kitchen helper, the mezzaluna.

The constant in Tuttle's work, especially satisfying in the softened, billowing, lyrical paintings of the recent *20 Pearls*, is drawing. It's so supple and suggestive that you don't feel you're viewing a product, you feel you're witnessing the simultaneous present and past of a mark-making event. The work conveys a palpable sense of the kinetics of the hand exercising not a deliberative process so much as chasing instinctual moves and directions and moods. The color drawings on paper, sometimes roughly framed in raw wood (the frames themselves sometimes painted), seem

like excited episodes in the history of the line. He has said that he wants "a line that doesn't represent anything beyond itself; in other words, the means to represent does not represent anything." The body of work, so far at least, tracks the animal of curiosity as it pursues an as yet unknown and unknowable stopping point, which itself becomes provisional as soon as it comes into existence. Fixities are irrelevant to such an enterprise. Process and invention are everything.

So What's New?

I have a writer friend whose clinical depression paralyzes him when he has to make a decision. He chokes up at butcher counters. Chicken or chops? I tried to imagine his response to scenes depicted in fourteen large format prints from *Copia*, a photo-essay by Brian Ulrich. This young Chicago-based artist has been making images in big-box retail stores like Wal-Mart and Target, mostly in the Midwest. Using a medium format camera (film, not digital) and shooting through a waist-high viewfinder, he sets the viewer on the same plane with the picture's contents and slathers the visual information so close to the front of the image that he sucks out the respiratory resilience that focal depth provides. He photographs enormous spaces so that we'll feel suffocated. (Disclosure: I can't patronize such stores because I get panic attacks.) He makes the Disney section of a hangar-sized toy store—ceiling-high shelves crowded with stuffed Mickies, Pooh Bears, and Eeyores—swell with desirability and promise. The plump, look-at-me! colors cram the frame so greedily that it takes a few beats to notice the real child standing there among the fuzzy huggies. She looks lost.

In mood and ambience, Ulrich's photographs are the chilliest I've ever seen, even when Kelley greens and jumpy reds splat across the image. We see large-size shoppers pushing large carts down an aisle of some mega-market's freezer compartments. In a store in Kenosha, Wisconsin, we see pallets with orange, red, and purple twelve-packs of soda stacked high into pied ziggurats. Such uniform bounty can intimidate. Ulrich's photographs are serial meditations on taste and expectations in a capitalist economy where we're constantly bullied by copiousness, color, and

packaging. Spread in front of those pallets in Kenosha, looking abandoned and forlorn, is a little archipelago of spilt milk. These pictures don't need to scold American consumer habits or the connection between consumerism and American-ism, whatever that may be. (Ulrich doesn't editorialize or condescend to his subject matter.) I have my own ill, hyperventilated feelings about certain kinds of American gigantism, but these spaces and organizations of goods are after all designed and patronized and in many cases enjoyed by human beings. Consumer goods consume *us*, but we collaborate in the devouring. One of these photographs did make me wonder if the culture has finally lost whatever sense of irony it may have once possessed: an ATM/Cash-Out alcove in what looks to be a casino is announced by a huge sign: CASH AND REDEMPTION.

Ulrich is a straight photographer. He shoots what he sees and doesn't pull the image out of the sphere of shared, recognizable realities, and he doesn't construct statements. Soon after looking at the Ulrich pictures I looked at a lot of things by photographers who were trying to break new ground in the 1970s and 1980s, by which time several had not only matriculated through M.F.A. programs but had become professors in them. So, to pull the standard formula inside out, the innovative is also the academic. Photography, like the other arts, certainly uses a more conceptual, head-ridden vocabulary to talk about itself, a vocabulary shared with literature, anthropology, history, and other academic disciplines. This scrupulous self-consciousness has made photography more intellectually reflective about its own means and ends, and terms like "constructed identity," "re-gendering," and "fetish commodification" have weaseled their way into the ongoing conversation about what's happening.

But cerebral armoring can sink an image. The American

Thomas Barrow, working after the manner of earlier experimental image-makers like Man Ray and Lázló Maholy-Nagy, specializes in the photogram, which involves exposing to light solid or translucent objects laid on light-sensitized paper: the paper around the object darkens depending on the exposure, the paper under it brightens according to the object's density. Photograms' fine-tissued imagery suggests memory's filmy overlays. In a picture like *Struggle for Identity 2*, though, Barrow overlays sheeted images of airplanes, a café booth, a negative of Manet's *"Le Déjeuner sur l'herbe,"* and other things of personal consequence, then "finishes" these textures by stenciling over them (in spray-painted car lacquer) the photograph's title, as if the contents don't already, in their nuanced way, create a field of meaning about his identity as an artist. Artists don't need to tell us how to think. That's not their proper work; their proper work is to express. When interviewers gave Robert Altman a hard time about *Nashville*'s moral ambiguities, he said his job was to set in motion a reality on screen, and so far as the audience went, he wasn't going to do their thinking for them.

More subtle, while still getting in its conceptual licks, is Roger Martin's series, *Plastic Dream Love*, where he lays cellophane over female nudes, creating opaque, oscillating surfaces. Women's bodies, packaged in that all-purpose preserving wrap, look like American-type Venuses, draped and shimmering, with brief shocks of exposed flesh. His prints are literally surfaces for reflection. We're not only *what* we see, we're *how* we see. Barbara De Genevieve, an American born in 1947, who like other women photographers got critically roasted for making stark, inquiring pictures of male nudes, wants her work not so much to be an art object as to make trouble: "I'm much more interested in the conversation/argument/debate that my photographs have the potential to create." Her tactics are usually comic and directed

at herself. She can only take herself and her work seriously if she doesn't take it—or seem to take it—too seriously.

One of Walker Evans's most famous images, his 1936 *Penny Picture Display*, which shows a photography studio window filled with wallet-sized portraits of ordinary folks, is the model for a stream of photographic practice that takes its form from the family album, the photo-booth film strip, or passport photo sheet. Rick Hock, for an amusing and rather melancholy album-style picture titled *Big Frank*, re-photographed vintage images on Polaroid film, transferred the wet paper negatives to heavy printing paper, and arranged them as a grid. It's an antic mix of the kind of essential debris we all carry around in our brains, which for better or worse shapes the quality of our intelligence. Hock's important mental icons include Albert Einstein, the Venus Hottentot, Popeye, Andy Warhol, illustrations from a "signing" instruction manual, James Joyce, and Frankenstein. He says he wanted the picture to be his own Frankenstein monster. *Big Frank* reminds us how the photographic medium devours the surfaces of things, but the X-ray effects of photograms let photography also see through things. Barbara Houghton, an American born in 1947, has produced a series of photograms titled *Women's Flimsy Things* that are spooky enchantments. She photographs women's intimate apparel—sample titles: *Bed Jacket*; *Sheer Nylons*—as ghostly fluorescent whites popping and wiggling and staining out from veil upon veil of translucent blues laid on cobalt black. The subject matter is fraught with mighty subjects about voyeurism, costume as constructed identity, and more from the shopping list I mentioned earlier, but the subject matter is, so to say, worn very lightly. The visual information is communicated slantingly, ethereally, and the conceptual content is realized sensuously. The stockings and lingerie phase in and out of realist representation.

Now you see them (as things), now you don't (because they've veiled themselves into abstractions). As we become aware of looking at something emptied out, the emptiness itself marvelously resolves into a form as solid and articulated as the electrodes in Frankenstein's neck.

Star Light Star Bright

I can only guess at the pact, tacit or otherwise, that squats like a toad between celebrities and photographers. Baudelaire said that a portrait—he was talking about paintings—is a model complicated by an artist. He said it in the mid-19th century, when Paris already had its celeb photographer in Nadar, who made portraits of Delacroix, Liszt, Balzac, Ingres, and Baudelaire himself, who said photography could never be an art. But if your model is Bruce Willis, Cindy Crawford, Jamie Foxx, or Jim Carrey, my guess is that they have some say in those complications. Celebrities become celebrities by crafting camera-ready selves. They train to master appearances, they know how to look "caught off guard" or "casual." One of the most provocative magazine photos ever was Annie Leibovitz's 1991 *Vanity Fair* cover shot of a naked, pregnant Demi Moore. There she stands, in proud profile, large with child, flesh burnished by a deep tan I hope someday to acquire for myself, one hand (demurely covering her breast) weighted with a Rock-of-Gibraltar diamond, the other tucked under her belly. She looks at the camera as if looking straight through us, daring anyone and everyone not to take her seriously. Her baroness hauteur is scary. Who's finally in control here? Not the photographer, that's for sure. The contract between model and artist reads: I'll expose myself if you swear allegiance to the insolent glamour of what I'm offering.

The Moore picture is one of many star portraits included in the splashy exhibition of Leibovitz's work that has been traveling the world. Leibovitz, now in her sixties, is the most famous and, given the restrictions of working to assignment, the greatest glossy-magazine photographer we have, now that Avedon is gone.

She has made portraits of stars of varying kinds and magnitudes: a suave Daniel Day-Lewis slouches like a 19th century Russian revolutionary; a skeletal Mick Jagger folds up like something you'd find hanging in a cave; an unbudgeable General H. Norman Schwartzkopf; the art star and Day-Lewis look-alike, Brice Marden; pin-up boy-toy Brad Pitt in velour, leopard-spotted pants. The portraits would seem to be about self-exposure, but the opposite is going on. I'm as enthusiastic a gawker and gossip hound as the next person, but in none of Leibovitz's high-profile portraits did I feel surprised by something *found*. A celeb picture has to be joltingly iconic and vacuum up all available attention; put too many of them in one place and the tang of surprise and mischievous spying turns bland. Star portraits just aren't very exciting as photographs. They're all about hot content playing it cool, nowhere cooler than in Leibovitz's picture of the ruffled dark prince, Al Pacino. I'd exempt the stiff formal poses of Schwartzkopf and Colin Powell; in both pictures, the eye is pulled not to the stolid faces but to the stars and ribbons blazoned across each man's chest. It's these that bespeak extraordinary experience of the world, though the pictures also suggest that power lies in decoration. Very little in her pictures of actors, painters, and dancers—Baryshnikov poses like an Art Deco hood ornament—bespeaks any experience other than that of self-regard. This can lead to serious moral slippage in the installation. Brad Pitt's shot hangs too close to one that Leibovitz took on her many travels with her companion, Susan Sontag, a picture titled *Traces of the massacre of Tutsi schoolchildren and villagers on a bathroom wall: Shangi Mission School, Rwanda*. The smears of blood and gore running down the wall are nearly identical to the scarlet and yellow palette of Pitt's portrait. The proximity is perverse: each mocks the other in historical weightiness.

Leibovitz started out working for *Rolling Stone* in the early

1970s and during her ten years there produced over a hundred covers as well as important photo essays on, among other events of that disordered time, the resignation of Richard Nixon and the 1975 Rolling Stones tour. She later worked for *Vanity Fair* and *Vogue* while along the way helping to create ad campaigns for assorted enterprises like the Milk Board and *The Sopranos*. The career suggests not just extraordinary industry but Leibovitz's peculiar adaptability to just about any assignment. Other well-known photographers like Robert Frank, Louis Faurer, and Diane Arbus served their time in the fashion world, but their ambition was too squirmy and independent to allow them to shape their gifts to the ostentatious perfectionism required by the kind of work Leibovitz does. The only Hollywood image here that got under my skin shows Todd Haynes directing Julianne Moore in a scene from *All That Heaven Allows*. The picture maps out a pattern of intimate concentration, manipulation, and conspiracy that results in charged movie scenes. Director and actress sit side by side in a car's front seat. He's in recessed shadow watching Moore watch whatever her motivation compels her to see in the rearview mirror. She's softly lighted in costume and full make-up, possessed by the diamond-tipped energy good actors concentrate in a passing gesture or expression. He's rumpled, and his dark-circled eyes glare at her like a stalker's.

This too-big exhibition—it includes nearly two hundred images—opens up the full range of Leibovitz's work, including dozens of photographs she took of her family in uneventful domestic situations (in kitchen and bedroom or at the beach) as well as what amounts to a mini-essay on Susan Sontag, a different kind of celebrity, an intellectual-cultural one who possessed astute, controlling camera-awareness. In addition to the nudes and portraits Sontag posed for, as well as candid shots of her in faraway locales

like Sarajevo (where she staged Beckett's *Waiting for Godot*), Leibovitz also photographed Sontag's objects—her manuscripts, her books, her rock and shell collections. They're viewed as workaday relics and reveal Leibovitz's adulation of writing and the word: these images are moments of self-disclosure that never creep into her glam shots. Photos of boring family activities don't have to be boring, but Leibovitz's pictures of her family droop with tedium. The vulnerability or chill of contingency that sometimes spills out of family albums and grabs us by the throat is somehow lost in the ordinariness of these images. A picture of an overweight aunt in a bathing suit mugging the camera can make the heart ache, but the family pictures in this exhibition don't evoke such feelings. I don't doubt these domestic moments touch and call to her, but they don't call to us in the same way. For all her formidable gifts suited to high-end magazine photography, I don't think Leibovitz has the instincts that allow photography to uncover the marvelous, the deeply or obliquely strange, in what's casual and familiar.

The rich exception, and the real surprise of the show for me, is a handful of huge landscapes. Leibovitz's pictures of Venice, probably the most photographed city in the world, are fresh. Her Venice is a fog-washed phantasm, its surfaces smudged and pricked with pinpoints of color. And her nebulous, heroic picture of VerKeerderkill Falls in upstate New York is a Romantic dream vision. Free of personality and pose, these pictures have a shivering looseness and vagueness that her other work doesn't, can't really, allow. When shooting tighter landscapes, she adjusts the scale to emotional attachments. Views she took from Vanessa Bell's bedroom in Sussex have a wiry wildness. Her peculiar covetousness regarding literary things shows itself again. Leibovitz was excited by the place because she associated the English countryside, and this spot in particular—Vanessa was Virginia Woolf's

sister—with Sontag, whose favorite book was Woolf's *Mrs. Dalloway*. And entire passages of the exhibition are a brooding eulogy to Sontag, who died in 2004. The photographer's relationship to her subject and lover is the exhibition's shadow narrative. Leibovitz doesn't have to complicate her model: Sontag was as camera savvy as Brad Pitt. (She made films and two of her many books were on photography.) Some of the images, like the one of Sontag in the brick-and-dust ruins of the Sarajevo National Library, document history's murderousness. Others, when she was sick, document nature's fatal course, when Sontag's camera-canniness gives way increasingly to a disturbing helplessness. Her self-composure breaks down. Time takes over, and Leibovitz records—coolly, methodically—its erosions.

Alley Fight

I'd wager even sophisticated viewers of photography have to re-
mind themselves not to imagine what preceded or ensued from
what Henri Cartier-Bresson called "the decisive moment" when
the camera fixes a scene and its hairline fracture in time. In *The
Principles of Psychology* William James gave us the phrase "stream
of consciousness" to describe how awareness doesn't click along
frame by frame but flows unstoppably even in sleep. In 1895 the
Lumiére brothers, Auguste and Louis, invented a projector that
showed on a sprocketed filmstrip a moving picture of workers
leaving a factory. The invention of movies piqued the impulse to
probe the "before" and "after" of still photography. The contact-
sheets of moderns like Robert Frank, Diane Arbus, and Lee Fried-
lander illuminate the decision-making process: which moment
from a succession of moments is the elect? Photographers have for
a long time experimented with stills as storytelling mechanisms.
Twenty years ago Duane Michals was making multi-paneled au-
tobiographical photographic sequences underscored by handwrit-
ten commentary. A much younger generation of photographers
have pushed this sort of thing into new territory with images that
exploit fable, motion pictures, fantasy, and other storytelling re-
sources. Their work, featured in the exhibition *Tell Me A Story:
Narrative Photography Now,* has a built-in tease that lures us to
extend in our imaginations the negative time and imagery unre-
corded but implied by what the artists allow us to see.

Some follow the lead of the slightly older generation of Jeff
Wall and Gregory Crewdson, who use film crews and actors to
stage complicated tableaux that they print in huge, color-intense
formats. The Australian Polixeni Papapetrou, who lives and works

in Melbourne, has made a series, *Haunted Country,* that draws on the lore of children lost in the Australian bush who die or go mad. It's also autobiographical: when Papapetrou was young, she wandered off from a friend's cabin, became disoriented in the wilderness, and spent several desperate hours trying to find her way back. For *Haunted Country* she took her two children to places like Hanging Rock (the location of Peter Weir's 1975 movie about lost children, *Picnic at Hanging Rock*), costumed them in vaguely 19th century garb, and blocked out scenes of children who find themselves in what seems to be an enchanted but terrifying place. She makes no attempt to override the artificiality of the set-ups. The children look stiffly posed; they're *acting,* as if manipulated by a director not very good at working with child actors. They "gaze" or "slumber" or "look lost." Papapetrou, however, knows exactly what she's doing: the out-of-scale, disorienting, menacing landscape settings give us a palpable sense of innocence in peril. Her images look like monstrous folktale illustrations.

The American Melanie Pullen, born in 1975, is one of the most disconcerting artists of her generation. Her series, *High Fashion Crime Scenes*, mixes grisly and gorgeous, actual and imagined— her provocations go way past the pictures' initial shock tactics. She uses actors and scripted preparations to craft crime scenes based on vintage photos from the Los Angeles Police Department and the County Coroner's Office. Some images are cropped so that we see only a part of the victim's body (reminding us of the fascination with abomination that TV shows like *CSI* tap into) as if it were found by accident or else *put* there as an occasion for meditation on the volatility and danger of chance. In the pastorally titled *Anna and the Grass*, we see the dead Anna's legs only from the calf down stretched on blindingly green grass, velvet scarlet pumps on her feet, those greens and reds recalling all of

life's vivacity. The picture titled *Miyake* pushes point-of-view to another extreme: the foreground of a long, deep-focus shot of Union Station's underground is filled, Brian de Palma-like, with the collapsed body of a knockout young woman, blood spilled and pilled under her head. I was vexed by my own fascination with the awfulness of such ruined beauty: the longer I lingered, the more I felt like a guilty thing exposed, but this kind of taunting vexation, the scrutiny of one's own moral assumptions about what's beautiful, is exactly what this artist intends.

The German Barbara Probst doesn't imitate other photographs or movies. She's creating her own hybrid form. In one photo essay she cants actual movie imagery into repetitive, identical images of herself looking at her wristwatch. She splices film moments, in other words, into the field of time the entire image composes: all time stops while she checks her watch, as if timing an exposure. The pictures include, as sidebars or backgrounds, the French actor Jean-Pierre Léaud and a shot of the Golden Gate Bridge from *Vertigo*; a car exploding in flames (a frame from— I'm trusting my infirm memory here—Costa-Gavras' *Z*); another image foregrounds her in front of the mimes' tennis game in Antonioni's *Blow-Up*, while another more or less puts her *in* an Antonioni movie: she photographs her own eyes and brow in extreme close-up to resemble Monica Vitti's look in *La Notte*.

Many of these younger narrative artists happen to be women, so it was cozy and apt to be able to see, a few days after looking at these pictures, a tightly edited photographic show titled *Women: A Celebration*. What that says is what you get. Women everywhere! The images celebrate, they go gaga, they dance a jig; they *don't* preach or pester or peddle an agenda. The pictures are by the famous (Lisette Model, Julia Margaret Cameron, Robert Doisneau,) the lesser known (Constantin Manos and Luis González

Palma), and the scrappy legendary "Anonymous." They're spread all over time and place: Cameron, 1869, England; Model, 1946, Coney Island; Palma, 1989, Guatemala. And the content? Manos captures the hopelessly aggrieved image of an African-American woman weeping at the funeral of a nephew killed in Vietnam; Bruce Davidson finds a couple close-dancing to a juke box in a Chicago joint; George Seeley, in *The Burning of Rome*, made in 1907, woozily evokes two maidens clinging to each other while in the background Rome, or *something*, seems to be burning.

The Seeley is pure Pictorialism, and its smudged, languorous style is a world apart from Elliot Erwitt's smart, stark, unsentimentalized 1953 portrait of a mother and child in a New York tenement. Women sorrowing, kicking up their heels, laboring, performing, nurturing—they're all here. Except that they're not all here. I was sorry not to see Graciela Iturbide's great shot of a traditionally dressed Mexican woman walking the Sonoran desert with a boombox in her hand, or Ruth Orkin's sassy *American Girl in Italy, 1951*, in which a young woman strolling past a corner café in long skirt, shawl, and sandals, like an American-type Artemis, eyes cast down, provokes the full range of rude physical stupidities—crotch-grabbing, kissy swooning—males are capable of. There's a not so hidden dialogue going on between this show (where you can see photographers reacting to how others represent women) and female narrative photographers who are so skeptical of what they'd call the "fetishizing" memorialized in *Woman: A Celebration*. Alley fights among artists are healthy and cleansing. It keeps them (more or less) honest. In time, you can bet other photographers will take issue with the work in *Tell Me A Story*. That'll be the day.

Desert Angel

A Mexican woman in traditional Indian garb, loose long hair sway-
ing, strides past stone outcroppings towards the Sonora Desert,
like a pilgrim or wanderer, except that she's carrying what was
called, in 1979 when the picture was taken, a ghetto blaster, like
a valise bearing new voices to some desiccated borderland. We
see her from behind, so the face doesn't tell us how to interpret
motive or mood. The photograph's visual information fuses to
opaque, unexplained myth about journeying ancient and modern.

Our Lady of Guadalupe tattooed on a young Tijuana man's naked
back: that inscription of the sacred (tattooing is a form of writ-
ing) declares a weird, mixed piety having to do with *cholo* iden-
tity, along with irrational religiosity, attitude, manhood rites, and
mother worship. The photograph's title: *La Frontera (The Border)*.

Haciendas in northern Oaxaca hire Mixtec Indians to slaughter goats.
Honoring a tradition that dates to an unremembered time, an
animal from each herd is spared and crowned with flowers. A
young man then lifts the goat on his shoulders and dances. In a
1992 photograph of such a slaughter, a barefoot feral Anna Mag-
nani type is skinning a goat, a knife clamped between her teeth,
her skirt soaked with its blood. Sacrificial ritual (the blood-root in
pre-Columbian culture) and raw sweaty sexuality spill one into
another.

These are three of an easy dozen images I could name to argue, as
if she needed it, that Graciela Iturbide is one of the great photogra-
phers of the past half-century. Each comes from portfolios she has

compiled the last thirty years. The title of that first picture, *Mujer angel* (*Desert Angel*), bespeaks this photographer's hot blend of sacred and secular in settings that can seem as remote and other as ancient Mycenae. She's a purveyor-archivist of phenomena that in a global culture less mechanized and materialistic than our own would inspire the creation of mystery cults. Even when she's photographing a common sight like a squall of black birds gusting from tree boughs, she throttles picture space with the force of some mystery of the separate orders of being. Born in 1942 to a well-off family and schooled in a convent, Iturbide married when she was twenty and within eight years had three children. Nineteen-seventy marked a momentous turn: her young daughter died in an accident, her marriage ended and, while enrolled in the *Centro Universitario de Estudios Cinematográficos* at the *Universidad Nacional Autónoma de México*, her teacher and mentor, Manuel Álvarez Bravo, the most famous Mexican photographer of his time, hired her as his assistant. He helped her develop impeccable craft and encouraged her—at a time when foreigners like Edward Weston, Paul Strand, and Tina Modotti had already adopted Mexico as a subject—to pursue indigenous material.

The goat slaughter takes place in La Mixteca in northern Oaxaca. Way south of there, in the small city of Juchitán de Zaragoza, a very different culture exists, the most purely indigenous and matriarchal community in Mexico, famous for the social, political, and economic independence of its Zapotec women, who favor the traditional dress worn by that desert angel, a long skirt and the short patterned blouse called a *huipil*. And what women they are! They put heft back into all the clichés about big, strong women. The Mexican writer Elena Poniatowska explains why males are best not to mess with them: "Man is a kitten between their legs, a puppy they have to admonish, 'Stay there'." The most

familiar picture from Iturbide's Juchitán series, which ponders the feminine in all stages and stations of life—infants, transvestites, virgin teens, crones, dwarves—is *Our Lady of the Iguanas*, an up-from-under shot of a woman who brought iguanas to the public market. (Iguana stew is a Zapotec delicacy, and the iguana figures in their myths and folklore.) She *wore* to market a crown of live critters on her head (after sewing shut their jaws) then put them on the ground to sell. In one of those instants photographers learn to wait for, though the waiting usually entails exposing as much film as possible, Iturbide snapped the picture the moment the broad-browed woman and her prehistoric consort all tipped up their chins. She looks like a risen, mythic queen of the under-world *and* she looks exactly like what she is, a vendor displaying her wares.

Iturbide says she isn't interested in religion as such, she's interested in the palpable presence of the gods among people. Her stated intent is "to photograph the most mythological aspects of people; I don't believe in anything, but I seek rituals of religion, the heroes of religion, the gods." The gods and the life of the tribe are usually associated with animals, a primal relatedness the western industrialized world has mostly suppressed, lost, or forgotten. I don't want to mislead: Iturbide's images aren't ethnographic curi-osities. Her pictures teem with local information but she doesn't simply document cultures. She seeks those "heroes of religion, the gods" from within these societies. She doesn't put us at a tes-timonial remove from her subjects, no matter if she's working in Texas, Tijuana, the American South, Los Angeles, or Oaxaca; her eye moves and glides amidst it all. She records cultural dynamics from the inside out. To her eye, nature and culture aren't pretty or adorable, and her gaze is unnervingly steady and consistent. She watches for life lived close to death and prowls for what's sacred

and terrifying. In *Danza de la cabrita* (*The Goat Dance*), her portfolio of slaughter culture, she rubs up against the membrane of ancient practice and savage (I use the word not to degrade but to esteem) observance. She shows us, as if snagged in the corner of her vision, goatskins stretched on trees like trapped kites. She practically puts us on top of a skinned, dirty-marble carcass hanging from a dark, bloody hand that holds a knife. The series sets off all kinds of associations, especially of slaughter as sacrifice to appease gods. It's festive (the dancing boy) and restorative (one animal spared and crowned), but blood's everywhere in *The Goat Dance*: in a heap of just-slaughtered animals, stockings of blood wash down over their hooves. For many indigenous societies, observance of blood rites helps a people to keep their community sane and prevent its soul from becoming deranged. Iturbide's images aren't shocking, they just contain a given ferocity and violence necessary to preserving something whole.

The *cholos* she photographed in East L.A. have their rites, too, but in Iturbide's images of young men and women (and their babies), the rituals have aimlessly meandered from the ancient underground stream of meaning preserved among the peoples of La Mixteca and Juchitán. The women of Juchitán have their traditional dress, and the 1980s gang-bangers of East L.A. have their own costume—jeans, wife-beaters, sometimes hairnets, always tattoos. They and their girls flash gang signs, and in one picture so does, or so it seems, a babe in arms. Approve or not, that's community. If there's something missing in all this, it's that the culture is more caught up in display than in piety or observance. The tattoos, the custom-job muscle cars, the mad dog look—so many of the Zapotecas look *happy*, but the barrio toughs squint at us like severe, closed down outsiders—all involve decorative surfaces. Though even this culture reveres its own back-in-the-day

traditions, especially the 1940s zoot suit *pachuco* culture that bursts from beautifully orchestrated murals its self-styled successors sometimes pose against. "I insist on astonishment," Iturbide says. She does, she does. She's also incorruptible and humane. Her goat and Juchitán pictures prep us to see past the *cholos*' hand signs and dead-eye stares to the skeleton and blood-fed tissue under the skin.

The *Flatlands* portfolio that resulted from Iturbide's trip through the American south shows off her formalist gifts in the wooly halftones of a haystack, or a farm-stand backed by mealy gray skies. In our South she finds her Mexico, in local cultures like cigar making and beekeeping. In North American settings she's still seeking her gods. She makes scrappy landscapes in Mississippi and Louisiana look like the Mexico City cactus gardens she photographed for her *El jardín* (*The Garden*) series. And her ongoing inquiry into feminine presence and power results in a shot of another poster icon (and yet another tattoo image) of Marilyn Monroe "overseeing" through window glass a young American boy.

Casasola

One of the most extensive photographic archives anywhere, the Instituto Nacional de Antropología e Historia in Mexico City, houses nearly five-hundred thousand images originally thought to have been made by Agustín Casasola, a photojournalist born in 1874 who documented the painful transformations in his country before, during, and after the Revolution. Scholars have determined that the enormous body of work attributed to Casasola was actually the product of numerous photographers, including his brother. Casasola erased from negatives the names of the original photographers and substituted his own. No matter, really, since the archive's critical importance lies not in any signature style but in its epic detailed mosaic of a country that took itself apart and tried to make a new picture from all those broken tiles. *Mexico: The Revolution and Beyond*, an exhibition that drew generously from the Casasola archive, narrated episodes in the lives of rich and poor, the powerful and dispossessed, insiders and outsiders. In troubled times, the photojournalist's first instinct is to chase trouble and freeze-frame trauma, day-to-day-ness, and the mutilations of change.

Casasola started out as a typesetter's apprentice and took up photography in the late 19th century. The new halftone printing process, which broke down an image into differently shaped dots, was expanding the black-and-white palette to include a fresh variety of grays and finer-grained resolution. Gun smoke looked different now. Soldiers' fingernail grime and the rim-markings on their cartridges looked inked-in with a superfine brush. The sky looked bluer than ever, though it still wasn't blue. Close-ups of people, things, and events made subjects almost palpable. The

times were changing, too, and Casasola's photographs teem with what Elias Canetti would years later describe (in *Crowds and Power*) as the most potent political entity of modern history: the crowd. The new crowd wielded power of different kinds: sociopolitical, commercial, and technological. A 1906 photo of a National Independence Day parade in downtown Mexico City shows the military class strutting their stuff while a mighty counterforce of urban workers and *campesinos* press close. The sombrero sea in several pictures represents an oppressed population's incipient power primed to detonate. Elsewhere we see a demonstration of angry out-of-work laborers in front of union offices. More hats. One post-Revolution image offers up the comic bad dream of a Mexico City traffic jam caused by a cabbie and limo-driver strike. The middle class, pre- and post-Revolution, could afford more automobiles, but the city's infrastructure, shaky at the best of times, lacked traffic signals. The judicial system changed, too: to decide famous cases, popular juries were convened—about one hundred and fifty "jurors" packed the courthouse and shouted their verdict.

The history paralleling the pictures is a familiar modern political cycle. A coup in 1876 placed in power General José de la Cruz Porfirio Díaz. A law-and-order hard ass, Don Porfirio, as he was called, cracked down on crime, social unrest, and dissent of any kind. He created the *Rurales*, grim paramilitaries who hunted down criminals (and subversives) in the countryside. He helped modernize his country by centralizing power and building infrastructure. He created railroads, which expedited trade and commerce but also allowed the government to quickly dispatch troops to trouble spots; he extended the telegraph throughout the country; he initiated universal schooling, including special schools for the disabled. Another perspective on these progressive initiatives is that each one extended and consolidated Don

Porfirio's autocratic powers—he expedited modernization by squashing opposition, jailing journalists, and murdering political dissidents. With the increased prosperity of the middle class that Diaz's policies encouraged (documented by Casasola's politically neutral photos of fashionably dressed socialites, theatrical entertainments, and new housing) came bigger, badder slums and a miserable underclass of meat-cutters, glass blowers, shoemakers, and newspaper balers.

In 1911, one hundred and thirty armed revolutionaries crossed the Texas border, heading south to Mexico City, led by Francisco I. Madero, later elected president of the Republic. Madero's match lit a fire that burned through the parched grass of all the passed-over populations in Don Porfirio's Mexico. Northern revolutionaries were led by a former bandit, Pancho Villa, southerners by Emiliano Zapata. Railroads were taken out, haciendas invaded, Mexico City rendered vulnerable. Diaz abdicated in 1911, Madero's presidency was opposed by Zapatistas and eventually overthrown by a former Díaz henchman. By 1923, Zapata and Villa had been assassinated—Casasola photographed both many times, as unsmiling rough-at-the-edges bravehearts, then as corpses. A million people died in the conflict. The economy was in shreds. The New York journalist Pete Hamill, who has spent many years in Mexico, has written that Casasola showed other Mexicans and the entire world that "a revolution was not a tea party."

The pictures in the exhibition showed it all. The Revolution distributed its own cruelties, established its own pantheon of heroic types, chief among them Zapata and Villa, but also the most adored image of revolutionary conviction, the *soldaderas*, female revolutionaries who assisted and fought alongside their revolutionary brothers. The most ambiguous and ferocious image illustrates the equal opportunity brutality exercised by both

presidential palace and revolutionary cadres: in the moment of execution of the "Gray Automobile Gang" in 1919, through a blur of gunpowder smoke bodies sag like rag dolls or seize up in convulsive shock. And for cultural dissonance in its purest form, you can't improve on a 1914 double portrait of the American Consul, one Mr. Carothers, alongside Zapata. The classic, potbellied, white dignitary in a three-piece suit beams with entitlement beside the stern, wiry, self-contained, but in his *caballero* outfit, darkly dashing revolutionary. Both, in their different ways, are committed troublemakers.

Many other Casasola images amuse and rattle us in the same instant. Before and after the Revolution, homosexuals and prostitutes were detested by society at large and brutalized by police. In one jailhouse scene, arrested queers camp it up for the camera. The inside of a woman's prison in another shot looks medieval: one guesses at the physical and psychological horrors hidden behind the window-less, solid steel cell doors. We see dozens of young women in a courtyard sitting at tables, blindfolded, because they're about to take a typewriting test. On a Mexico City street, an electrically powered streetcar is blocked by a herd of goats. An Indian woman accused of witchcraft sits outside a courtroom with a skull clamped between her knees. A detective investigating a murder scene sports a gas mask that looks like a proboscis sensitive to the smell of crime. Post-revolutionary governments encouraged foreign investments, so the archive—Casasola himself died in 1938—also turns up pictures of utility company ads, of Frigidaire appliances and console radios that look as if they've just stood up and are about to speak to you.

Surfboards and Body Shops

In the 1950s and 1960s, several Bay Area painters—David Park, Richard Diebenkorn, Elmer Bischoff, and others—were working to revivify traditional figurative painting while juggling Abstract Expressionism's issues about surface and illusionist depth. They painted portraits, bathers, domestic scenes, and still lifes, pushing the limits of representation. (Each at some point also painted abstractly.) A different scene was shaping up in Los Angeles, where artists were taking close-to-home materials—L.A.'s marine layer and chemically treated sunsets, surfing, car culture, found junk— to explore other possibilities that, even at their most crystalline and non-representational, usually came straight out of their experience. In the late 1960s, the artist and ardent surfer Peter Alexander, while using resin to repair a board noticed that the hardened substance refracted light but looked like liquid standing still, so he experimented with it as a sculptural medium, molding resins into standing wedges hazed through and through with mystical hues of faint purples and glassy aquamarines. His contemporary, Billy Al Bengston, raced cars and motorcycles and in his art imitated their hard, lacquered, candy-color looks. From customizing shops he got the idea of using metal as a support and re-tooling color for sculptural effects; he happily admitted that his art came directly out of Southern California freeway culture. Why not? It's artists who decide how art imitates life.

What Alexander and Bengston produced got called "finish fetish" art because of their obsession with showbiz surfaces and their use of fiberglass or aluminum supports instead of canvas or linen. (They and a few of their cohorts were tagged the Venice Boys, because they lived near Venice Beach when artists could

still afford to live there.) SoCal art in the 1960s and 1970s (when a second generation of Bay Area figurative painters were building on their predecessors' discoveries) scooped up everything from finish fetish art to Ed Kienholz's junkyard amalgams (including *Back Seat Dodge, '38*, which I'll get to in a minute) and Lyn Foulkes's muscular stereoscopic blue and rose landscapes, in which she scratches the canvas to create wild grasses and floats gestural squiggles above hilltops; and from shrine art that showcases L.A.'s mongrel mix of ethnicities to Kenneth Price's architectural ceramic sculptures with glazes so color-saturated and enameled that you want to knock on them. One Price piece is composed of a green upper-storey cantilevered over a "floor level" box with red, yellow, and orange facets. When I first saw it, I overheard somebody say: "They're building a complex behind my house that looks just like that."

In the 1960s and 1970s, contemporary social issues scraped back and forth across formal problems. Some L.A. artists were intent on making trouble, so trouble they made, nobody more than Kienholz. His *Back Seat Dodge, '38*, a cutaway view of a couple coupling in the snub-nosed jalopy of the title, its ambient space lit only by headlights, big-band music tinkling faintly from the radio, is so grungy and audacious—the dummy-woman's legs spread wide for the chicken-wire man pushing into her—that when it was first exhibited in 1966, the Los Angeles County Board of Supervisors deemed it pornographic and threatened to shut the museum, but they and the museum compromised: the assemblage could be shown if the car door was closed. (Gallery attendants opened the door to adults on request, but not if children were present.) *Back Seat Dodge, '38* is whoopee as noir-ish, shabby furtiveness, with mysterious effluvia fogging the car windows, discarded panties and empty beer bottles tossed here and there.

Kienholz knew how to get our attention so that he could then crit-
icize our attention: his art doesn't sandbag us in any vulgar way,
but it does celebrate vulgarity while slicing and dicing hypocrisies
about America's sexual mores. Kienholz, who died in 1994, was a
realist of disgust, of gutter clutter, and also a bad-boy satirist. The
ratty seat cushion of the abortionist's chair in *The Illegal Operation*
is actually a crushed female torso with stuffing, like a rag doll's
inners, oozing from her vagina. Cigarette butts and grimy nasty
instruments lie scattered around her. *The Illegal Operation* dates to
1962, and Kienholz's raspy sadness, grim outrage, and diabolical
in-your-face humor still shocks.

Texture counted more as an essence for Southern California
painters than it did for other regional styles, even when, or es-
pecially when, the work has obvious subjective meanings. Eric
Orr's *1979 Gold to Lead Strip* uses gold leaf on wood as Gothic art-
ists did hundreds of years ago, though the subject matter is auto-
biographical, since the carved surface grill contains his father's
portrait. In it and another of Orr's works, *Silence and Ion Wind*,
where sweet little rooms (or monastic cells) are drawn onto sand-
paper with pencil and gold pen then mounted on lead panel, the
artist achieves fresh effects using ancient methods. The junk art
equivalent of this would be, I think, personal narrative that's lit-
erally constructed from crafted or found materials. When John
Outterbridge was growing up during the Depression, his father
supported the family by operating a small hauling business with
a rattletrap pickup, exchanging his work for yams and watermel-
ons. The son's recent (1993) construction, *John Ivery's Truck: Haul-
ing Away the Traps and Saving the Yams*, owes a lot to Kienholz. A
toy truck with a business phone number painted crookedly on
the door gives up none of its pathos to the fond humor that also
defines it. It also flags the identity politics that took hold of SoCal

art in the 1990s, when another provocateur-enchanter, Betye Saar, constructed *Gris Gris Guardian*. Saar, of mixed ethnic descent, makes *Gris Gris Guardian* a retablo or shrine to her past, with candles, voodoo dolls, bones, feathers, cornhusks, and bottles of occult potions you'd find in a Santería shop.

Some SoCal art, like so much else, tracks back to the momentous split between Cubism—which re-visioned not only how we imagine we see physical reality but how that re-visioning could be represented in marginally abstract, louvered planes—and the Conceptualism Duchamp initiated when he said that if an artist calls something he or she has found "art"—a urinal, a bicycle wheel, whatever—then art it is. When Larry Bell in 1966 makes a transparent cube of vacuum-coated glass, or a year later when John McCracken in *Don't Tell Me When to Stop* crafts a tall candy-apple red rectangular slab and leans it against a wall as a sort of sculpture-yoga, they're still dealing with issues stirred up by Cubism. When Outterbridge builds a model of his father's truck, he's extending, as many artists are still trying to extend, the consequences of Duchamp's readymades. The art that slips these traces is the pure painting of SoCal artists who are essentially landscape painters, except that they're painting L.A.'s runny sunrises and sunsets. Norman Zammitt learned a lot by studying how light filters through Pacific sunsets, and of his brain-piercing picture of concave ribbons of color rising from bottom-most ruby maroons to ethereal cotton-wool blues, he said, "I wanted to make light with paint."

It would be easy to sandbag Southern California art for being, like the city it represents, smug with self-regard and obsessed with appearances. All art is concerned with appearances. L.A.'s spin is an art that has a see-here, unabashed, boastful air about it. Then again, every center—L.A., New York, San Francisco, wherever—

is provincial in its own (usually unaware) way. *And* there are still plenty of L.A. artists who practice traditional easel art, figurative or abstract. I'm not in the oracle business, so won't comment on what seems likely to last, and what does not, though my instincts tell me that Kienholz's plug uglies are here and welcome to stay. He wasn't interested in problem solving, he was preoccupied with crafting a nearly completed reality in everything he made, with uncomfortable moral consequences squirming in every tattered end and darkened nook.

Sleepyheads

Daniel Maclise. Paul Falconer Poole. Thomas Uwins. Familiar names, yes? And yet Maclise, Poole, and Uwins were among the best-known English history painters of the mid 19th century. (Any lesson here about waiting a long time before the dust storms of rumor and reputation settle?) Their refined academic technique imitated the exaggerated idealizing associated with Raphael that Joshua Reynolds, the dominant artist of his time, was proselytizing in the late 18th century. Reynolds preached that the "disposition to abstractions, to generalizing and classification, is the great glory of the human mind." (To which William Blake, bless him, who detested Reynolds's ideas, responded: "To Generalize is to be an Idiot; To Particularize is the Alone Distinction of Merit.") In 1848, Dante Gabriel Rossetti, John Everett Millais, and William Holman Hunt, young artists dissatisfied with the principles espoused by Reynolds ("Sir Sloshua," they called him) founded a revolutionary movement, the Pre-Raphaelite Brotherhood, P.R.B. for short, which in place of High Renaissance aesthetics announced new imperatives: to return to the pious values and painterly effects of 14th and 15th century, i.e., Pre-Raphael, art; to paint realistically from nature; and to treat (mostly medieval) subjects in order to spiritualize art's subject matter. "I shut myself in with my soul," Rossetti wrote, "and the shapes come eddying forth." But if you shut yourself off from actual experience, those shapes are also liable to be weirdly and stiffly antiqued.

The P.R.B. was endorsed by the most influential critic of the time, John Ruskin, who was already urging a return to the clarities of Piero della Francesca and Fra Angelico. Here's Ruskin's take on the Pre-Raphaelite enterprise: "They will draw either

what they see, or what they suppose might have been the actual facts of the scene they desire to represent." A great critic is nothing if not inconsistent. Ruskin swooned over Tintoretto, born two years before Raphael's death, whose decorations in the Scuola di San Rocco in Venice are the most heroically and gorgeously "incorrect" pictures in the world. Rossetti and his cohort, at any rate, looked back to the pristine observation and sharp drawing of "Early Christian" art, re-creating the transparent, gem-cut colors of Piero with thin glazes laid over a wet white ground. Rossetti's *Mary Magdalene,* for instance, shimmers with fine-combed reds and greens. The Magdalene was a favorite Pre-Raphaelite figure— they also drew on literary sources: Dante, Chaucer, Shakespeare, Byron, Keats, folk tales—but she's never a dusky Middle Eastern type. Rossetti's repentant is a lassie with a sea-swell of wavy, ardent red hair, draped in granular lighting that softens her glamour-girl allure. Like many P.R.B. portraits, Rossetti's *Mary Magdalene* is devotional art. Most of their pictures look like altarpieces, especially those coffined in their original hulking gold frames, even when they treat secular subjects like the scene from the original Sleeping Beauty tale depicted in Edward Burne-Jones's *The Council Chamber,* where the king and his entourage fall asleep in the briar wood, artfully posed in their recumbent states, faces tilted to catch the light—they look like they're vogueing. Some artists used gold leaf in their pictures, as Fra Angelico had done, though the pious Dominican Angelico was making devotional objects in fact. Like Ruskin, the P.R.B. over time were inconsistent. After 1850, Millais imitated medieval art less and less until he finally abandoned P.R.B. tenets, and none of the Brotherhood or their followers (Burne-Jones, Ford Madox Brown, Elizabeth Siddal, Frederick Sandys) in the end was comfortable with the trademark. History's contrariness produces odd results. Rossetti and the

others, who even before Oscar Wilde and Walter Pater propagated the phrase, believed in art for art's sake. They believed themselves innovators, restorers of anti-academic values that challenged received wisdom. But their art, in the afterburn of Courbet's realism, Impressionism, and the Post-Impressionism of Van Gogh, Gauguin, and Bonnard, has come to seem, well, medieval, antiquated, and irrelevant to all the juiced-up anarchies that would characterize modern art. And yet, like other smallish pouches in modern art history, Pre-Raphaelitism has gotten critical attention in recent years. Then again, so have Norman Rockwell and Grandma Moses. The P.R.B. specialized in Beauty, for sure, Beauty all over the place, so much Beauty that it makes me feel oxygen-deprived.

Most of the figure paintings the P.R.B. produced, including their contemporary portraits of women called "stunners," look like taxidermy, stuffed extinct birds, perfectly posed, not a hair or muscle or eyelash out of place, a faraway soupy dreaminess in their eyes. And the subjects? William Butler Yeats, who began as a Pre-Raphaelite painter, says in his *Autobiographies*: "Only ancient things and the stuff of dreams were beautiful." Ancient and dreamy usually ran together. Beatrice, Dante's real-life muse who died young and in *The Divine Comedy* guides him to Paradise, was a prime subject. The historical Beatrice was just a pre-adolescent girl, slight, pale (Dante sees light suffusing her), and frail. Marie Spartali Stillman's *Beatrice*, though made in 1895, is *echt* Pre-Raphaelitism. Twenty-something, robust, full-figured, "gazing" at nothing as if in a love reverie, she looks like Rita Hayworth in period dress. This isn't to say it's a bad picture, it's to say that the P.R.B.'s ambition of revivifying painting now looks inflated and zombie-fied, all the more evident when we consider the Romanticism that preceded it, Romanticism as enacted in Delacroix's wild,

bloody, sexy, maelstrom-brushworked pictures. What in the 1850s seemed so fresh has now become Romanticism's too well behaved stepchild, stale and self-enthralled.

The P.R.B.'s precepts carried over into crafts. Ruskin enthused over their design arts. A social reformer and England's public conscience about the ills of industrialization, he was already preaching a return to cottage-industry, where artisans produced objects start to finish, in lieu of the tedious piece-work production of the new manufacturing economy, what Blake called the "dark, satanic mills" of an industrialized England. One branch of Pre-Raphaelitism, led by the artist, writer, and designer William Morris, pursued a program that aligned perfectly with Ruskin's teachings. He and Edward Burne-Jones collaborated on a stunning stained-glass window featuring a Viking ship whose billowing sails look like sheeted copper ellipsoids designed by Frank Gehry. Morris collaborated with Rossetti, too, on a set of chairs that look like props from *The Adventures of Robin Hood*, rough-cut, with pinned mortise and tenon joinery, decorated with chivalric scenes. My favorite P.R.B. things are what they would have regarded as their slightest work, Rossetti's *Elephant Drawings*, comic sketches he sent along with letters to his one-time mistress, Fanny Cornforth. He spoofed them both. She was Elephant, he signed himself Rhinoceros (big-horned fellow, he must have been). He teases about their increasing corpulence and her chronic cash flow problems: in one sketch she's stashing in a safe banknotes Rossetti sent with a letter; in another she's killing time playing solitaire. The drawings air-out the hushed chambers of artists who were nothing if not *serious*. My other preferred P.R.B. things: zany, endearing ceramic tobacco jars of leering birds swabbed with gluey glazes.

Many artists produced much-in-demand Pre-Raphaelite stun-

ners. Different artists, same stunner, like the different but near-identical blond bombshells—the Marilyns and Jaynes—of the 1950s. Busty, auburn haired, cataracting silk and velvet bustles and skirts, plumped, bow-shaped, creamy red lips, usually accompanied by a "feminine" attribute like a violin or mirror or tea service. They're conventionalized beauties. It's not the type that concerns me—one person's primo babe is another's so-what—but the quality of the representation. They recall for all the wrong reasons Courbet's portrait in the Metropolitan of Whistler's mistress, *Jo,* who scrutinizes her face in a mirror while finger-raking sumptuous disheveled tresses: it drips with the erotic humidity that soaks the air between extraordinary artists and their models. Pre-Raphaelite stunners, like Rossetti's *Lady Lilith* (a virtual imitation of the Courbet), though easy on the eye, are matched to an idealizing template of select female qualities. Any one of them might make your breath click, but for some of us, if you've seen one, you've seen them all.

Still Learning

Like most great artists, Goya possessed a methodical all-or-nothing curiosity about the means and techniques of making art. Born Francesco José de Goya y Lucientes in a village in Aragon in 1746, after receiving some early training in Saragossa and spending a year in Italy to study Renaissance masters, he launched his career as a tapestry designer in Madrid. Tapestries, in Spain considered fine art, were much in demand as a semaphore of wealth and status. Designers provided cartoons, broadly painted scenes that weavers used as models. Goya's cartoons, mostly history and genre scenes, prefigured the quickened physicality of his later work—he already loved to depict figures roughhousing, flirting, fidgeting, and carousing. Much later, after a long career as a court painter who along the way created a scabrous visual archive of Spain's superstitions, cruelties, and historical atrocities, he ended his career in self-imposed exile in Bordeaux, where he lived from 1824 till his death in 1828.

Even near the end of his life he was experimenting with materials. At eighty, stone deaf from an illness when he was forty and only recently recovered from a near fatal illness in 1819, Goya experimented with painting on small, palm-pilot size ivory tablets. It was the highest form of play: he blackened the ivory, dropped water randomly to splotch the black, then pushed around water color until it began to suggest a form—a Biblical scene, a nude, a child—that he then shaped into a completed image. The ivories quiver with the velocity of their making. Goya could conform to conventions of late 18th century painting when occasion dictated, but he never gave up pushing against standards and assumptions. He wasn't indulging in idle after-dinner speaking when in 1792 he

announced to the Royal Academy in Madrid: "There are no rules in painting." In Bordeaux, a frail but hummingly energetic man approaching the end of his life, he made a drawing of a haggard, white-haired ancient gimping along on two walking sticks that he titled *Aun aprendo—I Am Still Learning*.

During the triumphant mature years in Madrid, Goya earned his reputation, and his bread, not with gaunt, ferocious etchings like the gristly, volatile *Disasters of War* and the bitterly obscene *Caprichos* or his uncanny paintings of beggars, witches, *majas*, and lunatics, but with portraits. He was appointed first painter to King Carlos IV in 1789, when his portraits were already being praised in the press, and worked at court till the end of Carlos' reign in 1808, where his official duties included portraits of the royal family, dignitaries, clerics, intellectuals, and the ruling elite, plus friends and acquaintances. I recently saw eleven choice specimens of Goya's artistry on display in a lightning-in-a-bottle exhibition, *"Goya's Portraits,"* a small but potent sampling of works from 1790 to 1815. His portraits before anything else scan the social and political hierarchies of his time, but the best of them inquire into or try to scrutinize the inner life of his subjects. Any portraitist of his day was expected to produce a satisfying likeness (including physical oddities) and establish the subject's office or profession, or in the case of women, social class and manner. He was also expected to capture something of the sitter's "nature," a compound of mood, temperament, and expressiveness. Like his great Spanish predecessor (and court painter) Diego Velázquez, Goya exploited the occasion of portraiture to express his own style of attentiveness and temperature of emotional response. His 1794 rendering of Félix Colón de Larriátegui situates the subject appropriately in a matrix of work and authority. Larriátegui served as Lieutenant General of the Royal Infantry Guard, and his physical carriage

fixes the dignity and distinction of his rank. Here's a man momen-
tarily distracted from assiduous work, quill in hand, surrounded
by books and documents, looking fatally fatigued by dutiful
public service. Goya concentrates Larriátegui's scrupulous intel-
ligence in his shadowed, pouchy eyes, and the stretched, horsey
face, with its aristocratic nose—its bridge starts way above the
brow line—sags with the weariness of decision-making.

Less formal, and much less reserved, is the portrait of Doña
Amalia Bonells de Costa, wife of Goya's doctor, who saved his
life when he was dying in 1819. (One of his greatest pictures is the
double portrait in the Minneapolis Institute of Arts of the doctor
ministering to him.) She meets Goya's scrutinizing gaze frank-
ly, with a welcoming disposition, her torso slightly turned and
pushed forward, as if prompting our response. The light in her
eyes bespeaks a springy courage in opening herself to the painter
and reciprocating his attention instead of resisting or shying from
it. Goya loved black, and by the time he painted this picture in
1813 he was exulting in the loose, whippy handling of his old age.
There's a thrilling, deft flashiness in the long black tracks of Doña
Amalia's skirt. A swift emerald green trims her dress and streaks
down and across her arm.

The woman in *Young Lady Wearing a Mantilla and Basquiña*
(a *basquiña* is a short-sleeved overdress) folds ambiguous sensual
hints into a countenance more complicated than Doña Ama-
lia's. The as-yet-unidentified subject clutches gloves and fan and
bunches together her mantilla in a vaguely coquettish pose. Rosy-
cheeked and vibrant, she's flirtatious but demure, her come-hither
expression cooled by self-possession. Goya's esteem for his subjects
takes a slightly different form in his picture of Pedro Romero, the
greatest matador of his time. Goya was an aficionado, and the
corrida was one of his recurrent subjects. (His series of etchings,

Tauromaquia, is an exhilarating treatment of blood sport.) To judge by Goya's rendering, Pedro Romero may also have been the most handsome man of his time; he's an answering male image to the carnal beauty of the *basquiña* girl. Goya expresses his admiration of Romero and his achievements in the ring with softly orchestrated rouges and satiny grays. All our attention is pulled toward the matador's caressingly illuminated hand, which is at once delicate and forceful. This consummately relaxed individual is completely at home in the world and accustomed to its adulation.

In a 1787 letter to his good friend Martín Zapater, Goya playfully laid out his preoccupation, as artist and man, with the changefulness of the human form: "I'd like to know if you are elegant, distinguished or disheveled, if you've grown a beard and have all your teeth, if your nose has grown, if you wear glasses, walk with a stoop, if you've gone gray, if time has gone by for you as quickly as it has for me." The portrait Goya made of Zapater a few years later is a careful essay in friendship. The warm candor with which the painter's gaze meets the sitter's presence is registered in the crush of bright light on Zapater's brow. The buttery textures of his silk waistcoat and velvet jacket exemplify the subtle inflections of tone and highlighting that Goya learned from Velázquez. Zapater isn't posing for the painter, he's merely presenting himself, as if about to engage his friend, the artist, in conversation, an engagement reciprocated by the artist's hand. At the height of his powers, Goya pitches his considerable energy and restlessness into an image of love's companionable serenity and ease.

The Freedom Machine

I'm a sucker for what I think of as A Conspiracy of Good Times photograph. Night owls in a smoke-threaded establishment cluster in animated conversation around linen-covered cocktail tables; one lifts a glass; another taps a cigarette on an ashtray. You can almost hear the small combo in the air. The details might change— add a gardenia behind a woman's ear, subtract the ashtrays—but it always adds up to a soft, gloved feeling for an intimate social moment. E. Salomon took such a picture in 1935. He shot his *Café Mac Mahon, Geneva, Switzerland, at 2 A.M.* with the latest in photographic technology, the 35 mm Leica, which he also used to make the first candids of murder trials, political rallies, and celebrity life. The small, portable 35 mm made it possible to catch events with gusting immediacy and without "artfulness." Its predecessor for serious photographers, the Grafley, was big and cumbersome, with mechanical gears and low-sensitivity film. The 35mm was the freedom machine.

An optics engineer named Oscar Barnack invented it as an aide to newsreel cameramen: instead of using notoriously unreliable light meters to set the aperture on their motion picture cameras, they used the little Leica loaded with film stock. These smart little beauties sported nifty knobs, buttons, and rocket-shaped viewfinders, and its portability made possible things like Salomon's club picture and Alfred Eisenstaedt's otherworldly vision of crewmen handling guy wires atop a zeppelin over the Atlantic. The flexibility and speed of the 35 mm also suited it perfectly to sports photography, and the Russians were first in line to exploit its possibilities. Georgi Zelma's coverage of the 1932 Winter Games resulted in zippy images of ice hockey combat, a

ski jumper in flight shot from below, and a high jumper clear-
ing a (ludicrously low) bar. And the 35mm became the camera of
choice of war photographers. When Robert Capa was given an
assignment by *Life* in 1943, later titled *It's a Tough War,* to document
Allied operations in Europe, he and his 35 mm scrambled with
troops foxhole to foxhole.

But World War II wasn't just a male photographer's war. The
35mm also enabled women photojournalists who in the 1930s and
1940s became frontierswomen in what had been a male club of war
photographers and social documentarians. Except for the famous
Margaret Bourke-White, whose images of poor rural families in
the American 1930s and South African gold miners in the 1950s
have become part of our national archive and, like the work of so
many of her colleagues, an inventory of the nation's conscience,
many of these women are still barely known. They form a little
Security Council of image-makers: Thérèse Bonney (French);
Olga Lander (Russian); Hansel Mieth (German); Grace Robertson
(English); and Esther Bubley (American). Fearless, compassionate
without being sentimental, responsive to the liberating technol-
ogy of the 35mm camera, every one exemplifies the critic Carol
McCusker's remark that women "leave evidence of the feminine
when they make photographs," and that, to a more delicate and
quick-tempered degree than most of their male colleagues, they
express, with an apparently casual brilliance, "emotional inti-
macy—often raw vulnerability—and a growing solidarity among
underrepresented populations." Without getting snarled in gen-
der-politics clichés, I'd add that these artists had a penetrating eye
for human interrelatedness.

The German-born Hansel Mieth, for instance, came to America
in the 1930s as a political activist and gravitated immediately toward
the Hoovervilles near Sacramento, the cotton fields picked by

destitute migrants, and the entire culture of poverty that trailed behind the Great Depression. Her images—African-American families scavenging food and tools in the Sacramento dump; filthy urchins framed in a half-open car door (*Cotton Workers' Kids—'Waiting All Day Long'*); a surging triangular mass of hats and outstretched hands of men begging work from a jobber—match up effortlessly against more famous images by Dorothea Lange. And Mieth's stark portrait of a Rosie the Riveter type deserves to be an American icon: a kneeling woman welder, wearing a knowing half-smile along with robotic gloves, helmet, and black goggles, looks like a superhero prototype.

After some brief art school training, the Midwesterner Esther Bubley was more or less groomed as a photojournalist by Roy Stryker, who, as director first of the Farm Security Administration in the 1930s then the Office of War Information in the 1940s, employed Lange, Gordon Parks, Russell Lee, and other straight photographers. Bubley quickly developed her own tropisms. She was attracted to family life, the American road, and small town culture. She also had the gift of making herself invisible around her subjects. Stryker described her disappearing act: "They didn't realize she was there . . . She wasn't invading them; she was sort of floating around. And all of a sudden they saw themselves, not unpleasantly, yet with her discernment, . . . and they said, 'My God, it's interesting'!" Along with night club imagery, I'm a sucker for on-the-road essays; and Bubley's *Bus Story* series, which includes shots of mechanics and window-washers, of slumped, dozing travelers in a terminal café, of affections displayed in the hazy slanted light of waiting rooms, and of curbside goodbyes, are classy, Grade-A Americana.

Good photography scrubs and clarifies perception. These women were drawn to machines as much as their male counter-

parts, and they were especially keen on the relation of the human to the technological. Thérèse Bonney, another unfamiliar but historically impressive presence (she was so famous in 1940s France that a comic book hero was modeled on her), made an image of two female mechanics symmetrically set inside a turbine. It's a witty, vaguely sexualized pairing—the sexuality of women grooming a machine. The images these photographers made force us to see commonplaces—a barber shop, a train loaded with refugees, concentration camp inmates, Italian landscapes and street scenes, couples in dance halls, cities in ruins—as if for the first time. These women and their 35 mm partners snap us to attention and remind us that the so-called canon is a work-in-progress. So does the work of certain contemporaries.

Two Americans born in the 1970s, Andrea Bruce and Stephanie Sinclair, have worked in Afghanistan and Iraq and produced color-soaked images that are, as Bourke-White's pictures often were, much closer to self-aware art photography than to the catch-me-if-you-can photojournalism of their predecessors, but they're pursuing a similar task of finding contemporary facts—of love, horror, despair, solidarity, isolation—and *framing* them for us.

In an essay on Grace Robertson, Val Williams once said that many women photographers abandoned very active careers after just a short time. Robertson's career, except for a brief later burst of work in the 1980s, lasted from 1951 to 1955; it tells us how much a man's world photojournalism was in the post-war period that she pitched her first story proposal under the moniker "Dick Muir." But she also realized that as a woman she could gain access to cultures which men either couldn't gain access to (like ladies' Turkish baths) or else shunned (like childbirth and its messiness). Her wildest photo essay treated women on pub outings. It's a girls' world—these raucous, high-spirited, impeccably attired bit-

ties howl joyfully during an amusement park ride or knock down pints while dressed in party hats and bonnets. Photojournalism in the post-war era—who knew? this boy certainly didn't—was very much a girls' world.

The Way It Felt

During off hours while working as a clerk at the Budapest stock exchange before the outbreak of The Great War, the young André Kertész took photographs and began warming up ambitions about making it his life's work. War intervened. Drafted into the Austro-Hungarian army in 1914, wounded in 1916, mustered out in 1918, when the war ended Kertész's new life as a photographer more or less began. In 1925, at age thirty-one, he moved from Budapest to Paris, took up freelance photography, and began to make some of the choicest 20th century images. In 1936 he immigrated to New York and spent many years supporting himself with commercial photography. (Between 1945 and 1962 *House and Garden* published over three thousand of his photographs, so the man had little wiggle room for his own work.) Luckily for us, Kertész lived to be ninety-one, so after a long commercial career, he began his second new life and returned to the personal, exploratory photography he'd practiced in Budapest and Paris. He was even able, in a way, to resurrect his young life: in the 1970s he learned about negatives he'd exposed fifty years earlier still stored somewhere in Paris, so he retrieved and printed them in a larger format than he was using when he first exposed the negatives.

About format. If you go to an exhibition of Kertész's photographs, bring a magnifying glass. Many of the pictures he created in the early season of his career were contact prints from negatives that measured, at a stretch, four by five inches, often only two by two inches, especially in the very early work from Hungary when he was already using a small portable camera. ("I worked from the start in the Leica spirit," he later said, "long before the Leica existed.") He was such a master printer that even his images

of grand spaces jammed with landscape or cityscape details have
an engraved precision and sublime gradations of light to shade to
darkness that yield one snappy revelation after another. Until he
began to make larger six by eight inch positives, he printed most
of his work on postcard stock that yielded softened, plush tex-
tures, which he either used at standard postcard size or trimmed
to the negative's size. He established two pressure systems in the
frame: miniaturization for dusky concentrates of black and white,
but within that extreme diminution a stunning spatial expansive-
ness in city and country scenes.

I throw in country (or small town) scenes because Kertész,
though he thought of himself as a man of the cities, also loved
provincial locales, especially in Hungary. In one of his earliest
pictures a fiddler crosses a dirt-pack village street with his beg-
ging shoeless son at his side. In another, three bare-assed gypsy
kids pad across a field pushing a wheelbarrow that, Kertész later
recalled, contained scavenged clothing. While the images brim
with pathos and empathy—"I photographed real life—not the
way it was but the way I felt it"—their rippled depths and crinkled,
knifing volumes pull us in. Kertész challenged himself to take the
most grandiose monuments and human "projects," like the Eiffel
Tower or Notre Dame, and treat them not as look-here views but
as more or less off-to-the-side mechanics of city life. He made the
colossal intimate by blending a broad tonal range of a city's grays,
blacks, and silvers. His picture from afar of the Eiffel Tower floats
our gaze out across rooftops till it discovers the Tower, miniscule
in the distance, rimmed with sizzling light. In another photo, he
makes Notre Dame into a ghostly happenstance visitant to a river
scene of workers and bridges and fat dockside blocks of stone. It's
evidence of another remark: "Have confidence in the inventions
and transformations of chance."

Good photographers sharpen our awareness of how our angle of approach to the seen determines our feeling for it. In his scrupulous 1928 street image, *Meudon, France*, our eye first finds a man crossing the street carrying a large flat parcel wrapped in newspaper. Buildings on each side narrow deeper in the picture to street's end, at which point we cannot *not* follow the compositional rhythms skyward where, way high in the picture, as if on a pedestal, a locomotive crosses a stone trestle like an apparition, trailing soft-muscled smoke. The entire scene is pretty shabby, with messy, incoherent construction going on at the foot of the trestle. The picture's subject is the act of finding, of "descrying," what's before our eyes but passes unnoticed until the photographer reveals to us the whole field of relatedness.

Kertész lived through modern art's major turns—Cubism, Abstraction, Conceptualism, Surrealism—and absorbed their findings into his native compositional instincts. He loved to use strangely angled overhead views to craft visual balances and cadences that charm the eye. In *The Harbor at Brest, France*, we see from above cubical crates crowding the bulwarks of a small, wooden, lozenge-shaped freighter nosing into a barge bearing white barrels. The vessels and their contents, including the flatbed stacked with metal pipes alongside the freighter, look arranged, a cubist maritime-industrial still life. A different sort of experimentation happens in a series of nudes titled *Distortions*. The Surrealists preached that if you combine two given objects you create a third reality that never before existed. In the early 1930s a men's magazine commissioned Kertész, who liked to call himself a "naturalist surrealist," to photograph nudes reflected in a parabolic mirror; working with a classical motif, the pictures he produced—the women's limbs are inflated like bladders or stretched like gum—swim in the same waters harvested by the

Surrealists. The rubbery, curvilinear joints and swooping fields of flesh come right out of Dalí and Picasso.

Kertész's late work holds an aura of contemplative serenity. He was always a purveyor of mystery. In a 1920 Budapest image, a young couple peers through a chink in a fence to sneak a peek at a circus we can't see: their backs (which are all we see), his round-brimmed hat, her head scarf, and the wood planks compose an image of secret pleasures hidden from sight. And the work of the 1960 and 1970s—around 1950 he'd had to quit the darkroom, when he developed allergies to the chemicals, and rely on assistants—have the same sensation of benevolent puzzlement and secret knowledge. An elegantly dressed man, his back to us, stands in Central park on a fall day pondering an empty broken park bench in the foreground visually reiterated by a loose chain of benches stretching into the distance. Modern photographs of New York register the city's cheeky energy and manic self-reinvention. I'm thinking of Alfred Stieglitz's photographs of horse-drawn trolleys slogging through snow, Robert Frank's image of Macy's Thanksgiving Day Parade, and Louis Faurer's eye-poppers of 42nd Street's neon. Kertész's bench picture has the sober stillness we see in his 1967 photograph (my favorite) of a street puddle. In the jagged mirror of the rainwater, which looks like a torn page pasted across the pavement, lies a reflection of nearly the entire height of the Empire State Building. A monumental icon of urban life is inverted, dematerialized, and laid to rest underfoot.

The images are sober but never leaden or dour. Kertész was in life a good-natured fellow, and it carried over into the work, which sometimes leans on sentimentality, as in a picture of a small cloud hovering—Oh, lonely! Oh, wandering!—near the Rockefeller Center. But when the quietude, technical inventiveness, benevolence, and seriousness come together, they result in

an image like *Martinique*, one of his last pictures. He and his wife were vacationing in a hotel where Kertész wanted to find some fresh connection between a pebbled glass balcony partition outside his room and his view of the Caribbean's horizon line. The image he made is low-key spooky: a shadow on the other side of the glass leans toward the balcony railing *this* side of the glass; the rail's flat fluorescent top triangulates with the horizon. With no apparent exertion, Kertész in his gentleness reminds us that in time we become shadows of ourselves, while the world wheels through its own changes: the tide ebbs, clouds blow by, and light paints itself on available surfaces.

Mouth Sewn Shut

One of the faint doggy odors that lingered in postwar American art (still does, for some) was the quality of Jackson Pollock's draftsmanship. He and others recognized his limitations early on. His brother Sande said that as a student at the Manual Arts High School in Los Angeles Pollock "couldn't make images out of other images." And in a 1930 letter to his other brother Charles: "My drawing I will tell you frankly is rotten it seems to lack freedom and rhythm it is cold and lifeless." But when Peggy Guggenheim began to show his work in 1943, he usually exhibited an equal number of works on paper and on canvas. The roughly seven hundred works on paper he produced from the early 1930s to 1952—his production dropped hard in the four years before his death in 1956—index his conflictedness about drawing as it relates to figuration and abstraction. Much of what came before and after the telluric floor paintings of 1947–1952 is come-and-go representational. Over the years, his work in different media—ink, gouache, colored pencils, poured enamel—tracked the argument with himself about figuration. Even at the end of his career, Pollock was still toiling with it, still drawing it, in his way. Some artists abandon what they can't do well, some knock themselves out trying to master what doesn't come naturally. William Carlos Williams was a lousy rhymer, so after some juvenilia he quit trying and instead developed a magical sense of timing and idiom. Although he produced traditional pencil drawings most of his working life—we have sketchbooks to prove it—Pollock had to meet the question some other way. Some claim that even when he seemed to be drawing, he was actually painting on paper. Well, you can dice it however you like, but it's still drawing, preliminary to some other work or not, even if executed with

291

brush, gravity stick, or colored pencil.

Pollock's strengths lay in exhilarating confabulations of skittering, halting line, not in what Baudelaire (describing Ingres' razorous drawing) called the rational deliberations of outline. The phrase Pollock coined to describe and defend his exploratory practice, applies to figurative and abstract work alike. They both have to do with pushing and streamer-ing toward edges while creating painting space of infinite inside-and-around possibility. No Pollock, on canvas or paper, was ever really concluded. Like a Williams poem, it had no rhetoric of resolution or completion: it simply stopped at the margins of its own self-enthralling, auto-hypnotic pursuit. The early work, though studious and restrained, showed where Pollock would go. The stiff springiness of a harbor-and-lighthouse watercolor from the 1930s has the torsional, bent-sheaves energy Pollock learned from his teacher Thomas Hart Benton. A bleak self-portrait from the early 1930s previews the lashing force that would later help him control the pushiness of the grandiose floor paintings. In life, Pollock swung from blackout rages to stony muteness. and the youthful face in the self-portrait, set in a tenebrous chapel-space, looks dumbstruck, shut down, half the face crushed and emaciated by shadowing that suggests a self terrified or abashed by exposure of any kind. The diffidence was part of the alcoholic pathology. Drunk, he was loutish, cruel, self-devouring. Sober, he was quiet-spoken and reserved. But Pollock wasn't just nonverbal. Most of us normally hear voices in our heads, but the voices in Pollock's head had their mouths stitched shut, and when he drank, the compression exploded into violence directed as much against his own heart and head as against other people. By the late 1930s he was in Jungian analysis, hoping that understanding the contents of the unconscious would help the alcoholism. His unconscious warehoused a

broil of imagery—American Indian (especially Pueblo) art, Asian art, cave paintings, petroglyphs, and the phantasmagoria of that menace Picasso. A colored pencil drawing from this period—his analyst used the drawings as evidence of his mental life—consists of an oval impacted with bladed convolutions. *Figure in a Landscape* (the title was attached later) is an egg containing an embryonic white-headed creature crouching in a spiky garden or field with a farmhouse snugly curved against the egg's wall. The form suggests the Brahmanonda, the Cosmic Egg of Hindu theology, but is really, or also, the inside of Jackson Pollock's skull: the egg is cracked (or trepanned) so that we can peer inside at its contents. It's a cramped color-cloister, a delicate but migraine-ish place to be.

Around 1937 Pollock was preoccupied, mostly though books and reproductions, with El Greco: his hand becomes defter and more aggressive, he acquires greater confidence in his quickened slanted line and agonized volumes. Figure drawings in sketch-books—real drawings, good ones, too—deploy El Greco's way of arcing and angling volumes skyward and creating sensuously austere outlines. At the same time, like Matta and Gorky, Pollock was caught up by Surrealism and its claims to unmediated access to the unconscious. His graceful mania and all-over attack took Surrealism's familiar vocabulary—feathery, root-system entanglements—and turned it into stretched, gelatinous, surging-and-retreating stews of line. He tapped the Surrealist vein off and on through the mid-forties, creating calligraphic pileups, color blots, and nut-shelled homunculi that contract to the center of the paper like things afraid. But as he matured, Pollock became a glyph-maker of the feral and unsayable: animals and biomorphic deformities (some cribbed from Picasso: maws and paws, bulls' heads, snouted ladies, bristling forked bipeds), stiletto draperies, sharp-edged lariats and blades, imaginary creatures

(usually troubled or in jeopardy), and motifs suggestive of Navajo sand painting, Hopi bowl designs, and the ceremonial bonfires of Pueblo cultures. The abstractions of the mid-forties are really preliminary drawings—he's testing the embedded axial uprights and contested symmetries that wheel and strut in paintings later in the decade, though the hand that races to evade symmetries also chases bristly nested structures. Sometimes the real subject of the work on paper is his anxiety about making original imagery. After El Greco and the Navajo sand painting technique he learned in David Alfaro Siqueiros' workshop—pouring a picture on a horizontal surface required a new understanding of "attack," a letting loose instead of application—the tentativeness exposed in his early tries at "making images out of other images" gets freed up into distressed lyrical tenderness. By 1947, in paintings and drawings alike, he's vasculating surfaces with fearless prophetic intensity.

Throughout it all (the pure abstractions excepted) the Haunter, the figure, comes and goes. A 1946 experiment comically illustrates Pollock's running hide-and-seek with representation: over a photograph of a dog he laminated film skimmed from enamel paint. Stressed-out canines appear often. In *Guardians of the Secret*, a slashingly drawn coyote-ish animal lying at the picture's bottom between gaunt male and female hierophants recalls the Prankster of American Indian stories. It's kin to another roughly drawn cult painting, *The She-Wolf*, and in a 1943 work on paper, one doggy creature bays at the sky while his companion's lopsided eyes cock straight out on at us. In this and other things from the period, Pollock treats pictorial space as a wall on which to make memorializing marks. Instead of bison, aurochs, and lions, he leaves the shape-shifting phantasmagoria of his imagination or dream life—uterine, ovular, and cranial forms, free-floating geometric abstractions, handprints, hulking half-vaporized titans, clenched

marks that look like math formulas, petroglyphic dots and domi-
no tiles and mysterious astrological notations. The imagery looks
draped on the support, hanging there like an animist veronica.

For me the big jolt comes in 1948. A wiry white-on-black enam-
el depicts sprinting radiographic figures that could have been mod-
eled from either a Greek vase or bent coat hangers. Another enamel
on paper, drawn black on white, traces in long, loopy, single-stroke
lines a fragile figure trio—heads, breasts, and pelvises all clearly ar-
ticulated; soaked into the paper, the lines bear a gray shadow, a run-
ning ghostly outline of itself, like a vigilante or memory of the line's
passage. It's unnerving to turn from these pictures and their zizzy,
nervous speed, to a poured abstraction of the same year painted
with congestive grays, blues, reds, and yellows that tremendously
pressurize the space the poured color creates. The fatter line moves
with the same tracery energy as in the black-and-white pictures, but
its glandular pulses of color create a kind of anxious *allegria*. I feel
the usual blood-rush while tracking lines and prying into the space
they create, but once my eye runs to the edges where the energy
stops, it hovers back and drills vertically—that's the sensation—into
the fractal-ed circulatory systems of paint from which it can at any
time elevate then drop again. Watching Pollock in the drawings
from 1948 dilate and contract space on a surface is like reading a
poet who in three lines can vamp from skipping, light-fingered tex-
tures to cranking, chunky dynamics.

The poured work from the late forties and early fifties, on
canvas and paper alike, has an explosive formal integrity: the paint
isn't veiled over a vertical surface, it's set in motion with steaming
enthusiasm, and Pollock seems at times, if not exactly a happy
artist, at least a poet of sweet if barely stable excitability, like Kit
Smart or John Clare, exercising a joy seamed and pressurized by
mysterious off-ness, or second sight, or gleeful anger, or despair so

internalized that its agent is himself unaware of how inseparable depression's energies are from the excitements of form-making. I have to confess that I've always been partial to the mysterious, hulking, figurative speculations Pollock made, mostly on paper, in the early 1950s, when some felt his gifts were in decline, where desperation dances with a fearless grace. Color and space are aerated, not dizzily impacted or self-referential. But for me the oil painting most subversive of consciousness from that period, by *any* painter, is Pollock's *Number 7* (1951) in the National Gallery. Like other late, sketchy pictures, it's a diptych: the left panel bristles with knobby black upright lines like pickets, gathered around a small egg-shaped fire of sticks; through the right panel stalks a meaty-thighed figure whose torso seams together male and female attributes, with an open-mouthed head split down the center by a line similar to those sticks. The left panel is a skeleton of the big poured pictures, a skeleton fleshed out just barely in the right panel, where the contrapposto figure turns both toward and away from those loose bones.

This most oddly gifted of moderns brainstormed his way to an idiosyncratic practice in the poured, Antaean pictures, having come from the struggles with figural drawing, then pushed onward back to the figure—often monstrous, never fleshy (like Picasso) in its reference to the actual body—and to the archeological or aboriginal. When Pollock experimented with stacked, porous Japanese papers in 1951, his colors bled through the topmost sheet to others beneath, creating minatory shadows of continuity and contingency. In a sense, all his flat and upright surfaces showed deposits of a restless but extremely specialized artistic intelligence *behaving* the pictures into existence, as cave and sand paintings were behaved into existence, as if trying to find a new order of imagery for his tribe.

Appendix: Exhibitions, Venues, Dates

ʔ

"When Can I See You Again" (page 3): *Giorgio Morandi: 1890-1964*. The Metropolitan Museum of Art, 2008.

SAINTS ʔ 2000–2002

"The Full Treatment" (page 13): *Frida Kahlo, Diego Rivera, and Twentieth-Century Mexican Art: The Jacques and Natasha Gelman Collection*. Museum of Contemporary Art San Diego, 2000. *Frida Kahlo: Portrait of an Icon*. The Museum of Photographic Arts, 2003.

"My People" (page 17): *Norman Rockwell: Pictures for the American People*. San Diego Museum of Art, 2000.

"Museum Going" (page 22): *The Museum As Muse*. Museum of Contemporary Art San Diego, 2000.

"Our Lady of the Mineshaft" (page 26): *El Alma del Pueblo: Spanish Folk Art and its Transformation in the Americas*. San Diego Museum of Art, 2000.

"Origins" (page 30): *The Road to Aztlan: Art from a Mythic Homeland*. Los Angeles County Museum of Art, 2001.

"Mastering" (page 34): *Manuel Alvarez Bravo: Optical Parables*. J. Paul Getty Center, 2002.

"Stray Dog" (page 38): *Daido Moriyama: Stray Dog*. The Museum of Photographic Arts, 2001.

"Bluebirds of Happiness" (page 42): *Grandma Moses in the 21st Century*. San Diego Museum of Art, 2001.

"French-American" (page 46): *Frederick Carl Frieseke: Evolution of an American Impressionist*. San Diego Museum of Art, 2002.

"Hit and Run" (page 50): *The Photography of Bill Brandt*. The Museum of Photographic Arts, 2002.

"City Lights" (page 55): *Louis Faurer*. The Museum of Photographic Arts, 2002.

"Head Shots" (page 59): *Double Vision*. The Museum of Photographic Arts, 2002.

"Rembrandt's Etchings" (page 68): *The Age of Rembrandt: Etchings from Holland's Golden Century*. San Diego Museum of Art, 2002.

"Pretty Girls" (page 73): *Idol of the Moderns: Pierre-Auguste Renoir and American Painting*. San Diego Museum of Art, 2002.

"Plaster Angels" (page 77): *José Clemente Orozco in the United States, 1927–1934*. San Diego Museum of Art, 2002.

"Sea Creatures" (page 81): *Pre-Columbian Art: Marine Animal Forms*. Minghei International Museum, 2002.

"Healthy Minds" (page 85): *Eastman Johnson: Painting America*. San Diego Museum of Art, 2000.

"Spiritual America" (page 90): *The Photography of Alfred Stieglitz: Georgia O'Keefe's Enduring Legacy*. Museum of Photographic Arts, 2002.

"The Anatomic Bomb" (page 95): *Vital Forms: American Art and Design in the Atomic Age, 1940–1960*. San Diego Museum of Art, 2003.

WHAT'S LEFT ❦ 2003–2005

"Montmartre in Chicago" (page 107): *Toulouse-Lautrec and Montmartre*. The Art Institute of Chicago, 2005.

"Left Unfinished" (page 114): *Degas in Bronze: The Complete Sculptures*. San Diego Museum of Art, 2003.

"Victorian One-Hour Photo" (page 118): *First Photographs: William Henry Fox Talbot and the Birth of Photography*. The Museum of Photographic Arts, 2003.

"Hard Times" (page 123): *About Life: The Photographs of Dorothea Lange* and *The Grapes of Wrath: Horace Bristol's California Photographs*. J. Paul Getty Center, 2003.

"Hot Chocolate With Chiles" (page 128): *The Grandeur of Viceregal Mexico: Treasures from the Museo Franz Mayer*. San Diego Museum of Art, 2003.

"Black and White" (page 132): *Roger Ballen: Photographs*. Museum of Contemporary Art San Diego, 2003.

"Montparnasse" (page 136): *Modigliani & the Artists of Montparnasse*. Los Angeles County Museum of Art, 2003.

"Throw It Away" (page 140): *Lucian Freud*. Museum of Contemporary Art, Los Angeles, 2004.

"America! America!" (page 145): *American Beauty: Paintings from the Detroit Institute of Arts 1770–1920*. San Diego Museum of Art, 2004.

"Casta Painting" (page 149): *Inventing Race: Casta Painting and Eighteenth-Century Mexico*. Los Angeles County Museum of Art, 2004.

"Spiritual Diaries" (page 154): *George Inness and the Visionary*. San Diego Museum of Art, 2004.

"Reality Under Construction" (page 158): *Jeff Bridges—Pictures* and *Andreas Feininger: Man on the Street*. The Museum of Photographic Arts, 2004.

"Zoot Suits" (page 163): *Chicano Visions: Painters on the Verge*. Museum of Contemporary Art San Diego, 2004.

"Field of Dreams" (page 168): *Maxfield Parrish: Master of Make-Believe*. San Diego Museum of Art, 2004.

"More Meat" (page 173): *Andrea Modica: Treadwell/Fountain*. The Museum of Photographic Arts, 2005.

"Rembrandt's Religious Portraits" (page 177): *Rembrandt's Late Religious Portraits*. J. Paul Getty Center, 2005.

"Angry Kid" (page 182): *Basquiat*. Museum of Contemporary Art, 2005.

"Black and White and Color" (page 187): *Only Skin Deep: Changing Visions of the American Self*. The Museum of Photographic Arts and San Diego Museum of Art, 2005.

"Snap Shots" (page 192): *Snapshot Photographs: A Snapshot of Your Life*. The Museum of Photographic Arts, 2005.

"Lords of Creation" (page 197): *Lords of Creation: The Origins of Sacred Maya Kingship*. Los Angeles County Museum of Art, 2005.

"What's Left" (page 202): *Manufactured Landscapes: The Photographs of Edward Burtynsky*. The Museum of Photographic Arts, 2005.

HARD SHADOWS ～ 2006–2008

"The Scream" (page 209): *Becoming Edvard Munch*. The Art Institute of Chicago. 2009

"Pressure Zones" (page 217): *The Photographer's Eye: Ways of Seeing the Permanent Collection*. Museum of Photographic Arts, 2008.

"Hard Shadows" (page 222): *Harry Callahan: The Photographer at Work*. The Museum of Photographic Arts, 2007.

"The Internationals" (page 232): *Transactions: Contemporary Latin American and Latino Art*. Museum of Contemporary Art San Diego, 2007.

"What Suffices" (page 237): *The Art of Richard Tuttle*. Museum of Contemporary Art Los Angeles, 2007.

"So What's New" (page 242): *Brian Ulrich*. Museum of Contemporary Art San Diego; *Rebels & Revelers: Experimental Decades, 1970s–1980s, Gifts from the Joyce and Ted Strauss Collection*. The Museum of Photographic Arts, 2007.

"Star Light Star Bright" (page 247): *Annie Leibovitz: A Photographer's Life, 1990–2005*. San Diego Museum of Art, 2007, and other international venues through 2009.

"Alley Fight" (page 252): *Tell Me A Story: Narrative Photography Now; Woman: A Celebration*. The Museum of Photographic Arts, 2007.

"Desert Angel" (page 256): *Danza de la cabrita: fotografías de Graciela Iturbide* (*The Goat's Dance: Photographs by Graciela Iturbide*). J. Paul Getty Center, 2008.

"Casasola" (page 261): *Mexico: The Revolution and Beyond—Photographs by Agustín Victor Casasola, 1900–1940*. The Museum of Photographic Arts, 2007.

"Surfboards and Body Shops" (page 265): *SoCal: Southern California Art of the 1960s and 1970s.* Los Angeles County Museum of Art, 2008.

"Sleepyheads" (page 270): *Waking Dreams: The Art of the Pre-Raphaelites from the Delaware Art Museum.* San Diego Museum of Art, 2007.

"Still Learning" (page 275) *Goya's Portraits.* San Diego Museum of Art, 2006.

"The Freedom Machine" (page 279): *Breaking the Frame: Pioneering Women in Photojournalism.* The Museum of Photographic Arts, 2006.

"The Way It Felt" (page 284): *André Kertész: Seven Decades.* J. Paul Getty Center.

≈

"Mouth Sewn Shut" (page 291): *No Limits, Just Edges: Jackson Pollock Paintings on Paper.* Guggenheim Museum, 2006.

Acknowledgments

It was Jim Holman, editor-in-chief of the *San Diego Reader*, who signed me on to write about the visual arts in 1999, knowing I'd never done straight-up art journalism. Without his dispensations and provocations this book would not be. Wendy Lesser, editor of *Threepenny Review*, over the years has ordered up essays on art then edited them with scary expertise. She's responsible for the essays on Morandi, Lautrec, and Pollock. Kathryn Crim didn't write this book but she and her critical-editorial magic made it. She sorted through heaps of writing, helped me see what to keep or toss, then arranged the material into a more or less coherent mass. Jennifer Foerster read and criticized chunks of the manuscript-in-progress then patiently combed through the finished thing. She kept me honest.